80 Years, Gone in a Flash.

The Memoirs of a Photojournalist

John Jochimsen

Author's Note

This is my story, having been born in 1929, during the days of the General Strike and a world recession. It is the story of my childhood, living through a world war, National Service, and then becoming a photojournalist, ending with retirement.

My father, a journalist on *The Times* during the Thirties and the war, had a great influence on my formative years. I very rarely saw him for months on end as he would be sent to Paris or Berlin for two months most years. During the war my mother, while often alone, had to raise me as best she could, and during the Blitz would sit for hours with me underneath the stairs, while I did my homework or slept.

Having no idea what I would do on leaving school, I struggled with suggestions, before intuition steered me into photography, first cine, then stills.

After fifty years in photography and an extraordinary life of travel and adventure, I received many accolades for my work. I enjoyed my career in a creative art form that gave me immense pleasure and satisfaction. But now, at the age of eighty two, I write as a hobby, and a few years ago I published my first book, a fictional wartime adventure called *Three Stayed Home*.

These memoirs are my story, the story of my life, with no embellishment – read and enjoy it. It's also a history of fifty years of photography entwined with my memories of a richly unique life, lived both here and abroad.

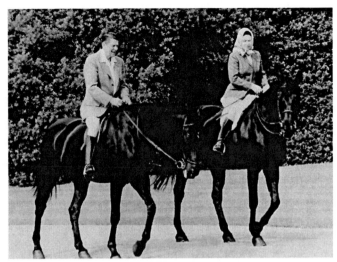

*Ronald Reagan and Her Majesty the Queen
riding in Windsor Park*

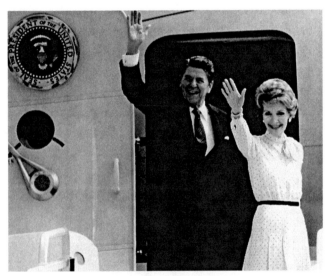

*Ronald and Nancy Reagan leaving
the UK after their Royal visit*

Prologue

My next assignment for the MOD was totally different. I was to take a train to Edinburgh, then get a taxi to Rosyth Dockyard and join a flotilla of wooden minesweepers for a trip to Liverpool sailing round the north of Scotland. This was the 10th Mine Counter Measures Squadron of the Royal Navy Reserve, with part-time seamen manning the ships for the exercise. Having been introduced to the admiral, I was told there were ten ships in all and I was on HMS *Crofton* with Lieutenant Commander Arnold Course as Captain. Leaving Rosyth in the early afternoon and steaming up the Firth of Forth, I was told we'd be getting to Liverpool some three days later, due to the navy's invariable habit of throwing in extra exercises that nobody knew anything about.

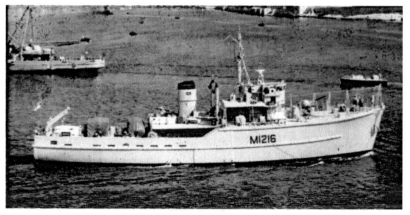

HMS Crofton

HMS *Crofton* was one of the slower ships, but luckily for me she had an enclosed bridge. During the afternoon the sun came out, and because we were in the centre of the line I was able to get fore and aft shots of the other vessels. Next, I took pictures on the bridge and the steering position below, level with the deck. There was a 40/60 Bofors gun forward of the bridge, the only armament on the ship,

while aft of the bridge housing was the sweep deck – a flat area used for handling cables and floats that would cut mines adrift from their moorings, either to be exploded by rifle fire or holed to make them sink.

As we steamed up the east coast of Scotland, *Crofton* was deployed away from the rest of the flotilla to investigate a Russian trawler, apparently harassing an underwater research vessel, the signal from the Admiralty being to 'proceed with all dispatch'. *Crofton* was not recognised as one of the speediest of the 'ton' class sweepers, and at almost her top speed the ship merely crept away from the others. So with a bit of artistic licence from the senior engineer MEA Graham Mackenzie, who after discussion with the captain took the engine revs higher than he normally would, gave the ship nineteen to twenty knots. This caused the exhaust temperature in the funnel to creep up, so he organised a small gang with hoses to spray the funnel exterior to keep the temperature within limits. At the same time, the cox'n was organising a boarding party in case the Russians needed to be convinced still further.

After about two hours of steaming at their highest speed, the *Crofton* came across the offending trawler, and with a little coercion told them to go elsewhere while I took pictures of the encounter.

I was to sleep in the small wardroom, on one of the padded benches that were around the table. So, after a good meal and further night shots on the bridge, I lay down, ready to be up early the following morning.

During the night the ship turned into the Pentland Firth, and not surprisingly started to feel the effects of the Atlantic swell, with the wind picking up between force nine and ten as we rounded Cape Wrath, making anything that was not secured highly dangerous or lost over the side.

I was certainly not secured, and in the middle of the night I was thrown to the floor. As I tried to get up I was promptly elevated back

onto the seat I had just left. Luckily, I hadn't undressed, just taken off my jacket, so trying to put it back on, I began to realise how badly the ship was throwing herself about. Grabbing my camera case I started up the interior steps to the bridge, bouncing off the sides as I went. Arriving, I saw the waves were well over sixteen feet high, and as the ship went over one, it went down with a shattering crash as it hit 'the milestone', instantly climbing back up to do the same gyrations again, straight back down. The captain was hanging on to anything that gave him a semblance of standing, while the other watch-keeping officer fell and slid across the bridge, injuring himself as he crashed into the bridge structure. By this time I had got myself wedged in the small chartroom at the rear of the bridge, so that I couldn't be thrown about, though the constant banging of my body on the chart tables wasn't helping. Managing to open the cupboard and get the camera case in and wedged, so that it couldn't move, I was able to concentrate more on my own survival of standing.

All the way through the Pentland Firth *Crofton* was pitching heavily, with a speed of about fourteen knots, so when we rounded Cape Wrath and turned south into the Minch the pitching was replaced with heavy rolling.

The captain shouted across to me that they were in the midst of a force-nine gale, which I had already realised as I was hanging on for dear life! At about the same time two seaman appeared, helping the injured officer to get below to be treated.

And so the night wore on, with most of the crew down with severe seasickness and the ship rolling and diving as if it had a life of its own. It ended up with the chief petty officer in the engine room, seemingly unaffected by it all, and the captain and myself the only crew on the bridge, both not sick but in no state to do very much. The cox'n was just managing to hang on to the wheel below, but was being very ill with sickness. I had just managed to get over to the captain at the same moment that the cox'n collapsed to the floor in the

wheelhouse. With no one else left standing to take over the wheel, the captain asked me to go down and steer the ship.

Having never steered a ship before, and never likely to do it again especially in those conditions, I agreed and struggling below, took many more knocks on the way. Finding the cox'n on the floor, in a very bad state. I managed somehow to get him wedged so that he couldn't be thrown about, and then got hold of the wheel to stop it gyrating on its own as we plunged down again before climbing back up the huge wave. Trying to get a grip on things, the captain shouted down the voice pipe from the bridge, to convey the course we were trying to steer. Getting the pointer onto it, I tried to keep it there, finding I had to go past and then back with the wheel all the time, to keep the ship on anything like an average course. All this, combined with trying to stand up while my feet wanted to slide away on the wet deck. How long this went on for I just couldn't remember, as I had lost all sense or count of time. I was aching all over from seemingly hitting everything in sight because of the constant battering of the waves. The captain managed to get down twice, bringing ship's biscuits and tins of Coke – all the sustenance he could lay his hands on for us both. The weather lasted like this until we eventually found shelter in the calmer waters off the Hebrides. It was only then that the ship started to behave again, with a fair number of the crew becoming operational, with one, thankfully taking over the wheel from me.

Tired, bruised and exhausted, with any thought of pictures having to wait, I had to rest. On getting back to the wardroom, I collapsed on the couch and had a stiff drink, followed quickly by another. I then had a wash in the basin before even starting to think about the cameras, just hoping they were still intact in the cupboard on the bridge.

A couple of hours later I almost felt my old self again, although very bruised and battered. As I collected the cameras and started to take pictures, I began to realise what that little ship and I had been

through that night. Later I lay down, remembering no more till I woke feeling better for the short sleep.

Getting into Liverpool, and looking forward to feeling the land under my feet again, I said my goodbyes to the captain and the crew of HMS *Crofton*. Walking along the dock past the other moored ships of the squadron, I met the admiral I had been introduced to at Rosyth.

'How did you get on?' he asked.

'Fine,' I said. 'For the middle part of the trip I was steering the ship'

With that the admiral laughed, saying, 'So was I, and I hadn't done it for years.'

Replying I said, 'I have never steered a ship in my life before, and after what I went through, I don't intend to bloody well do it again either!'

With a smile we both shook hands, and I limped off to catch my train back to London, knowing whatever form of transport I took, somehow something was always going to happen!

Chapter 1

It was a sticky, warm night in London, especially in the bedroom of flat 99 Stormont Road, just off Clapham Common, where, on 20th July 1929, Kitty gave birth to her first and only child, John. Harold, her husband, was also there, the two having been married for just over four years before I arrived.

Before they met, Kitty had lived with her mother Kate at the sweetshop in York Road, Battersea. Kate, originally from Lowestoft, had lived with her husband Charles Evans in Tottenham Court Road before he died of the Spanish 'flu, in the epidemic of 1918. Harold, Kitty's husband and John's father, was twenty-seven, being the fifth child born to his parents Gustav and Alice.

Gustav had emigrated from Denmark in the late 1800s. His brother had gone to America at the same time, both having left their country to try and earn a decent living elsewhere. He married Alice, an English girl from St Pancras in London. She and Gustav had four daughters before Harold: Ida, Nellie, Alice and Elsie. These all remained spinsters till their death, never marrying due to the lack of young men after the 1914–18 war.

So, as an infant, my father's parents gave me four maiden aunts and two grandparents, while on my mother's side just a grandmother called Kate. We were a normal family, conditioned to the structure of the late Victorian era, when most people lived in their cosy world of make-believe, sure another war was impossible after the carnage of the last one. The feeling being that the country could only improve after the General Strike and recession.

My father was a journalist on the London *Times*, a man with safe employment, who for the few days of the strike had been a guard on the buses. He could afford to give his small family a reasonable life with his future secure, although money was tight. There was enough to live on in those days, but now that I had arrived all expenses had to be looked at twice, before any thoughts of such things as holidays or

new clothes.

I can barely remember those early days, though was told in later life that I tasted every object I came across, while everything I found as I crawled around needed closer inspection.

By the age of four I had started to develop my own character. I can remember pram journeys to see my grandparents in Battersea, over Lavender Hill and down to the Latchmere and eventually to Brynmaer Road where they lived. As I got older, I used to run out and hide behind the post box as we left, while my mother pretended to look for me, a familiar game with a predictable outcome. It was much later in life that my mother told me that some weeks during this period, she had to borrow half a crown from the grandparents to see her through to the end of the week, until my father was paid. She would then repay it the following week, without saying a word to my father. My mother had a very peculiar way of accounting for the housekeeping, as she had five purses. The money for the housekeeping went in the first one, then out of that came her private spending money, which she put in the second, followed by so much for holidays in the third. The fourth was for presents and cards on birthdays, and the fifth for any savings over the week, being little and not very often.

These were exciting days for me, as I had very few thoughts about danger, especially from dogs on the common. I couldn't understand why I couldn't play with them, or why my poor mother tried to catch me when I took off across the grass.

I recall doing things at home that made her cross, like pushing pencils into the winding hole of the gramophone and breaking them off, so that it couldn't be played, or pulling up plants in the garden and starting to eat them until I spat them out, not liking the taste.

One day, while I was having a meal with my grandparents and aunts in Battersea, my grandfather suddenly put his hand to his mouth, with a look of pain on his face.

Alice, looking worried, asked 'What's the matter, Dad?'

11

Saying he had a pip under his plate, I picked up *my* plate and looked underneath, saying 'There aren't any under mine, Grandpa.'

I also remember the trips my mother and I took to visit Kate, my other grandmother. We would take the 77A bus from where it turned round in Raynes Park and take it to Wandsworth where she lived, in a first floor flat in Ringford Road. My great delight was to be lifted up to turn on the gas lamps when it started to get dark. I would pull the little chain and watch the mantle start to glow as the light increased. The gas light was new to me as everywhere I had ever been before had electricity.

While I was growing up, my father was promoted from the foreign desk to relief correspondent in Paris, and sometimes Berlin, to give the permanent correspondents holidays. That meant every year he was away for two months mainly in Paris, starting in the early 1930s.

Arriving at the office in the Opera, Paris for the first time, and meeting the correspondent, my father signed for the petty cash in the safe, which was for emergencies, which up to that time had never been used.

For three days all was quiet with no stories worth reporting, but on the fourth day, 5th October 1934, all hell broke loose. The R101, Britain's airship, had crashed into a hill at Allone near Beauvais, on its way to India. My father and the photographer had to get to the site quickly, which was about fifty miles north of Paris.

Opening the safe, he found it full of pieces of paper, IOUs but no money. Now not knowing what to do, he looked out of the office window and spotted a car, which he was told hadn't moved for a long time. So the two of them 'borrowed' it, swung it to start and drove to the crash site, where my father phoned his story to London, whilst the photographer took his pictures. After motoring back and parking the car exactly where it had been before, they left it. Nothing was ever said and as far as they knew, the owner never found out why his car had done over a hundred miles, seemingly on its own, and probably

12

scratched his head when he found it had a full tank of petrol as well. Needless to say, when the permanent correspondent came back, my father made sure he signed for the money that wasn't in the safe, never telling him about the IOUs, and making sure he never got caught like that a second time.

It might have been the R101 that I saw when on holiday at Bognor that year, as I remember an airship that flew over the beach. I know it was Bognor as my parents always took me there for holidays, to the same bed and breakfast in a fisherman's cottage in the Steyne, run by two sisters, the Misses Ide. Every year was like this, the same place and the same digs while I played happily every day on the sands just west of the pier. The summers always seemed to be hot, with blue skies and the water always warm. I have vivid memories of the Punch and Judy shows, the crazy golf and especially the ice creams. Also the photographers who would take pictures and develop them in a cup attached to the tripod before drying them and charging pence, and the barrel organ with a monkey on the top. These to me were beautiful carefree days with no worries.

As I got older and started to become more interested in what was going on around me, my father took me to London to see the Silver Jubilee of George V and Queen Mary, which I watched from the *Times* office in Printing House Square. This was May 1935 and I had never seen anything like it before, with the mounted guards, foot soldiers and especially the carriages with the King and Queen waving to the crowds, while everyone seemed to have flags to wave back.

As it was a hot day, my father took me to the canteen for an ice cream after the procession had passed, before we returned home on the train, all quite an experience for a lad of five, especially seeing all the steam engines at Waterloo.

I was beginning to take in quite abstract things, such as for example I realised that London was much bigger than I had thought any place could be. Although I saw many places, I knew home was

my safe haven, and that with the love of my parents everything would always be all right. So when they told me we were going to move to Raynes Park, it worried me. Would what I had known all my young life be suddenly changed, living somewhere totally different?

We moved in July 1935 to a new terraced three-bedroom house in Gore Road. It had a small back garden with a toilet just outside the back door, two living rooms, a kitchen with a coke boiler, an upstairs bathroom and toilet, two good-sized bedrooms and a box room. The heating was from fireplaces in the living rooms, while upstairs in the bedrooms were the fire places that were never lit.

I just remember the moving day with my mother washing the place down, clearing the mess made by the builders, while I rode up and down the pavement on my tricycle. Soon the house became home, with the three of us settling down in our new property. In later years, I learnt the cost of the house was £485, plus the moving expenses, which was an awful lot of money in those days.

The coal bunker was in the back garden, so when the coalman delivered my mother would put newspaper all over the floor from the front to the back of the house, as the bags had to be brought through, as did the dustbin which went out weekly.

I clearly recollect the house next door catching fire. On that fateful evening it was touch-and-go whether the firemen would be able to save our house from the flames. The hoses had to come through the interior of our house to get water to the back of next door, but luckily the only damage to us was two or three windows broken by the heat and some painting that had to be redone afterwards.

At least it stopped the lady next door banging on my wall most nights calling out 'Can you hear me, sister?' The first time it happened, it frightened the life out of me, so I covered my head with the bedclothes and didn't surface for the rest of that night.

That summer was very hot, and a canvas blind was put over the front door, which could then be left open to get a draft through the

house. People in those days never seemed to lock their front doors, or if they did the key was usually hanging on a string that could be got by just lifting the letter box: everyone trusted everyone else, it seemed.

I soon settled into the house and the area, forgetting all about the flat where I was born. My father would go away for two to three months at a time, but Mother was always there, and so became my strength and the one who meant most to me in my young days.

In September of that same year I went to my first school, a small private establishment in Grand Drive called Cumberland House School. The headmaster was an Irishman whose discipline was strict, but I didn't realise the meaning of the word.

School and learning were the start of my realisation that the world was a lot bigger than either Raynes Park or London. I also found out that I had another name besides John, my surname, which was quite a shock to me.

The first day at school was perhaps my biggest eye-opener since I had been born. My mother introduced me to the headmaster, who then took me into my classroom to meet the teacher, Miss Samson.

It had once been the drawing room of the large house, but now was full of long desks with benches attached, inkwells and footrests. There was a large bay window and on the wall were two large maps showing the British colonies in pink. I wondered, when I came to understand that these were of the whole world, how that little piece called Britain could own so much.

Cumberland House School

Miss Samson sat high on a desk, higher than mine with the heating alongside her, one gas fire for the whole room. Others joined that day so the class consisted of new members and some boys who had been kept down. The morning went quickly and lunch was in another building, at the bottom of what was formerly a long garden, now a small field. My mother had packed sandwiches, which I ate in silence while watching others from different forms laughing and joking. After they had all finished eating there was time for twenty minutes' play. I, being a shy boy in those days, just stood and watched until a group of boys picked me up and put me in a dustbin, which was empty, luckily. Putting the lid on, they left me, and I was rescued by a prefect who had heard my cries from inside the bin. Scratched and bruised, I made up my mind that it wouldn't happen again – not to me – and from then on I was in the thick of anything going.

I started to work, trying to understand such things as arithmetic and writing, which progressed slowly but well. I got to like and

understand school as now I had friends in the class. Often finding myself standing facing the wall in the corner, I realised it wasn't all play, so having simple homework in those early days, I took the first steps in applying myself.

One Saturday my father took me again to London. As we walked down Regent Street, I marvelled at the shops and the crowds, suddenly noticing a very tall black gentleman coming towards us. I remember the meeting very clearly but not what was said, for when the man bent down he touched my head. My father told me years later that it was Prince Mona Lu Lu, a Zulu chief, well known in London as a tipster and for his flamboyant dress. He said to my father that day that I would be very artistic when I grew up and then walked on. No wonder I remembered that meeting, as in those days it was so very unusual to see a black man, especially one dressed in such bright colours as he was, walking round London.

When my mother had got the house looking as she wanted, finally finishing with the cleaning, she started to go to the cinema twice a week. She would go to the one o'clock performance, and between the two films that were showing, tea would be served on a tray in her seat. In those days, the Rialto always showed two films every performance, with a change of films on a Wednesday, and a further change Sunday for one day only. These early screenings enabled her to see the complete programme, and be home in time for me when I came home from school. She rarely went to the pictures on a Sunday, unless it was something she really wanted to see – then I would go with her.

Every day she went shopping for food, mainly because there were no such things as fridges in those days, and produce couldn't be kept fresh for long. We had a meat safe on the wall outside the kitchen where cold cooked meat could be put, away from the flies. It had a perforated zinc front, sides and top, with two shelves so that in colder weather it kept the meat chilled, but was never used during the summer, when the meat was put in a cupboard and covered with a

17

gauze lid.

Likewise the two pints of milk that were delivered by the milkman daily – these were put in ceramic covers and stood in saucers with water in, the whole thing left standing on the front step. This was to keep the milk from going off during the very hot weather, as the water would evaporate slowly through the baked clay keeping the milk surprisingly cool while standing in the shade.

I remember vividly the first milkman we had, with the horse and trap and the milk churn in the back, and the man using a pint measure to pour it into your jug. Then later, it was the horse-drawn milk float with glass bottles all sealed and far more hygienic. One day, in my excitement, I ran under the horse's head, getting myself picked up by its teeth and dropped facedown on the road. When I was examined I had a circular row of teeth marks on my back, which took a few weeks to disappear while I made sure I didn't go anywhere near those horses again.

My father had only Saturday's off each week, due to *The Times* not having a Sunday edition in those days, but he had to work on Sundays for the Monday paper.

His next trip to Paris was in 1936 when the riots were in full swing. As he stuck his head up behind the barricade, a bullet passed through his high-crowned trilby, luckily without touching him. Taking off his hat and looking at the holes, one in and one out, he nearly passed out with fright and, clutching the ruined piece of headgear, made his way rather swiftly back to the office in the Rue Halevy. Arriving back and taking a stiff drink or two, he wrote his story without going anywhere near the action again.

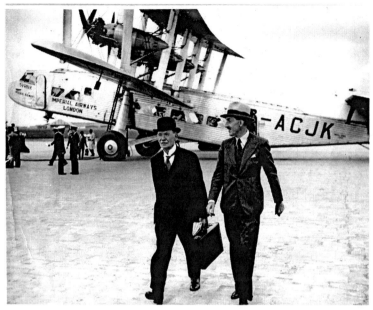

Paris 1936, my father meets my grandfather at Le Bourget,
who flew in from Croydon

That hat had pride of place in the Paris office with a plaque on it and became part of *The Times*'s history in Paris for years, until the war came. It was in the year 1936 that my grandfather flew out from Croydon to spend a couple of days with his son. They met at Le Bourget along with the staff photographer. The two glass plates he used are still with me, showing my father in his new hat but he never got over the fact that *his* father was pictured holding a copy of *The Daily Telegraph* in both shots, and not *The Times*.

The next year he was back in Paris again. The night he arrived he was so tired from the travelling that he went to bed early, only to be awoken with the sounds of shooting and machine guns. Putting on his dressing gown he rushed down to the concierge in the hotel, asking what was going on – had the riots started again?

'No,' was the man's reply, for it was only the cinema next door

showing *The Lives of a Bengal Lancer*. With that, Dad retired to his bed, his face a little red.

One night, my mother woke me to see the large red glow in the sky over London, visible over the houses opposite. That night was 30th November 1936, and the fire was the Crystal Palace aflame, leaving only a skeleton of twisted steel girders, though in four years time I was going to see many more of the fires over London.

A lot happened in 1936 and 1937, though I was too young at the time to understand. George V died in early January and was succeeded by the Prince of Wales, who became Edward VIII. He abdicated in the December for the love of an American, Mrs Wallace Simpson, leaving his younger brother to take over and become King George VI, with his wife Queen Elizabeth. The Coronation took place on 12th May 1937. Also in that year the Prime Minister changed, with Stanley Baldwin being succeeded by Neville Chamberlain.

At my age I was unconcerned with politics and royalty, focusing only on school and my friends. I had met two boys who lived opposite, twins called Clive and Lawson, and another called Geoff, who lived in the next street. My garden met his and we chatted for hours over the fence, while Doug – who I had met at school – lived close by, as did Terry, who was just up the road. All remained great friends of mine in the years to come, but uncertain years as it turned out.

The last trip my father made to Paris was in late 1938. On his first day in the office, he noticed that a portrait of the founder of *The Times*, Lord Astor, had been altered. Instead of the man sitting and reading their paper, the name of the journal had been changed to *Ce Soir*, and where his hand rested on the table a foaming tankard had been painted and a big black moustache added to his face. Thinking it was well done and noticing that his hat with its plaque still had pride of place, he settled down to work. Nothing outstanding happened on that last trip, except for a lot of talk about the possibility of a

forthcoming war as he left Paris for the last time.

He heard later that the editor had paid a visit to the Paris office, and seeing the defaced portrait had charged every one of the permanent staff for its restoration. It cost a lot of money, Dad was told, and he was relieved that he hadn't been there for the visit.

I knew that my father had gone at some time to Berlin, where he had met and became great friends with Douglas Reed, the permanent correspondent who later wrote the best selling book *Insanity Fair*. My father said very little about that visit – the only thing I heard about later in life was that he had walked down the Friederichstrasse, touching both sides at once. As that particular road was over a quarter of a mile from one side to the other, he must have had a good skinful with, thankfully, someone looking after him.

Talk of war was in the air, but nobody took it too seriously, saying it just couldn't happen again. At the age of ten, to me and my friends it was not important, nor did we really understand what was happening. For us it was the same thing, school and play. Not so much in the winter but during the long days of summer where my companions and I spent most of our time in the St George's playing field at the end of the road, just the other side of the dual carriageway.

The road had been one of the first in the area to be made into two lanes, but with little traffic in those days it was not difficult or dangerous to cross. The fields were large and divided by mature trees, and gave the impression of the grounds of a large house, which no doubt had been the case in earlier years.

We made bows and arrows and wooden swords, and would have battles among ourselves in these idyllic surroundings; no one ever winning but all tired out when we returned home.

It was about this time that I had my tonsils out. The operation was performed by two doctors, one morning at home on the dining table. All I remember was one put a thing that looked like a flour sifter over my nose and mouth, and started to sprinkle chloroform over the

gauze. I remembered no more until I awoke, with a very sore throat and a lot of blood in and around my mouth. The doctors had gone and so my mother looked after me. I remember acutely the uncomfortable time I had trying to talk, which probably gave my parents peace and quiet.

At Christmas 1937 I was in the school play at St Matthew's church hall in Durham Road, a little way from the school. I was dressed as a robin, in a costume my mother had made from dark brown cloth with an orange front, and a stiffened bit in the shape of a beak. I will always remember the lines I had to say, drummed into me by the teacher in charge of the production. They were: 'The north wind shall blow and we shall have snow and what will the robins do then, poor things, poor things?' The parents all clapped, probably wondering how long it was going to go on for, wanting to get their children home to bed as it was going to be a late night.

We spent Christmas that year with the relatives in Battersea, with my grandmother Kate also there. She had sold the sweetshop in York Road and taken a job in West Malling, Kent, as housekeeper to a Lady Ashwell, and was much happier than she had been selling confectionary. Christmas night came, and as usual I couldn't get to sleep, though I must have done so because when I woke in the early morning there, hanging at the end of the bed, was a pillowcase full of toys and sweets left by my aunts, with my main present from my parents underneath.

With Christmas over, we returned home on the train. When we got indoors the fog was coming down and beginning to get thick. The low clouds and all the smoke from coal fires and factory chimneys formed minute particles of soot that covered the towns with a thick, greenish choking fog that blocked out the light from the streetlamps, unless one was directly underneath.

That evening, looking out of our lounge window, I couldn't even see the houses directly across the road, when suddenly a double-

decker bus went past with all its lights on, its driver obviously not realising he had taken a wrong turn into Gore Road, a dead end. How the passengers found their way home I don't know, but the bus stayed at the end of the road for two days, until the fog cleared. Then it had to be backed all the way out, as there was no way anyone could turn it round in such a narrow road.

The following year things took a turn for the worse in Germany, with the possibility of war coming ever closer. I realised that war was going to happen when the school started to make one room safe from gas attacks. We spent many days forcing wet paper into the gaps between the floorboards and around the windows, and a couple of months later gasmasks were distributed to everyone in the population. I knew by the way my parents talked that war was not far off, but forgot about it, and lived in a world of my own with toys and games.

Without really understanding what was going on in the world, I helped the workmen in the fields build a large air raid shelter and earned a shilling for carting bricks.

I remember the time that my Auntie Alice took me to the Stoll cinema in Kingsway in 1938, to see Errol Flynn in *Robin Hood*. It was the first film I had ever seen in colour and I refused to come out until I had watched the programme two and a half times, shows being continuous in those days. Then I remember the time my mother took me on the train to the Victoria Palace a few months later, to see Lupino Lane in *Me and My Girl*. This was the first time I had ever seen a live London show, and the seats were up in the gods, which frightened me because the stairs to where we were sitting were so steep I felt I would fall all the way down to the stage.

It was the same year that Neville Chamberlain had flown from Germany after seeing Adolf Hitler, to try and stop the confrontation between our two countries. Getting out of his plane at Croydon and waving a piece of paper, he looked at the newsreel cameras and said 'Peace in our time' and a year later Britain was at war.

23

In the months that followed, trenches were dug, shelters were built and the army was put on a more active training. The RAF were training with their new fighters, Spitfires and Hurricanes. People were buying blackout material to make their windows lightproof, and the tops of pillar boxes were painted in a yellow green colour that would change if poison gas was present. All making people realise that war was now inevitable.

Hitler started by invading first Austria, then Sudetenland and Czechoslovakia, and later, on 1st September 1939, Poland. I knew then that we were all in for something very nasty, though at ten I had no understanding of how bad it would become.

The three of us were all listening to the wireless on that fateful day, 11.15 a.m. on 3rd September 1939. I remember that broadcast very well, with the three of us standing round the radio listening to every word Chamberlain uttered. It was one of those occasions that one never forgets, at whatever age. When I looked out of the window I saw no one in the street, as everyone must have been listening to the broadcast.

Big Ben struck the quarter hour as the Prime Minister Neville Chamberlain said, 'I am speaking to you from the cabinet office at 10 Downing Street.... I have to tell you now that no such undertaking has been received, and consequently this country is now at war with Germany.'

Within five minutes of the broadcast, and before anyone had time to take in the seriousness of the situation, the sirens started to wail their warning. Although it was a mistake, it brought home to everyone our vulnerabilities in war time, which would go on for nearly six years until it was all over.

Chapter 2

Petrol was the first commodity to be rationed. The few people who owned cars at the start of the war rushed to fill up their tanks. Petrol stations soon ran out, leaving only those car owners on vital war work with any fuel, which wasn't very much!

Food was next, starting with bacon, butter and sugar, followed by other things in short supply. There was no fruit from abroad and only produce that was home grown in this country could be bought. After Christmas of 1939, with rationing starting in 1940, food that families had saved for the festive season had been eaten, and people were reliant for the rest of the war on the small weekly allowance from the ration books. All were encouraged to grow their own food by turning their lawns and flowerbeds into vegetable gardens.

Allotments on open land such as playing fields were made available for people wanting more space to grow their own food. The Ministry of Food started the 'Dig for Victory' campaign, and even recommended people have a few chickens in their back gardens. I remember my parents planting the garden with potatoes and other vegetables, with my father saying how it saved him mowing the grass.

I was 'evacuated' to Leatherhead to stay with friends for the duration, but because I kicked up so much, and as it was only about ten miles from home, after four days I was brought back and stayed with my parents for the rest of the war.

My new school, a large secondary called Raynes Park County, which had been built in 1935, was about three quarters of a mile from home. My father talked the headmaster, John Garrett, into giving me a place, saying that as most boys were being evacuated, there must be room for his son. So I became a pupil there, and my father took me to Wimbledon to buy the school uniform, long trousers to replace the shorts I had grown up in, together with cap, blazer, tie and two new shirts.

There were no buses that ran on my route to school, so I had to

walk there and back every day, come rain or shine. Dressed in my new school outfit, I trudged over the large bridge daily past Senior's fish paste factory and Decca's. I carried my gasmask in a round tin, the cardboard box having disintegrated some time before, and a satchel with my books, pens and pencils on my back.

On Mondays I had to take the money for my school lunches, while in my desk I kept a mug for my daily milk. This was served during the morning break from a large bowl by the PT master, Mr Sweeney, with a cut-down saucepan to measure a third of a pint, the milk being paid for by the government, in the hope of keeping school children healthy.

The school consisted of four houses and I was in Halliwell's, named after a teacher when the school first opened. There were three of the original masters still there when I first started, but as conscription came two disappeared, leaving only one, Mr Gibb. He was older than the rest, but a great shot with the blackboard rubber if any boy was caught talking or messing about during one of his lessons. This projectile was made of wood, and Gibb never missed, so when it hit the boy he knew all about it. Another of this master's tricks was to take hold of a boy's short hair by his ear and lift, when the culprit would rise to ease the pain.

Form 1 had its own classroom, as did all the other classes, but I had to move around the school for such things as chemistry, woodwork and PT. When the bell rang, signifying the end of a lesson, the school was full of pupils all going in different directions, trying to get to their next classes.

Every boy had a numbered peg for his coat in the cloakroom, with a place beneath for his games and PT kit. The door to the cloakroom was locked after morning assembly, and was opened only just before going-home time. Everyone had to remember when PT or games were, as the kit had to be removed first thing next morning or after school, when it was taken home for washing.

Talking of washing, I was allowed only one bath a week, on a

Friday. This was because of the shortage of water, which was caused by diminishing fuel for the pumps and the main pipes being broken by bombing. When I had my weekly bath, I was only allowed three inches of water, being the height of a brick on its side. My parents and I had to do full washes all over on the other six days, just using the basin.

Air raid shelters were being built in the school sports field in those early days of the war, and when they were completed the entire roll of pupils was made to practise orderly evacuation. There was chaos from the beginning as boys were missing having got into the wrong shelters. It was soon noted that the ones who did this most frequently were trying not to be counted and were put on detention which was every Saturday morning.

Gradually, things started to sort themselves out after the trial runs, and it was not long before the shelters were needed when the air raids started in earnest, in early 1940. Inside the shelters were narrow wooden benches to sit on, with candles the only source of light. The shelters were each about forty feet in length, and as the candles were in the middle where the master sat, left and right of him was in darkness. That meant that at either end boys couldn't be seen, as the light was so weak. I, in common with most of the boys, soon realised this was the place to sit, out of the watchful eye of the master. We were all told during raids to sit forward and not touch the wall with our backs because, if a bomb landed nearby, we could be injured by the blast transmitted through the bricks.

Christmas came and everyone celebrated as usual. I had my toys in a pillowcase on Christmas morning, all wrapped in brown paper and string, lead soldiers being the main present from my parents, as there was very little else that could be bought. My father had wanted to buy me an electric train set that first wartime Christmas, from Batemans on the corner of our road. He told me later that he couldn't afford the £5 for it and soon after electric trains were not seen again until the

war ended.

During those early months, people went about their business much as usual, and it came as quite a shock when German planes started to bomb the fighter airfields and factories in the south. This was the precursor of Hitler's strategy to invade England, but first he knew he would need complete mastery of the skies. The warning sirens became more frequent as German aircraft flew low after their attacks on the airfields, mostly with Spitfires or Hurricanes on their tails.

The sirens had gone early one morning as I left home on my way to school, and I was just the school side of the bridge when a Me109 appeared behind me from nowhere, firing its machine guns, while being chased by a Spitfire doing the same. The bullets missed me, luckily, stitching a line along the middle of the road. It was all over so fast that it took me till I got to school to realise what had happened. I never forgot that first skirmish with death, realising how close I had come to it.

Years later, in about 2005, I was told by a lady from Raynes Park that I was not the only boy who had had the experience that day. There had been another boy called Porter who was about to cross the road, on the opposite side from me when it happened. How strange was that! I suppose I was so frightened that I wouldn't have noticed anyone else at the time

Later, two batteries of anti-aircraft guns were stationed on the fields at the end of our road, causing quite a stir among the locals. My pals and I went over to see the guns being dug into place and the RDF being established, though at the time we had no idea as to what it was. Huts were quickly put up for the troops manning the guns and, when the work was completed, it took up only a part of the fields, leaving the rest for us to play in.

In early May, Winston Churchill was appointed Prime Minister and was eagerly listened to on the wireless. His speeches made people feel a lot safer, knowing that he was in charge. Later in the same

month came the evacuation from Dunkirk, leaving the whole population stunned at the speed of the German advance across Europe.

My father went to the office of *The Times* every day in London, leaving home at about four in the afternoon and coming back in the early hours of the night on the milk train. This meant that I saw him only on a Saturday, but he was most insistent that my English homework should be left out for him to read every night, whatever time he got home. He would look at it in the early mornings and generally leave it with written comments!

He got very upset one day when he saw that a big 'F' had been painted on his front garden wall, denoting that he was a firewatcher. He was already doing this in London at *The Times*, and couldn't see how on earth he could do it in two places, especially as he was never home at night.

As the days progressed the German 'blitzkrieg' got worse. Hitler was incensed by the way the RAF had bombed Berlin and was keeping him at bay, so he started bombing London by day instead of the fighter airfields. Losing a lot of aircraft by daylight bombing on 7th September 1940, he started bombing London at night, causing terrific damage to the docks and the East End. A short time after, Hitler cancelled the invasion of Britain having failed to get mastery of the skies but carried on with the blitz all over England, Wales and Scotland. It was at this time that Churchill made his famous speech that ended with those immortal words, 'Never in the field of human conflict was so much owed by so many to so few'.

My mother and I had taken to spending the nights in the cupboard under the stairs, with a mattress over the stairs above us. The raids would start as soon as it got dark, with the sirens wailing their warning, always seeming to me that it was after the six o'clock news on the wireless. Just as the news was finishing the sirens would start, and the volume of the wireless would drop or the signal would

disappear all together before coming back intermittently. This we discovered later was because the BBC kept changing transmitters, so that the German bombers couldn't get a radio fix on any one mast to guide them to their target. When the signal was strong enough we listened to *ITMA* or *Monday Night at Eight*, and other programmes like *The Man in Black*, which was a favourite providing the raid was not too heavy and the guns and bombs didn't drown it out.

I slept with my head under the lower part of the stairs, with my mother facing, her feet near my head. I had to do my homework in this confined space, which was difficult as I had to sit up to write. The school made no exceptions for homework not done, unless we were bombed out, which in our case fortunately never happened. My work must have suffered from the gunfire and bombs exploding all night, but I felt that this somehow must have been taken into account by the school.

If the bombing got really bad, Mum and I would run across the road to the Clements, who had an Anderson shelter, and usually stayed with them till dawn. The nights under the stairs or in the shelter quickly became part of our lives, and my mother, in the quieter periods of the nights, would say, 'I think we'll have a cup of tea, I'll just put the kettle on while nothing is happening.' She would get out from under the stairs and half fill the small tin kettle, before putting it on the gas. The gas mains were being hit and the pressure was practically non-existent, so the flame was usually no higher than a quarter of an inch. It could take anything up to three quarters of an hour for the water to boil, and on many occasions I was asleep by the time the tea was made.

The shrapnel and the shaking from the guns created more damage to our house than the bombs ever did. Shrapnel would hit the roof, bringing the tiles down, which made going outside extremely dangerous when the guns were firing at aircraft overhead. Sometimes in the mornings I would pick up pieces of shell fragments that littered

the road, never touching those in the garden among the vegetables as they were hidden and usually very sharp.

Every night, all the curtains in the house were pulled, not only because of the blackout but to stop shattered flying glass when bombs dropped close by, as happened on one or two occasions. Those in the back room covering the French doors were thick, blackout ones. If a bomb fell nearby, the suction from the explosion would make the doors spring outwards, though they were bolted, and close back, having sucked the curtains outside that were still attached to the rails inside, and leaving the doors still locked tight. One of my regular jobs in the morning was to open the doors and get the curtains back, in the hope that they weren't soaked with rain during the night.

Train windows and those on trolley buses were covered in a green thick net that was glued to the glass, to stop it from shattering. This made trying to look out almost impossible, so I would find a corner where other passengers had scraped it off to see where we were. This covering, combined with weak blue bulbs in the buses and trains during the hours of darkness, and no street or station lighting, saw many people getting lost. My father had painted the front door windows with a translucent dark blue paint and replaced the white bulb inside with one coloured orange. Orange being the opposite end of the spectrum to blue meant no light could be seen from outside and yet it was bright in the hallway.

As the days progressed and the raids worsened over the whole of London, my father started using the newspaper van to get home at night, as the railway got more unreliable and the all night trains stopped due to the bombing. So on a Saturday, he would tell me of some of the hairier moments in the van.

One night they had been driving down a road in south London but had to turn back because of a big fire at the end, where a bomb had exploded only moments before. Finding a side street, they eventually got to their next stop at a shop, when it all happened again. This my

31

father braved night after night, getting home much later than he would have done on the train. So on some very rare occasions, I would have breakfast with him before going to school.

He was a heavy smoker and had said to me on many occasions that when he was in the office, it was quite usual for him to have lit six cigarettes when they were busy, smoking one and leaving the others burning in ashtrays around the room. Although cigarettes were not rationed they were in short supply, and so he used to half-smoke one and put it back in the packet for later, ending up with a packet full of half-smoked fags. I always had a supply of caps for my toy pistol so one day, seeing a packet of half-smoked cigarettes, I gently pushed a cap inside each, between the tobacco and the paper, managing to get them about half an inch down, and then forgot all about them. Two days later my father lit one on the train while going to work, taking a good drag and holding it lightly between his fingers. It went off with a bang and shot across the carriage, much to the consternation of the rest of the travellers.

Confused at this, he apologised and quickly lit another. This of course acted in the same way, and a third flew into a lady's lap, and only the quick action by my father saved her dress. Now the realisation came to him that I must have had something to do with the exploding cigarettes. Not daring to light another until arriving at Waterloo, he bought a further packet and threw the rest of the exploding ones away when he got to the office

Luckily for me, I didn't see him until the weekend, by which time Dad could see the funny side of it, so I got off lightly, without the damned good hiding had it happened later in the week.

My friends and I took the war very much in our stride. We understood the news, but tended to put it behind us whether good or bad, thinking more about school or play.

We were frightened often, especially at night with all the bombs dropping around us, but always hoping that nothing would happen to

us or our families.

One evening quite late, my mother pulled back the blackout and looked out of the front windows during a quiet period after a very heavy evening of bombing. I remember coming out from under the stairs to see the whole of the night sky red, reflecting off the clouds over London, knowing it could only be the East End in a firestorm. I remembered having seen the same when the Crystal Palace had gone up in flames before the war, but the firelight that night of the 29th December 1940 looked like the morning sunrise, though my mother and I both knew there would be no new day for many of those brave people dying in the inferno.

The Blitz had started in early September 1940 and went on for nine months without respite, not only over London but Coventry, Manchester, Birmingham, Portsmouth and Plymouth, to mention but a few of the other towns and cities. People carried on moaning about the lack of sleep but never gave up, most just wondering if it would ever end. But with young children like my pals and I growing up under those wartime conditions, it seemed normal, while all our parents made sure we got the best of the rationed food to the detriment of themselves.

Nearly every night fire and high explosive bombs fell around my street, while the smaller firebombs seemed mainly to land in the fields, not exploding due to the soft earth, though many must have started fires in houses. Doug and I would pick up a couple of unexploded firebombs in the fields at the weekend, unscrew them and take out the fuse, which was a small copper cylinder that would have gone off had it hit the hard ground. Taking our trophies back to Doug's shed in his back garden, we would pour the magnesium powder into a jar and get rid of the rest of the casing, which was made of the same material. Why we did this I don't really know, nor did we think of the danger involved, but must have thought it was something different to do. Following on from this we made gunpowder and

rockets that really worked. Never thinking of the danger to ourselves or the consequences of setting off bangs in wartime, we soon realised we could get into serious trouble with the authorities, though not before we thought of another explosive made from iodine crystals. This was very unstable when dry but safe when under liquid. If a little was taken out with a spatula and allowed to dry, even if a fly walked on it a small explosion would decimate it. Doug and I spent endless hours playing jokes on people, putting it under chair legs or on tables, so that when things were moved small bangs like caps would go off, causing people to wonder what was happening.

Towards the end of the war, Doug found a bottle of this in the shed, and not knowing what to do with it buried it in his garden. It was eighteen months after the end of the war when there was a small explosion in his back garden, which blew a small hole in the lawn. Only Doug and I knew what must have caused this.

As we got older, we all started to go to the youth club at the Methodist church hall on a Wednesday evening for a couple of hours. Girls started to become more important as we got older, while at the same time we enjoyed a more sensitive lifestyle, instead of trying to blow ourselves up.

The war, with the blackout and rationing, went on, with every one getting used to the nightly bombing as if it was the norm. This attitude persisted and kept everyone sane as the bombers came over night after night with their familiar intermittent drone, while my mother and I still slept under the stairs, running across the road to the Clements if it got bad.

People went to work every day even though some parts of London would have disappeared, stepping over the shattered glass and debris left behind from the over night bombing. My father still left for work on the train at 4pm every day, and came home in the paper van every night between 4 and 8 am

As the winter got colder and the losses of ships from America and

Canada bringing in the food increased, the rations went down to just over subsistence levels, making things like rabbits a rare treat. People became very good at stretching the ration out and very flexible in preparing meals with the little they had. Stomachs shrank, and in later years after the war, it was thought that those had been the healthiest years of the whole century, though at the time it never felt like it.

The British got very used to queuing. Women shopped every day in the hope of getting something off ration. My mother told me that if she saw a queue she would join it, in the hope of finding something at the end of it off ration. It became a way of life in those days, with everyone queuing in front of food shops, buses, cinemas, etc. Today with the older generation it is still the same, they all still queue as they did during the war, while most of the older women still shop daily, though supermarkets have now taken the place of the small shops. Many in central London slept in the Underground every night, safe, while many more were still being killed in the raids, including the brave firemen, police and ambulance drivers above. All who were spared and were on duty during the raids every night would go home exhausted.

Then Hitler invaded Russia, after having signed a neutrality pact with them a few months earlier. Then the raids became less frequent and there was a general sigh of relief when it was realised we now had more time, time to act for the future, especially as it looked as if America might soon come in on our side.

To me, things were no different. Getting up in the morning after a troubled night's sleep due to the guns and bombs, having breakfast with my mother in our small kitchen and going to school while hoping that last night's homework was correct, was mainly all I thought about. Most nights I managed at least four untroubled hours' sleep, not realising that my mother just dozed in fits and starts with bombs crashing all around us, trying to make sure her son was safe.

Over one weekend, a bomb had gone through the science lab at

school, exploding in the woodwork shop beneath. The damaged part was boarded up and chemistry experiments curtailed for a period. As for woodwork, it was lost until repairs to the school were made. The bomb had been probably meant for the factory next door to the school, Bradbury Wilkinson who manufactured bank notes for here and abroad.

Eventually the work was done, so that by the start of December 1941 the school was back to normal, except that the wood work had turned itself into pottery. Many years later when I drove past the school, I would always look to see if anything was different with the building and noticed every time the different colour roof tiles where the bomb had gone through.

Christmas 1942 was sparser than ever. My mother had been trying to find a chicken for Christmas dinner as all the relations were coming from Battersea. When I was told there would be a further seven to eat and sleep, I knew straightaway that I had lost my bed, but perhaps I might sleep in front of the fire, the nights at that time being freezing. There was no heat in my bedroom anyway and my breath froze on the insides of the windows at night as I slept.

People were already trying to find little extras that would make Christmas, but with things so scarce, it was practically impossible.

The Japanese attacked Pearl Harbour in the Pacific just before Christmas, bringing the USA into the war, with people realising we were not alone anymore. About the middle of December, I would start making paper chains from strips of coloured paper to decorate the front room. My parents would then hang them in cross fashion across the room with the light at the centre. As there were few Christmas trees, we hoped to find an old artificial one and clean it up. With very few cards in the shops to send, we managed to make it as cheery as possible somehow with the few that had been sent to us.

Two days before Christmas Day, my father arrived home early with a dead goose, still in feather. He had won the sweepstake at the

office and had started home with two. He sold one on the way home, so not only would we have a feast at Christmas but it was all paid for by the selling of the other bird, including the chicken that my mother had managed to find. Dad paid the butcher to clean and truss the goose and a good few meals were had by all, but as nobody had refrigeration in those days everyone was sick and tired of eating goose by the time it was all over. I had been allowed to sit up late and play whist with my aunts and old Kate on Christmas night, as I was now twelve and longing to join in with the festivities, even to the point of a few small sips of port, for which I must admit I got a liking.

Things went on the same way for the rest of the war for me, the war news became everyday happenings, and I just took every day as normal. Blackout was a nuisance during the winter but the summer months made up for it as I went to bed before dark. With the wireless as the only form of pleasure at nights, and the cinema during the day for my mother, the youth club on a Wednesday for me became very important. I met new friends, and girls were really starting to interest me. I played badminton and billiards, drank tea and chatted – a great relief from those frugal evenings under the stairs, which were becoming fewer as the raids diminished. In fact, I started to live the life of a normal teenager on that one evening a week. My pals and I started meeting in the evenings as we got older, playing tricks on people in the blackout. We would tie black cotton between a tree on the pavement and a fence, at a height that would take a city gent's bowler hat off in the dark. Usually bowlers, but high-crowned trilbies as well were caught. The cotton would break as soon as the hat came off, doing no harm except to the self-esteem of the victim, who picked up his hat, wondering why it had flown off.

So life went on, with weekend visits to the Southern Railway sports ground with Doug's parents, who played tennis and bowls there in the summer months. One day a lone German plane came over in daylight, dropped its bombs just missing the club, blowing great holes

in the field next to it, but generally the weekend visits were quiet and enjoyable.

As the war started to go Britain's way for a change, there was talk of future invasion of the Continent. At last, Britain was not alone, but very little else seemed to have changed, making it feel it had always been like this, though in reality it had been only a few years.

Mr Clements across the road was in the Home Guard. He took me one Sunday morning to their small headquarters just off the railway track alongside the station. He showed me all their weapons, especially the new Piat antitank gun, which was something for attacking tanks and rocket-assisted. Those men were very proud to be helping in the war effort, and every weekend they would be seen creeping around the roads and in people's front gardens.

I kept a map, which was up to date as far as possible, of the different areas within the confines of censorship, so that I knew at a glance what was happening. It had taken a long time but it now appeared to me that at last the war was taking a turn for the better.

School was much the same, except as I got older more tricks were played on masters and mistresses, most of whom hadn't been called up because of their ages. The lady who took religious instruction should not have been teaching boys of our age. She was short-sighted and nearly deaf, and we boys played her up. When she wrote on the blackboard and turned to speak, someone would get up and rub it off behind her, as she didn't hear him. Then when she turned to refer to the board, there was nothing there. The chemistry teacher, Mr Smith, would start an experiment at the front of the class and a boy at the back of the room would blow down his gas pipe, putting the teacher's Bunsen burner out. Mr Smith would carry on with the lesson, only to find that the experiment had been ruined because his Bunsen burner had gone out. When I look back at those pranks, I begin to feel very sorry for those older teachers, especially the women who had come out of retirement to take the place of all those who had joined up.

The RAF was now giving Germany some of what the British had put up with during the Blitz, starting to raze the Third Reich to the ground, letting their civilian population know what it was like to be bombed night after night.

But Hitler was not finished with the population of London: he sent over unmanned aircraft known as buzz bombs or V1s, ramjet drones filled with explosives. While the jet engine was going there was no problem, but directly it stopped the nose went down and it crashed, blowing up indiscriminately, killing wherever it fell, with nobody knowing where the next one was going to hit.

As the invading troops got nearer Germany, and overran the launch sites, the buzz bombs were superseded by much longer-range rockets. Where guns and aircraft had been able to shoot some V1s down whilst out in the country, the rockets, V2s, had no such vulnerability. One very rarely saw them, though I caught sight of one for a minute fraction of a second before it hit, as the reflection of the sun caught it before the terrific explosion that seemed to be from the direction of my own house. It was as I was going across the bridge from school that evening when it fell. I started running home, very relieved to see my road still standing, but four roads up there was complete and utter devastation.

These were the last of Germany's secret weapons as the advancing allied troops captured their bases in the Netherlands, but the V1 and V2 had left parts of London in a very bad way. It is said today that there are still well over a hundred unexploded bombs under London alone. I wonder how many are left under the whole of the British Isles?

Early in December that year in London, the Home Guard held its last parade down the Mall in front of the King and Queen, with people cheering the men and women who had helped to keep Britain safe in its hour of need.

Rationing was not so strict for Christmas 1944 and I, like everyone

else, started to realise that the war was in its last phase. Although there were still blackout restrictions, people no longer needed to shelter at nights – in fact the country was starting to get back to normal, just waiting for that final push that would end the conflict. The 8th May 1945 brought the war in Europe to a close, with myself, who was now sixteen, celebrating the end with my friends, in common with people all over the British Isles.

After those few happy days of celebration, people began to realise that the war in the East was still going on against the Japanese, and that British soldiers were still fighting and dying in Burma together with their colleagues in the RAF and navy.

I was still at school, preparing to take my big final exam, the school certificate, or if I was really clever and got the higher marks, Matric. These were a collection of written papers on all subjects, which had to be taken together over the course of a week or so, one in the morning and another in the afternoon, and so on. Further tries at individual subjects were not allowed, for in only that one attempt rested one's pass or fail. I passed school certificate and was to find in later life that nobody was in the least interested in the results. Still, I had done it as well as I could and not let my parents down.

On 14th August 1945, Japan finally surrendered to the Allies, and the war was over. My friends and I decided to go to London that evening to celebrate, together with most of the population. Somehow we got into a pub called The Coal Hole in the Strand and started drinking beer, which we had been doing for some time, unbeknown to our parents.

Unfortunately, someone gave me a double rum, which I knocked back after having drunk three pints of beer. After that I didn't remember any more about the remaining celebrations, or being got home by my friends.

The war was over and now came the time to choose my future profession, which I'd felt could wait, as I had only just left school.

Although I had been only ten when the war had started, I couldn't remember much about my life before. But now in peacetime I had to start again with a new way of life, earning a living.

Chapter 3

I hadn't a clue as to my future employment, nor what trade or profession I would follow. Having left school at sixteen and learning shorthand in order to follow my father into journalism, would be like learning a foreign language. However, realising I had to do something, I said I would like to go into the film industry and, much to my surprise, my father replied that he knew a few people in the documentary side of the business. Then saying he would take me to London the following week, in the hope of finding me an opening, it was fixed.

The day came and my father took me to explore the possibility of a job with a couple of documentary film companies. Getting off the tube at Tottenham Court Road we walked around to Soho Square, a lovely tranquil oasis in the heart of the West End. Outside number 21 a plaque caught my eye, 'The Colonial Film Unit'.

Grabbing my father's arm, I said, 'Let's try here, Dad, that sounds good!'

My father, looking around, said, 'You can't just go in on the off chance.'

'Of course we can,' I replied, so together we went up the stairs to the office on the first floor.

Asking at reception if there might be an opening for a young boy, the receptionist replied that she would go and ask the manager. Returning, she told us that Mr Bradshaw would see us and led the way. After shaking hands, we sat down and my father opened the conversation by saying that I had just left school and was looking for an opening for a beginner in the film industry. Bradshaw asked me a few questions about why I felt this was what I wanted to do and then casually asked which school I had attended. When I replied, he came straight out with the first headmaster's name, John Garrett, as it turned out they were good friends. Mr Bradshaw then told me the job was mine and with work times and salary discussed, he said he would

confirm my appointment by letter. We both got up and saying our goodbyes went out to the square, not believing our luck in finding me a job at the first place we tried. To have found a film unit that needed someone at that time was very lucky for me, and to convince the manager of my eagerness to make film my career was indeed a feather in my cap.

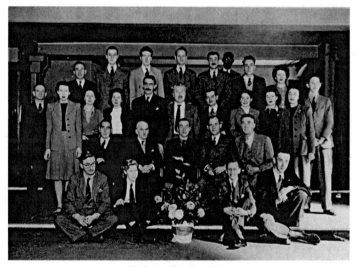

Colonial Film Unit

It was three days after the trip to London that the letter arrived, confirming my appointment. The starting salary was £2 10s a week, with the hours set out, though there would be times when I would be away or working late. The job would consist of helping in all departments, learning how films were made and put together. Out of my salary I had to pay for my return train journeys to and from the office, my lunch, and give my mother something towards the housekeeping, leaving very little over for pleasure. I was to start in September 1945, which gave me a few weeks to enjoy my last school holiday before starting my career.

Having passed school certificate, I saw I had missed matriculating by one credit. Still, I felt I hadn't done badly as I knew I hadn't worked hard or long enough to get higher marks.

Going around with my friends and knowing that two of them had found work, time dragged before I could start my job. My father had paid for a three-month season ticket to London for me, which I was to pay back at a little each week, being a lot cheaper than daily returns. My parents also bought me some new clothes so that I would be well dressed for the first step on the path to my chosen career.

The day came at last and with my hair trimmed and money in my pocket from my mother, I set out on the journey to London, not knowing what to expect on my first day at work.

As it turned out, all went very smoothly, as I was shown round by another lad of about the same age, Dennis, who had been hired only a short time before me. I was taken to the camera room, cutting rooms and cinema including the projectors and sound system.

The first thing I learnt was how to handle the switchboard, for the phones had different plug-in cables and lines. Then I learned how to answer calls, to direct them to the right people and to remember who was in which office. In the beginning people seemed to get the wrong person, causing quite a bit of confusion for everyone concerned. Soon however I was looking after reception when Jean the receptionist was called away, and starting to feel at home while getting to know everybody and what they did. For the first week this was all I did, but it enabled me to understand a little of what made the whole place work. In the second week I was put into the capable hands of the projectionist, Mr Andre Smith, who started to teach me the intricacies of the projectors: lacing them up in the correct way, and handling the carbon arc light, so that it always burnt white and not go blue, which could happen if the two carbon rods were out of alignment. It took only a couple of weeks for me to master the projection box, and within three weeks I was left on my own, showing films including

changeovers between two projectors.

Smith had a sideline going, making radios, which he built from parts and sold. Quite often he would leave a partly built one on test on the bench near one of the projectors, without its cover on. One day, having seen the film many times, I stretched over to turn up the volume on the radio while holding on to the projector with the other hand. Leaning over and hanging on to the motor of the projector for balance, I earthed myself and got an enormous shock, which nearly threw me to the floor. Luckily, it also separated me from the radio, and I vowed never to do such a thing again. I was well shaken up and had nearly put an end to a very promising career before it had started.

The first film I went on was at Pinewood Studios, where the late great George Pearson was directing a film called *An African in England*, and I was there to look and learn and assist wherever needed. The set of a village hall had been built with the lighting gantry above, and hanging on the walls were pictures of prize bulls that added to the atmosphere. The cameraman, Peter Sargant, had lit the set and everything was ready for the first take after a couple of rehearsals with the actors. Pearson said, 'Quiet please, mark this and action,' but just as he said 'action' a voice from out the darkness above said, 'If I had a set of balls like those, I wouldn't be up here doing this bloody job.' There was dead silence on the set and then laughter broke out among the crew, with Pearson wiping tears from his eyes. It must have taken a good few minutes before things settled down again, and even then there were some who just couldn't stop laughing, including the actors. At last there was silence and the shot was taken, but it took three or more takes before it was right.

On that first afternoon I was just walking about the set, waiting for someone to ask me to do something, when I tripped over a large nail sticking out of the floor. Bending down, I wriggled it out, as it was dangerous. It brought everyone out on strike in the whole of Pinewood Studios, as I should have asked a carpenter to do it.

Standing there with the nail in my hand, not understanding what I had done, I was told to shut up and stay quiet until this could be sorted out, and everything could return to normal. It took about ten minutes before everyone was back at work whilst I vowed that any rogue nails could stay where they were.

The next day we were short of a boy actor, so I was made up and told what to do, but to keep quiet about it as I wasn't in the right union. After the previous day's fiasco, it seemed to me that this could also bring the whole place out, with me being the cause once more. However, it passed off all right and the film was finished the following day. After Pinewood, it was back to the projection box for me to carry on showing films, while the chief projectionist carried on building and selling his radios. Every day Dennis and I would go for lunch at the café round the corner, where it was cheap, as neither of us could afford much.

I went out with the crew quite often when another pair of hands was needed, and was learning all the time about lights and cameras, wanting to learn more about photography. So Dennis and I joined evening classes at the Regent Street Poly on lighting and using still cameras. When my father had asked me at the beginning what I wanted to do, I never realised at the time that I had picked the right profession, but now I was sure that photography, either stills or cine, was going to be my future.

Part of the same film I had been on at Pinewood was to be shot on location at St Neot's in a grocery shop. All the food was on display, including a large square block of butter standing on a marble slab, from where the grocer would take two wooden butter pats, weigh the right amount and wrap it. Food was still rationed but was starting to get a little more plentiful as time went on. The shop was lit and the filming was going well, until someone realised that the heat from the lamps was melting the butter, which by this time was running all over the floor, with the crew and actors literally slipping and sliding all

over the shop. Stopping to clear up the mess, there was a further problem – how to get more butter for the shopkeeper when it was still rationed. Eventually the right forms were filled in, and two phone calls later a new block of butter was supplied, replacing what was all over the floor. The filming had now taken twice as long to finish due to the mess, but no doubt the shop owner did all right in the end.

There were three other boys who started at Colonial about the same time as I did: Sidney Samulson, who ended up as President of BAFTA, Bob Paynter, who became Director of Photography on all the Superman films with Christopher Reeve, while the other was Billy Williams.

He and I became great friends over many years. He shot over twenty-five features, including *On Golden Pond* and *Ghandi*, for which he won an Oscar.

Back in those early days at the Colonial Film Unit, I realised that photography of any sort was my way forward in life. I got myself on every film the unit made, gaining experience and talking to the cameramen whenever I didn't understand.

The next assignment was the arrival of troops from West Africa, who were coming over for the victory parade in London. The unit made newsreels in those days for use in the colonies, showing different peoples how the British government was helping them, and these would be sent out into the different territories, one every two months.

Arriving at Tilbury, the crew and I were to go out on the pilot boat to the *Empire Fowey*, and go onboard to do the shooting while the ship was underway up the Thames before she docked. As the tiny pilot boat got alongside the massive liner, I saw the pilot shin up a rope-and-wood-slatted ladder that was hanging down for him. Realising this was the only way up, I was told by Peter to sling the camera on my back and follow him. The Newman Sinclair camera was heavy in its thick, leather padded case, and not wanting to show

47

how scared I was I slung it on my back. Taking hold of the ladder, which was starting to gyrate, I started to climb the towering side of the liner. The weight on my back made me climb leaning backwards and looking up. Having got halfway and feeling nearly exhausted I looked down, and to my horror saw the pilot boat had left and was on its way back to the dock. Because I was the last of the film crew to make the ascent, there was me, halfway up the side of a liner underway, knowing it was either carry on up or drop into the river and drown. Gritting my teeth, and from God knows where I got the energy to make it to the deck high above, I arrived in a complete state of collapse. They gave me a short break to get myself together, while I tried to forget my terrifying ascent up the side of the liner.

After getting all the footage required before we docked, the gear was packed, and directly the gangplank was lowered we were off, only this time the safe way! I had picked up the camera case again, slung it over my shoulder and walked off the ship, passing the dock police and immigration on the dockside with just a nod. However, I had failed to notice that Peter was carrying the camera. It wasn't until we were back in the unit truck that the case was opened, and instead of the camera I was looking at eight bottles of whisky, which I had walked off with, through all the checks at the gates. Peter said to me on the way back that if they had told me, my face would have given it away. This turned out to be one day at the start of my career that I would never forget. Nearly dying climbing up into the ship, with possibly jail on leaving it.

There were other stories about the newsreel, one being at the Hospital for the Incurables at the top of Wandsworth Hill. Here they were having a fair to raise money for the patients, and Leary Constantine, the well known cricketer, was there. I remember the day well, mainly because it was the first time that Bob Paynter was allowed to shoot some film with a handheld Eymo camera, and look where he ended up!

48

It was now halfway through 1946 and I was seventeen, learning fast and becoming more useful to the unit. A small rise in salary meant that I could go out with my friends more often, but on the other hand I was away more, working on productions.

For the last time I went on holiday to Bognor with my parents, to the same place we had always been for as many years as I could remember, to the Misses Ides. The beaches had been cleared of mines and the rusty barbed wire taken away, and I spent most of my time there, swimming and enjoying the freedom. My parents did their own thing and we got together in the evenings, though I went to bed early most nights after the exertion of swimming most of the day.

I had been back at work for only a couple of days when I got the news that I was wanted for a film at Fleetwood on inshore fishing. This was to be for three-weeks-plus, as the whole film was to be shot in one go, with everyone staying at the North Euston Hotel for the duration.

A mock-up of a boat's cabin had been built in an old warehouse for the interior shots, as there was not enough room in the real thing, the boats being fairly small. As it happened, the weather was too bad for exterior shooting at the start, so we began work on the mock-up. My job was to get the three lights, 500-watt 'pups', onto the set, but not to connect them. Peter lit the mock-up, and by the time he had two of the lights on the power went off. I had never seen such antique wiring even for 1946, it consisted of single red and black insulated wires, held apart by porcelain spacers. After the lights failed, the natural thing was to go to the box and replace the fuse with a larger one to take the load. However, the new fuse blew when the second light was turned on, leaving us in darkness. This time, instead of fuse wire, they put in a six-inch nail, which held until someone noticed that the wires coming down the wooden wall were starting to glow red and burn. So once again everything was off before the whole warehouse went up in flames, with one of the crew frantically searching the

49

phone book to hire a generator. Eventually one was traced and filming started after a whole morning had been lost. I couldn't help wondering how long the wiring stayed like that, with a nail instead of a fuse.

With the weather clearing and having eventually got all the interiors needed, the crew started the exterior shots of the boats fishing. Two were used, but at the outset the amount of filming was limited, because most of the film crew, including myself, were seasick. Eventually we all felt better, settled down and the shooting resumed. The day's rushes were sent to the labs by train nightly and shown in the local cinema each morning before further filming commenced. Evenings were fun: the crew would all get on the billiard table after dinner, making up two sides while the beer flowed.

One evening, George Pearson got very excited about a shot he was just about to take, and going on tiptoe at the corner of the table got his 'crown jewels' stuck, along with the snooker balls in the pocket. He couldn't move, as his feet were off the floor and it took four of us to lift him safely back on his feet again. He never tried that shot anymore, and from then on he was very careful how he played any shot, keeping well away from the pockets.

I, by this time, had got talking to one of the young maids who worked at the hotel, much to the amusement of the rest of the crew. I remember it well, as my first serious encounter with a girl, but as to her name or what she looked like my mind is a blank today. Still, it was my first feeling of puppy love, though there was really nothing in it at all.

The filming went on well, using two boats, one to shoot the fishing from, and while the other came into dock unloading her catch.

There was panic as the boat I was on one day netted a wartime German mine instead of fish, as it had to keep going forward slowly in a circle to stop the thing floating towards the boat. The coast guard was called on the radio, who then called a naval ship to meet us before we ran out of fuel. By this time, all the film crew were as far forward

as we could get on the boat, but we could still see the mine bobbing up and down at the end of the net as we circled. Eventually the skipper released the net while the navy took rifle shots at it to explode the mine. Luckily, we were well away when it went up, but it was still near enough for us to feel the explosion. I often wondered what would have happened had it gone up closer to the boat when we were towing it round and round.

At the end of four weeks we all left Fleetwood, driving back to Soho Square, and normality until the next time.

All the time I spent filming brought me nearer my goal of learning all I could about the camera and its operation. What different length lenses did to change the picture, depth of field or focus, exposure, and above all how to compose and light a picture. All these components came together in either cine or still photography, and from my job mainly on the camera, combined with night school, I found that I was learning different techniques every time I was with people who really knew about photography, watching them work. My friend Bill, because he was his father's assistant in those days, was learning faster about film than myself, but I was quite happy with the way my knowledge was progressing.

Some from the unit, including Bill and his father, were being sent to West Africa to make a series of films on life there. Wanting to tell about the forthcoming productions in the newsreel, some of the unit went to a well-known tent manufacturer, Benjamin Edgington Ltd in the Old Kent Road, to shoot a piece about the units forthcoming visit. I was there with two others, helping to hump the gear and trying not to get in the way. Because I was not needed for ten minutes or so while they were setting up, I went for a wander round the premises on my own. I found myself in a large room with ropes hanging down and nooses at the end with leather stitched to the insides. While I was wondering what these were, a short man with glasses, and going thin on the top, walked in. He greeted me, shook hands and said, 'I am

Albert Pierrepoint, nice to meet you.' I then realised what these ropes were and that I was in the presence of the best-known hangman in Britain. Mumbling how nice it was to meet him and saying goodbye, I made a quick exit, knowing that Pierrepoint was there to pick the rope for his next hanging. Getting back with the other two, I said nothing of this encounter, not wanting to walk about the place anymore.

About June that year, I was called to a medical for National Service, as I was going to be eighteen in the July. I got into the RAF but was grade four because of my flat feet, something that had never worried me very much. Still, I was hopeful of getting on a photographic course as I was already working in the film industry. I would be called up some time in September, so in the meantime I carried on at the film unit.

The last shoot I went on was with a cameraman called Hal Morey, whom I had never worked with before, but knew well. It was to film the King and Queen with the princesses leaving Portsmouth on HMS *Vanguard* for a visit to South Africa. Joining up with Hal at Hassocks, we spent the night in a pub at Portsmouth and were down on the small beach in the old town by five the following morning, both half asleep. Daylight was just beginning to break through an overcast sky, as we set up the camera alongside others from different newsreels and newspapers. The sea mist was making it darker than it should have been at that time of the morning, meaning that Hal had to drop the speed of the camera down from twenty-four frames a second to sixteen. This increased the time each frame was in the gate, giving more exposure per frame, as the black-and-white film stock was slow. If this was not corrected when printed it would make the ship look as if it was going a lot faster than in reality it was, but this could be put right after processing by printing every other frame twice. This wasn't the only problem that morning because, as the battleship came into sight, it was so enormous that the camera could see only part of it at a time. This was because the position we were shooting from was too

52

close for a complete view of the ship as it passed. But there was nothing that could be done and I don't think it was used in the end.

During the last month before I joined up, I spent most of my time in the projection box at work and out with my pals in the evenings. Doug had already gone into the army but Geoff was following me into the RAF. So another new life was ahead for us all, having just got used to the first ones, our chosen professions.

In the meantime my father had left *The Times* after twenty-odd years and joined Hansard, the official report of the House of Commons, which for him was a big change.

Chapter 4

It was 1st September 1947 when I joined the RAF. My father took me to London to make sure I got on the right train while my mother had packed me some underwear and shaving gear, in a little leather case which was on my knees as I sat in the compartment. It happened that my old art master, Mr Hanson, was sitting opposite me as he was going north to see friends, so the journey went quickly, giving me little time to worry about what I was getting into or what was going to happen.

Arriving at Warrington Station, all us new recruits got off the train and were told to get in the back of a lorry which drove us to RAF Padgate, an establishment very well known in the air force as the entry for newcomers in those days.

John in the RAF

54

Then it started: 'Get in line, put that down, stand up straight, what are you laughing at?' until I wondered if it was always going to be like this. Next, I was shown my billet and bed and how to make it with three so-called 'biscuits', two blankets and a sheet, with a small bolster-type thing called a pillow. Next day I was lining up for a medical, mainly to see if I was still warm and alive. So, in my vest and pants and without shoes, I lined up with all the rest.

It had been questioned as to whether or not I should have joined up at all, being grade four flat feet, so I decided to say something when it came to my turn as the doctor was asking if one had any problems. When it got to my turn I told him about my feet and played on how much they hurt. The forward movement of the entire line having stopped, the doctor started looking at my papers, while talking to a nurse. Eventually, they came to a decision. I was told I would be sent to Halton Hospital where they would try and sort my feet out. In the meantime, till the appointment could be arranged, I was to sleep in a hut nicknamed 'The Dead and Dying Unit', where anyone with a medical problem was billeted.

The recruits in there had not been fitted with uniforms but sent on duties around the camp while waiting for medical appointments. I was put on duty helping to issue '1250's, the RAF identity card. My third night in that billet was unbearable as a terrible smell that no one could trace permeated the whole building.

Eventually, in the middle of the night, it was traced to a little Scottish recruit who had been a dustman in the Gorbals. About ten of the sufferers got hold of him, and put him and his bed outside on the drill square. Being September and cold, any heating in the billet had gone out of the open door by this time, but it was felt he wouldn't come to any harm out there where he could smell as much as he liked. Morning came and the sergeant who had charge of the hut and had seen the bed outside was told the story. Arranging for him to be fumigated and what clothes he had with him burnt, it was found later

that the feet of his socks were worn through and all that was left were the bits round the ankles. Whether he had ever bathed in his life was not known but he was taken away and never seen again. With the windows wide open and the fresh air taking the last of the smells away and all his bedding burnt, peace returned to the hut.

My appointment at Halton came through during the following week, and collecting a rail pass I took the train down south to the hospital, wondering what they could do to right my flat feet. I had been getting treatment at the Royal Orthopaedic Hospital for years – could the RAF do any better, I wondered?

After my examination I was told that I would be excused boots and given a chit stating that I was 'excused guard duty, PT, parades, marching and any other standing-up job'. I would also be given special shoes with built-in supports instead of the regulation boots. That piece of paper was worth its weight in gold for my future service and I took great care of it, having to renew it regularly at three-monthly intervals with the station doctor, for the rest of my service.

I had to wait for my new shoes before they would kit me out with my whole uniform, so I went back to issuing identity cards until the footwear arrived. Three weeks later the shoes turned up and I was given my uniform as an Aircraftsman 2nd Class in the RAF. Then I was on the train again, this time to RAF Innsworth for my square bashing, or, as it was called, preliminary training. Arriving at Cheltenham Station with a whole crowd of recruits I didn't know, I was shouted at and pushed into place by a sergeant who was vainly trying to get this 'shower' into some semblance of order. I went up to him with my chit saying, 'Please read this, Sergeant,' just adding to his frustration.

At least it stopped him from shouting at the rest while he read it, then looking at me said, 'Well, what bloody good are you to me?'

I replied, 'I don't really know.'

I expected a tirade of foul language from him, but he said quietly,

'You had better get into the lorry while I march this lot back to camp and see me later in the billet.'

So I climbed into the lorry for the ride back to my new billet, realising for the first time the power of that small piece of paper.

As I had arrived first, I picked the best bed space before all the rest got a chance. I chose the place next to the sergeant's room so that I had a wall one side of my bed, to keep away the drafts. Sitting on the bed as the rest rushed in, I knew I had chosen the best and warmest place as it was now snowing outside. After supper that evening, I was called into the sergeant's room to find out what the hell could be done with me.

The conversation ended with me being put in charge of the boiler, in the ablutions building behind the billet. As it was impossible for me to do any training, the sergeant thought it was the best thing to do with me, especially as the whole billet would gain from the plentiful supply of hot water for the showers.

So for the next three weeks I walked over to the mess to have breakfast, came back until dinner time, then after that perhaps enjoyed a read with my feet up in the warm, and then went back into the hut as the rest arrived cold and hungry after drilling in the snow.

After the first four weeks, a forty-eight-hour pass home was given in the middle of basic training, so on the Friday all had their first home run since joining. I hitched a ride back to London on a lorry that was full of airmen going home for the weekend. Arriving at Marble Arch at midnight, I got a bus to Waterloo and then home, for in those days trains to Raynes Park ran every hour during the night.

I didn't see my father on Saturday until the evening as he was doing a stint on *The News of the World*. On Sunday we started talking and I produced my chit, which impressed the old man, until he asked, 'So what are you doing in the way of training?'

'Nothing,' said I, 'just looking after a boiler so that everyone has hot water.'

'Looking after a boiler, we will soon see about that!' Dad said. I didn't attach much importance to what my father had said at the time and carried on the conversation about the photographic course. I went out and saw two of my pals who were also on leave, and caught the train back to camp on the Sunday, making sure that I was in before 23.59, otherwise I would be on a charge. Monday came and things were the same, on my own with my feet up, looking after the boiler.

Tuesday morning dawned with the snow coming down even faster. I had just settled down with my book after breakfast when everybody started looking for me. The CO of the camp wanted me: but why? I hadn't a clue.

Finding one recruit in a training camp that supported hundreds was no mean feat, but eventually the sergeant, being the only one that had any idea where I was, found me still stoking the boiler and looking forward to another uncomplicated day. Instead of that the NCO rushed me to station headquarters, in through the outer office, into the secretaries' typing pool until we came to the CO's door. With just enough time to catch my breath, I was called in and faced with the CO behind his desk and another group captain sitting.

'Airman,' the CO said, 'I have called you in as I have received a signal this morning regarding you and your feet. There is no need to worry as this other officer is an orthopaedic specialist, here to examine you.'

Wondering what the hell was going on, I was told to take off my shoes and walk up and down on the CO's carpet. The specialist watching my progress told me to sit and take off my socks. I did this, still wondering whether everyone had gone mad.

After feeling my feet he said, 'You can now put your socks and shoes on again, Airman, and wait outside.'

It was silent outside the CO's office, with only my sergeant present. He was obviously bursting to know what was happening while I was thinking, 'He's not the only one!' At that moment the

58

specialist came out, and motioned me into the office, before leaving. The CO told me to sit once more and asked, 'What training have you done since joining, Airman?'

I thought for a moment and then said, 'None, sir, I have been looking after a boiler.'

'Looking after a boiler?' the CO said. 'Have you had no training at all?'

'None at all, sir, because of my flat feet and this chit I was given at Halton,' I said, showing him the dog-eared piece of paper.

At this point the officer looked up from reading it, asking, 'Your father, what does he do?'

'He is in the House of Commons, sir,' I replied.

At this point the CO went very quiet as he said to himself, 'Oh my God,' and buried his head in his hands. Still not knowing what was going on, I was beginning to see now some sense to the whole episode.

Pulling himself together, the CO said to me, I was to be posted the following day to Benson to start my photographic training, and that he would send his car to take me to the station after breakfast.

I was then dismissed, and walked out in a daze, knowing now that I had to phone my father urgently that evening to find out what on earth he had done. As I walked out of station HQ, my sergeant caught up with me, saying he'd discovered the CO had received a signal from the Air Ministry about me only that morning. Returning to the billet, and still trying to make some sense out of it, I realised now that my old man must have been responsible for all the chaos that had been caused.

That evening I phoned him, and he told me the whole story. He had been drinking in the press bar at the House of Commons when Geoffrey de Frietas, who was Secretary of State for Air at the time, walked in. Somehow my father knew him from, I think his Fleet Street days and so they started talking, mainly about me looking after

a boiler when I should have been on my photographic course. It seemed that the beer had flowed freely with de Frietas saying, 'I was a squadron leader in the last lot, I think it's about time some people were shaken up a bit, leave it with me. Have another pint?' So my father did and what happened on that Tuesday morning was the outcome.

The sergeant saw me off the following morning in the CO's car, as promised. He had a long talk to me about my position that last evening, with both of us coming to the conclusion that it could do nothing but good for me as I was going to get a great training in photography. A friendship had started between the two of us while I had been at Innsworth and in a way the NCO was sorry to see me go, as were the rest of the billet, as they had to do without their hot water.

Putting my kitbag in the boot of the car the next day, the driver took me to the station, interested to learn the whole story because the CO and the adjutant had talked of it during one of their journeys the day before.

Arriving at Benson, I was put in a billet and given an arrival chit, which I completed the following day. That evening I was put on the night shift at the photo section, which was outside the camp, on the way to a village called Ewelme. I was given a bike and with another airman, cycled to the section about 10.30 that evening. Consisting of a group of huts to the right of the road, there was all the equipment for the processing and printing of films brought back by the aircraft, Benson being the photographic reconnaissance unit for the whole RAF. I was put on a multi-printer and was soon into the swing of things, producing hundreds of prints from the air camera negatives.

We had a break for a meal at about two in the morning and the shift finished just as the dawn light was coming up. Cycling back in time for breakfast and then bed, I was tired out after my night's work. As time went on I would have a few beers in the NAAFI every night with some pals from the section before starting work, but

unfortunately one night I had a few too many and forgot about the watercress beds either side of the road, so the inevitable happened, I ended up in one.

Luckily it wasn't deeper than about six inches, but it soaked my trousers and shoes. Arriving at work soaking wet, I lost no time getting my shoes off, together with socks and trousers, and going to work with a roller towel wrapped round me, thankful that there were no WAAFs about. The wet clothes were put on a heater to dry and were ready for me to wear by the end of the shift. That taught me not to drink so much when going on shift, but it didn't stop others doing the same thing, coming to work soaking wet!

For four more weeks I worked in the section and then got news of my posting to Wellesbourne Mountford, the home of the photographic course.

I had to do the same old thing again, going round with my arrivals chit, getting everyone to sign it so that everyone knew I was in the camp. Going past a billet on the second day, I walked straight into Bill Williams, who, unbeknown to me, had joined up at about the same time. That was great as I now had a friend, though Bill was on a course ahead of me.

Everybody awaiting training was given a job in the camp to keep them busy. I was put in the sick bay when it was discovered I could type. For three weeks I typed out medical reports that were required by the medical officer, with only a sergeant and myself to keep the whole place going when the MO was away. One morning I walked in, and found the whole of the small operating table full of dandelion flowers. These had been put there to dry by the NCO, so that he could turn them into wine. Happy days!

At last I started my photographic course, learning how to develop and print and take pictures of static objects around the camp. I had done quite a lot of this at the poly in London but solid daily teaching made all the difference and I very soon became proficient. Also, the

training that Benson had given me on multi-printers and air cameras, such as the F36 and F24, helped when it came to the tests and exams that seemed to come round with amazing regularity.

The course lasted about two months, and when I finished, every day at about 4.30, I was free until the following morning. So a few of us either took the bus to Stratford-on-Avon or Leamington, usually missing the last bus back and having to walk. Stratford was about six miles away and Leamington eleven. After six to ten pints of beer, it was probably better to take the long way back to camp, walking asleep and sobering up before arriving, while peeing in the country lanes. One night as I was coming back, almost asleep, a cow put its head over a farm gate I was passing and mooed in my face. In fright, I fell over and for a good few nights after that didn't venture out, let alone drink. I had met a girl in Leamington called Diana, so for the rest of the course I was backwards and forwards on the bus most evenings. A lot of the time I had to walk the eleven miles back to camp having missed the last one, but I kept saying to myself that this was keeping me very fit.

Passing out from my course as an AC1, I was posted to Nuneham Park, a short way outside the south of Oxford. It was right in the country, with the camp built around a large mansion where tri-service personnel were trained to evaluate air photos. I found on arrival that I was to work in the photo section, which was in the converted stables. That, with the mansion, mausoleum, billets and NAAFI, made up the camp, with farmland surrounding it.

I was first put on the multi-printers as I had a lot of experience of them. There were about four of these big machines, which made nine-by-nine contact prints from the aerial negatives. It was a very busy section and needed two people to handle each printer. A pal of mine, Sandy Rawlinson, decided to try and break the record for the number of prints produced in one day. Both he and a WAAF called Slim worked all through breaks and lunch to produce some 2,500 prints in

the one day, way above the old record. The corporal called Sandy over the next day to tell him all the prints had been scrapped, as he had printed all the wrong negative numbers. He was moved the next day to special copying with an old friend of mine, Bill Williams in charge, who had also been posted to Nuneham.

I was moved eventually to the library where rolls of aerial negatives, in round cans with the serial numbers painted on the side, were stored. It was a lot quieter in there but I used to get myself in a mess when trying to find the right can. There were hundreds of them and I had to keep a list of those that were out being printed, otherwise I wouldn't have known where they were.

Pay parade was every Friday in the section. Everyone formed up, and with two steps forward and a salute to the officer the money was placed in your hand. Sometimes we had those little known things called 'credits' handed out. What they were for and how they were calculated was a mystery, but any money was a help.

People used to dry their socks and collars on the glazer, a machine for drying and putting a glaze on prints. This was frowned on and nearly every time I did it, it seemed that the warrant officer was walking past as the pieces of my apparel fell off, yet he was never amused.

I used to get home quite regularly at weekends, and once a chap called Brice volunteered to give me a lift on his motorbike, as he lived in Croydon, quite close to where I lived. It was a quick but hair-raising ride, as Brice used to say, 'If I go through a crossroad at ninety, I have half the chance of getting killed as if I cross at forty.' Needless to say, I went with him just that once.

At Christmas 1948, I went home for the holiday, while Sandy for some reason had stayed on at camp. On Christmas Day, those that were left in camp were served their lunch by the officers. Most then carried on drinking in the NAAFI until all the beer had gone. The next thing Sandy could remember on Boxing Day morning was waking up

'stark bollock naked' as he put it, on the wrong side of the fence in farmland. To this day he has no recollection of how he got there or how he managed to get back over the barbed wire, only that he found his uniform laid out on his bed when he got back.

I was now a leading aircraftsman and was very soon promoted to corporal, as I had been trained in photography before joining up. The stripes were sewn on my uniform by a WAAF called Briddie, with whom I had got very friendly, and who worked in the sergeants' mess. She would give me treats like eggs, which I couldn't cook, so I just put them in my locker. One evening I wondered what the terrible smell was, and tracing it to my locker found two really rotten eggs. My first thought was to throw them outside, but thinking about it decided to throw them into Bill's hut just across the corridor. So when the lights went out, I crept over and slowly opened the door to Bill and Sandy's billet. Having thrown them in, I shot back into bed, and it was not very long before complete upheaval overtook the other hut. Doors to the outside crashed open, then the sound of shovels and shouting was heard, with a smell so foul that it even infiltrated my own billet. At last all sound died down and peace once more reigned, with a smell that could never be forgotten.

A guard of six in the mansion took place nightly. One morning Station Warrant Officer McCann told me that I was to be Corporal of the Guard that night. Trying to tell the SWO that my chit didn't allow me to do guard duty was hopeless, so I decided to do it and ask questions after. The night arrived and I marched the guard down to the mansion from the guardroom with me walking behind. One sat at the top of the stairs at the point where they divided into two flights. The one on guard sat under a single light with his rifle, while the rest of the enormous hallway was in darkness. The airman sitting there that night was a little Welshman who was frightened of his own shadow, let alone the surrounding darkness. I would take over from him when he rang the bell, that let me know he had to answer the call

of nature. This chap was always fiddling with his empty rifle, pulling the bolt back and forth and pulling the trigger as he sat with nothing else to do. It happened that I had a blank .303 cartridge in my pocket, which I had had for a month or two. So when the little Welshman had gone to have his pee, I put the blank cartridge in, and cocking his rifle leant the weapon back against the wall. After he returned, I went upstairs to the guardroom, and it wasn't long before a loud bang reverberated through the empty building. On looking over the banisters I was just in time to see Taff going hell for leather for the door. Luckily for me, nobody else was around at the time but it took a good ten minutes to get him back and calmed down before the orderly officer came round on his nightly check.

Next morning, I reported sick, telling the MO about the night's guard. The MO in turn told the CO, Wing Commander Melvin, who made sure there was no more guard duty for me. The CO then had the SWO in and tore him off a strip for making me do guard duty, while knowing about my medical chit. After that there was no more communication between the SWO and the corporal.

I was not averse to a few pranks, which most got up to during the two years, such as the ghost of Nuneham. A few blokes and WAAFs, including myself, were having a drink in the NAAFI on a cold, misty moonlight night. The conversation got round to the mausoleum with its graveyard for the Harcourt family. From that it led to ghosts, and Johnny Curtis suggested that we all go down to see if any could be seen. While I took the group to the hill outside the mausoleum, Johnny got two chaps out of bed, telling them to take one sheet each and run along the bottom of the rise, holding their white bed sheets high, and then to start tucking them into their greatcoats as they ran. This they did just as the group and I arrived at the top among the gravestones. It looked for all the world like two ghostly images floating above the ground and then disappearing, as the sheets were bundled into the greatcoats. A WAAF called Peggy Hole screamed as

everybody turned to see a white figure rise from behind a tombstone. With that, pandemonium broke out and everyone ran back to the shelter of the camp, with the women screaming and sobbing as they ran. The girls were still screaming as they got to their billets, telling their stories, while those that were just going to bed shut all the windows and locked the doors. The CO was got out of bed and the RAF police started an investigation. My pals and I were quick to get into bed so that we appeared asleep when the lights went on and we were inspected. Nobody in authority could find out anything, so it was put down to ghostly intervention, which gave myself and those involved who had engineered it peace of mind from being charged. The story of the 'haunting' stayed with the camp until it was finally closed in 1956, and to this day not many know it was a hoax.

I was asked to photograph the officers' mess dinner at Nuneham one evening. Knowing that the Speed Graphic would not synchronise with the flash bulb, I took a tripod to mount the camera on so I didn't have to hold it, enabling me to open the shutter and fire the flash manually. The picture required was of a fairly long table with officers seated either side. The first course was soup, which had been put before the officers before I was ready, so with all of them looking towards the camera, I opened the shutter and fired the flash. There was a 'plop' but no flash, and looking at the bulb I saw that the top had come off and a shower of magnesium pieces like confetti were floating down, all over the officers and their soup. Quickly putting in another bulb, I took the shot again and got away as soon as I could before they discovered the magnesium floating in their starter.

A couple of days before I got demobbed, Squadron Leader Halliday called me in saying he was sending Sandy Rawlinson and myself over to Benson to photograph a large yearly officers' mess party. Asking why we were being sent when Benson had about thirty photographers, Halliday told us it was because their people had got drunk every year while endeavouring to take pictures, so no shots had

been produced for over two years. They were now going to try Nuneham's photographers to see if it made a difference, in the hope of getting some pictures of the party.

Sandy and I got into the darkroom and cut large sheets of ortho film down to five inches by four, and loaded them into double dark slides for the Speed Graphic. Having given ourselves fifty sheets of film we realised that the flash bulbs still would not synchronise with the camera. So we hit on the idea of me holding and focusing the camera while Sandy, when I had opened the shutter, fired the flash independently, and I closed the shutter. This would work well because the speed of the film was low as was the ambient lighting in the mess, meaning that only light from the flash bulb would register during the time the shutter was open.

It required working in tandem. We managed to get forty-six good shots out of the fifty we loaded. However, the drink was flowing, and as the waiters came out they would pass a glass to each of us, picking the empties up on their way back. I wasn't quite as bad as Sandy and at about midnight I had to take the flash gun off him and finish the last few pictures myself, while he slept in the hall.

At this point one flash bulb failed to go off and somehow the air commodore was betting me, in both our inebriated states, that it would go off if I tried it again. Knowing it was dud, and getting a drink from the AC every time I tried it, I drank more than was good for me. However, all the shots had been taken so it didn't matter that both the AC and myself could hardly stand.

It was all right until Sandy and I went out to the car park and the night air hit us. Our driver wasn't there because she didn't think we were going back that night, so someone had to be sent to get her up.

The car turned up in about fifteen minutes, at the same time as a fed-up and very tired military policeman tried to arrest Sandy for being drunk, but as luck would have it the MO from Nuneham came out at the same time and stopped him.

Sandy and I got into the car and I fell asleep immediately we drove off, due to the excess of alcohol. Some time later I was suddenly awakened by Sandy shouting, 'Stop, I need a pee.' He got out and both the WAAF and I fell asleep again. I remember as it was just getting light a banging on the door that woke the two of us up. A voice was saying, 'Is that your mate lying in the field, soaking wet in the dew? I don't know whether he's dead or alive but I can't raise him.' I staggered out and with the help of the lorry driver who had stopped to relieve himself and got the sodden Sandy into the car and back to Nuneham. There somehow we processed all the films, proving that Sandy and I could take pictures, pissed or not. But if anyone had asked us to caption any shot, we couldn't have done it.

I remember Sandy telling me about a guard that Corporal Tony Moore took one evening. He had got all his men into the mansion with the first on guard when the phone rang. Picking it up, Tony listened to the so-called duty officer, who told him to get the airman in line as he was coming down to inspect them. Tony immediately did this and waited for the officer to show. They waited and they waited and no duty officer came, so an hour later things got back to normal. It wasn't until the next day that Tony found out that it was Bill who had rung, pretending to be the orderly officer. I heard later that the air was blue, with Tony saying he would get his own back, but he never did.

Two days later, I was demobbed at RAF Kirkham just outside Blackpool. Going home on the train to London I felt that the two years' service had been a bit of a waste of time but in a way I was sorry it was over. It wasn't until I had been demobbed for six months or so that I began to realise that the discipline and comradeship had turned me into a man who could now stand on his own. I had worked hard with the camera, learning all I could in those two years, so when I started work again I knew I was a competent photographer and all I needed was time and experience.

Chapter 5

I took two weeks demob leave before returning to work at the film unit, knowing I would have to get used to living at home with my parents again after the two-year break in the RAF. Also, I wanted to see more of my pals who were being demobbed about the same time and who were also getting ready for work again, after service life.

I knew it would take me time to integrate with the family. But feeling I was my own man now who wanted his independence, I tried very hard, finding that I had changed, but not being able to tell my parents of my feelings, as I didn't wish to hurt them. I knew they only wanted to look after me as they always had done, but not having been told what to do in my personal life for two years, I was frustrated. After a short period I managed to settle down without causing too much friction, occasionally telling a little white lie if I was out late.

The two weeks came to an end and I went back to the film unit, to the projection box where I carried on as if I hadn't been away. Dennis was still there, he hadn't been called up, but he seemed to be the same, only a little older. Bill Williams also came back after demob as his father's assistant, though he didn't stay long.

I had made a darkroom in my bedroom so that I could carry on with still photography, processing and printing pictures that I had taken. This I did to learn more about darkroom techniques while I processed the prints and negatives in the bathroom. Putting a board across the bath with the developer and fixer trays on it, and with the bath half-full for washing the finished prints, I worked at nights so that I didn't have to black out the room while printing under an orange safe light. To dry the finished prints, I fixed up a line across the bathroom and using my mother's pegs hung them up, teaching myself a lot about photographic printing and what could be done to enhance the final result. This is where I could be found most nights, sometimes as late as two in the morning.

For three months I worked back at the film unit, sometimes in the

projection box but mostly out on location with the camera crew. Then one Friday morning I was called into Mr Bradshaw's office, to be told that the film unit was going to be wound up by the Central Office of Information (COI). This meant I would become redundant, but because I seemed more interested in still photography as a career, for the remaining time left before the closure a sideways transfer had been arranged for me at photographs division, COI, whose offices those days were in Montague Mansions, York Street, just off Baker Street.

First, it came as a shock to me but I soon realised I would get further training there, helping me to become a better photographer. Thanking Mr Bradshaw for organising the transfer, I left the office, telling the others my news.

Getting home that night and telling my parents of the change to my career, I knew this is what I had really wanted all along. It would give me the opportunity to work with true professionals and become a top-line still photographer, with the help of this new piece of luck. I was sorry to be leaving the film unit as it had been my first job and I had learnt a lot there, but combined with my training in the RAF, I felt I was now on my way to my chosen career.

The following week I was at the photographs division with everyone helping me settle in. I was introduced to the director, Barbara Fell, and her assistant, Bob Howarth. He took me down to the basement where I met Mr Kearne, who was in charge of the darkrooms, his assistant Peter Streatfield and the printing staff.

Then I was taken to meet the photographers with their own darkrooms and rest room, whom I would be working with. Only one was in, Norman Smith, the other four being out on assignments. He immediately took me under his wing, asking what I had done before and helping me to get organised. Norman was a lot older than I was, and during the war had been a photographer in the desert, taking a lot of what are now very famous pictures of that campaign. Before the

70

war, he had been with Fox Photos for many years and was a professional Fleet Street man through and through. He told me to use his darkroom for processing negatives, and gave more insight into the different types of jobs I could be tackling. I went out with Norman on many occasions, and he introduced me to many other newspaper photographers who were pals of his. It was like a club in those days, everyone helped everyone else to get the picture. There was n[o] pushing and shoving, everyone got the shot he wanted, unlike toda[y] with the paparazzi. It was Norman Smith who made me feel really [at] home in my new environment and Fleet Street, making me realise th[at] if it hadn't been for the RAF and their training, I couldn't have tak[en] my place among these professionals.

Norman told me about some of the jobs he had been on befor[e the] war. There was one in particular that showed how press photograp[hers] worked in those days. The job he talked of was somewhere in S[...] and there were about six of Fleet Street's finest who had arriv[ed by] train. A large car turned up with a further photographer drivin[g. The] car was of the open type, with the hood down. In those days th[ey took] their pictures and afterwards all caught the same train back to [London] and on arrival sprinted for their offices to get the pictures ou[t. The] photographer having a car was different as he could get bac[k faster] than the train, and pull a fast one over the rest. Norman size[d up] and when no one was looking tucked his slides into the f[olds of the] car's roof. Then phoning his office at Fox Photos, he got o[n the train] with the rest who were all moaning about the trick with the [car. When] the car arrived in Fleet Street, its owner went for a dri[nk as] there was plenty of time for him before he needed to [develop his] pictures. Unbeknown to him, a lad from Fox had tak[en the] slides out and run back to get them processed. Norm[an's picture] came out in the lunch-time edition of *The Star* that da[y...,] driver of the car wondering how the hell Norman had d[one it.]

I met the other four photographers as they came [...]

71

nments up and down the country. First there was Richard Stone,
man with a small black beard and a mop of hair to match, who
senior. Then Peter Anderson, known as Andy who had small
eard and a bald head, always wore sandals and belted his
vith a tie looking bohemian in his dress. Next was Gregory,
Greg, who had been commissioned in the navy during the
stly Fred Carrol, a London cockney with a heart of gold.
man, had been in Fleet Street before the war, and like
professionals.

ught me how to synchronise the flash bulb to a Speed
using a piece of kit that the air force hadn't had.
ies of the VN camera, which was totally different
ad used before. This camera used glass plates and
an attached arm to the lens mount, calibrated from
y. It had no compur shutter, only a focal plane
the camera. The slit could be adjusted, together
a scale of one to ten. To use it meant to gauge the
lit size as well as the tension to get the right
g to judge the distance as well, it took me a long
sure and focus in varying weather conditions, as
uld have been of little use. It was just a matter
holding my wet finger up to check the wind
e sun was going to appear from behind the
ime in mastering and taking pictures with the
t were correctly exposed and sharp, I knew
than anything else.
n small jobs that could be re-shot if I made a
pt for the first time when my nerves got the
e very acceptable.
Hewent was on the outskirts of Oxford, when Dr
to his Canterbury, and known as the red dean due
munism and Stalin, would be arriving by

72

helicopter and talking to a crowd just outside the town. Norman drove, as my driving test was still two weeks away. Dick Forsdick, the picture editor, was hedging his bets as to whether I would cope alone on my first real assignment, hence Norman being with me.

The day turned out fine and the aircraft landed in front of the small crowd that had assembled to hear the words of Dr Johnson. I shot four pictures, one close-up of the dean, another two of him talking to the crowd, and finally a trip up in the helicopter to shoot down at the people waving. Norman did similar pictures but hadn't managed to get a flight.

Both sets of plates were processed and contact prints made: they were shown to Dick, who picked three, all mine, out of the eight taken by the pair of us. Norman congratulated me, saying, 'You beat me fair and square, they are great shots.' It was the start of a firm friendship between Norman and me, one that lasted many years.

Another of my assignments, on my own this time, was at De Havilland's, Hatfield, where John Cunningham had just completed the first 'hands off' landing in a Trident airliner. I thought the picture would be of Cunningham in front of the aircraft, but on arrival I learnt I was flying with them to photograph an actual landing. Standing behind the two pilots as they flew round in a circle to come into land, I knew instinctively the only shot was of the two with their arms folded, facing slightly inwards, with the runway showing through the front windscreen. I managed two exposures from behind them, the second as the runway got nearer, and I breathed a sigh of relief as the wheels touched down. On the ground, I did other pictures of the two pilots, with the aircraft in the background, the one and only picture I thought I was going to do on that assignment.

I had done well at photographs division and learnt a lot, but was very upset when told I was now redundant at the film unit and therefore had to leave the COI. However, I put on a brave face as I said goodbye to my new friends, knowing that this was where I

73

wanted to have a full-time job in the future.

Knowing I had to do something to continue to earn money, I turned to freelancing in a small way. I started off working for the two local Odeon cinemas, taking pictures of their front-of-house displays. While this nearly made up what I was earning a week when employed, I needed to get another full- or part-time job. One evening, my father told me he would have a chat with the photographer on the *News of the World*, and see if there was a chance of a Saturday stint on the paper for me.

Once again luck was on my side. They did need another photographer on Saturdays to take the load off the full-time man, as being a Sunday paper most of the pictures for the editions were taken on the Saturday of every week.

Although slightly worried about working on a national paper, I knew that with the training I had so far from the COI, it was a matter of getting more experience in order to know the picture that was required.

The first Saturday came and my father and I travelled to London by car, parking in Bouverie Street, keeping away from the rolls of newsprint being unloaded and craned up into the presses. Dad took me up in the lift to the photo section and left me in charge of the permanent photographer, while he went to 'news telephones' where he was in charge.

I was given the camera, and asked, 'Do you know how to use this VN?' It gave me quite a shock to see the same camera that I had used and got used to at the COI. Feeling quite at home with the equipment, I was told that my first job would be to go to the Arsenal football ground and cover the first half, getting a good picture of the action round the goal. As there were no such things as telephoto lenses in those days, I had to be close to the action to get anything from a camera with only a normal lens. I had to wait before kick-off in the afternoon, so I talked to the printer, getting to know the type of

picture required until it was time to catch the bus.

Arriving at the ground, I was pleased to see another photographer from Central Press I had met before with Norman. It was just starting to rain, so when the match got underway I was sitting on my camera case on the touchline alongside the goal with the other photographers. I was wearing a long gabardine raincoat, which hung in the mud while I sat on the case, concentrating on the match, knowing very little about football, as I was a rugby fan. I had six slides to get a good picture for the paper, and I had to leave after the first half to get back to Fleet Street for the northern edition.

Watching hard, I saw that most of the action was at the other end and it seemed to take an age before anything happened where I was. When it did, I took my first shot and before I could put another slide in, the ball hit me full in the chest, knocking me back into the mud, which by this time had turned into a glutinous mess because of the rain. Here I was, with only one picture taken, covered in mud, wondering if the glass plates were still intact. Not giving up, I pulled myself up and took three more pictures, getting the shot of the one and only goal. With rain and mud dripping off me, I made my way back to Fleet Street, to see if my picture was sharp. I was soaked and had to take off my muddy coat to be able to sit on the bus. The picture turned out a great shot, and was printed large on the back page of the paper. I knew that it had just been luck that I had taken the shot at the right moment, but then all good football pictures are taken at the right moment.

Every week, my first job was always a football match at one or other of the London clubs. I had a reputation to keep up with that first picture but I never liked the game, seemingly always finding myself at the wrong end at the wrong time, and always in bad winter weather. When I got back, the plates had to be 'cooked up' in the developer because of the bad light and slow speed of the emulsion. Where photographers always sat in those days, one or more nearly always got

hit with the ball. But I was now taking good pictures and dodging the ball by standing instead of sitting, not bothering to listen to the shouts of 'sit down' from behind me.

After a few weeks of football, they started to give me other types of assignments. As the spring came, one job was at Teddington Lock on the River Thames. The lockkeeper had won the award for the best-kept lock and the paper wanted a picture of it with a launch, and girls in bikinis, the usual type of thing for the *News of the World*. Leaving it to me to organise, I got two girls from the youth club to go with me in the car with their costumes on under their coats.

It was quite cold and the girls had to stand on the launch, waving at the lockkeeper. By the time I was satisfied with the picture, the girls were turning a shade of blue, so getting them in the car I drove them home then went back to London and caught the edition.

Other jobs followed, such as athletics and horse racing, together with shots of Clarence House the day after Queen Mary had been burgled. As I couldn't get into the place, all I could shoot was an exterior of the house, while wondering how a burglar managed to get in past all that security.

I was sent to the Windmill Theatre on many occasions to photograph the nudes. I would go in the morning, as it was more peaceful then, stand in the wings and take pictures of the girls in the altogether. I got to know Sheila Van Damm very well during those visits, as well as quite a few others, as every picture published was good publicity for the theatre. I met her father at times but he had handed over the running of the place mainly to his daughter by this time. The word among the girls was that he was using the casting couch more and more, and hadn't got time for visitors. I was always amazed when watching from the wings, seeing men climbing over the seats every time anyone left the front row, trying to get as close as possible to the stage. Some had to be restrained when they actually climbed on the stage.

In July 1950 I was twenty-one and my parents threw a party for me at home. My aunts and grandmother came as well as some of my friends' parents. I had my pals and some of the girls from the youth club, together with three of the photographers from COI, Richard Stone and his wife, Greg and Norman Smith. Norman took a few shots and everyone had a great time, finishing at about one in the morning, with everyone a bit the worse for wear.

On one Saturday there was a job for me at the Albert Hall, to photograph three holders of the Victoria Cross at the armistice ceremony, and all I had were their names. The hall was full when I arrived and I wondered how I was going to find three among the thousands that were there. Luckily, I walked into two of them, talking together near the entrance. Explaining to them that I needed to find the third, I asked them to stay where they were while I went off to find him. On my search, I recognised the purple ribbon, and asked the wearer to come back and join the other two before the ceremony started. With all three now together, I took my pictures and was back at the paper in time for the edition, thinking to myself how lucky I had been to find the three among those crowds of people.

The following week I was sent down to Canterbury to take pictures of a theatre group acting a religious play outside the cathedral. Asking my father if I could take the car, as I had passed my driving test the previous week, I drove to Canterbury, did the job, but was late back due to a hold-up on the roads. Parking the car and leaving the plates to be processed, I went in search of my father, finding him in the Clachan a little the worse for the beer he'd consumed. I drove him home, and explained to my mother that it was all my fault.

I was called by the paper one week to go to the Isle of Wight to photograph an old miner who had travelled all the way down from the north, to see his old pit pony now put out to grass on the island. Luckily Dad had helped me buy a car, a second-hand 1939 Rover, a few days before, knowing that if he hadn't he would never see his

own car when he wanted it.

At Southampton I parked and took the ferry over, and got the train on the island for the last part of my journey. There I met the old gentleman who had spent a lot of money to see his old pony. After talking to him and getting the story and buying him lunch, I did the pictures and returned the way I had come. I had to drive to London to get the picture in the paper for the Irish edition, which was printed on a Wednesday evening. At the wheel, thinking of nothing in particular, I noticed that the car was accelerating on its own. For a moment I couldn't think what to do as the speed had reached about eighty with the engine revving like mad. Realising the only way was to turn the ignition off, when I did the engine made some enormous bangs, but with the help of the brakes I got the car under control and stopped. Lifting the bonnet and looking at the linkage to the carburettor, I saw that it had parted at a small ball-and-socket joint, and that the weight was fully opening the carburettor. Clicking it back together and waiting for the engine to cool down, I wiped the sweat from my face before resuming the journey, knowing what to check in future, as it had nearly made me have a nasty accident.

The COI had also given me some freelance assignments for the army, and I had met Captain John Foley who was on the staff of the public relations department. Foley lived at Worcester Park with his wife and family, and was very interested in photography. During the war he had been in the Tank Corps and afterwards had written a book called *The Mailed Fist*. All my work for the army was with him and we became the best of friends, and he always said how much he liked the pictures I took. It was soon after the last of these assignments that Bob Howarth phoned to ask me if I would like to apply for the post of press photographer with the photographs division at COI, there being a vacancy. This is what I had always hoped for, and applying I waited for the interview.

My freelancing with the *News of the World* carried on for the next

month, with my last job being in London. It was to take a picture of a woman who had had an accident and was claiming for the cost of cosmetic surgery to her face. The judge in his summing up had said that having seen the picture of her after the accident, he felt she looked better then than she did after having had the surgery, so she was not happy to have her picture taken.

The paper had a picture of her before surgery and I was sent to get one of her as she looked now. The flat was over some shops with the entrance at the back, up an iron staircase. With the camera at the ready, I got to the top of the steps, and finding the door to the flat open crept in. Knowing she didn't want her picture taken, and knowing I would have to snatch it, unfortunately for me I failed to see the man standing in the kitchen. Going into the living room, I took a shot of her sitting on the sofa. As I turned to go I was caught from behind, pushed out the door and down the iron stairs, arriving at the bottom bruised and bleeding, not knowing if the glass plate was still intact in the camera. Putting the sheath back in the slide, and hearing a slight grinding noise, I didn't wait to find out, and I was not going back. Instead, I ran round the corner and caught the bus back to Fleet Street. The shot of her was good but the plate had lost a few slivers of glass down one side, which luckily hadn't interfered with the picture.

That was the last time I worked for the paper, as the following week I had the interview and was offered the job at the COI, the job I had always wanted since leaving the film unit. In reality, the experience I had now gained stood me in good stead for the future, a future I was really looking forward to.

Chapter 6

Having now got the job I really wanted I knew if I hadn't had the training in the film unit and the RAF, and working for a top London paper, I wouldn't be in a position to take on such a daunting task at the young age of twenty-one.

Walking into Montague Mansions again on that first morning, I immediately felt at home. I knew all the people in the division and now I was one of its small group of professional photographers.

On that first morning, my assignment was in London, with the new French ambassador going to the Foreign Office to present his credentials. Dick Forsdick had given this job to me, to work me in. It was a lovely morning and the sun broke through the trees at just the right time, as the diplomat was getting into the coach for his short trip to Whitehall. He was dressed in his finery and I took a shot as he turned with one foot on the carriage. It was the only shot needed, and it turned out to be the best picture from my first assignment.

I had been given three cameras on my arrival at COI, together with an official car, a 1939 Austin Ten saloon, which was kept in a garage just up from the offices. After the first small job, I spent two days checking the cameras and making sure of the film stocks I was to use. Once again Norman came to my rescue with answers to my countless questions, and so at the end of a few days I was ready for any job that came my way.

Never having driven far from London, one of my first purchases was a road map of the British Isles, knowing it wouldn't be long before I would be travelling round the country, as the others always seemed to do. I knew I would have to get a bag of clothes and washing kit together to leave at the office never knowing when I would be sent off in a hurry anywhere. After the initial job, I was left very much on my own to get organised, so by the Friday of the first week I knew I was ready for anything. Looking on my board before leaving on that first Friday, I found six jobs for me the following

week. I had the weekend off, and that would be unusual as I knew I could be asked to work seven days a week, depending on the stories and where they were. In any case it was a five-and-a-half-day week, as Saturday mornings were included as normal working days.

On the Monday I was on my way to Thetford. The story was the first trial of a heavy drop from an aircraft, a Jeep by parachute over the army ranges. Parking my car, I was met by John Foley, who drove me to the drop zone. There I had to wait for the aircraft to appear, while I chatted to the other photographers and newsreel cameramen who had turned up for the event.

At last the aircraft was seen at about a thousand feet, with the large double doors at the rear open. Out came the Jeep with three out of it's four chutes opening. Dropping down faster than it was meant to, it hit the ground and bounced twice before coming to rest, smashing the vehicle to pieces with wheels and bits of Jeep thrown everywhere. I was using the Rollieflex camera, giving me twelve shots on a roll of film that showed the sorry state of the whole drop from start to finish. Something made me look up and I was just in time to see the fourth chute, which had now opened having somehow got detached from the load, coming down on top of me. Luckily, there was nothing heavy attached to it, so I managed to extricate myself from under the nylon chute, while avoiding the wheels and pieces of vehicle that had been strewn all over the field.

After this, my next assignment was at a Canadian Air Force station in Rutland, called North Luffenham, where I was to make a picture feature story for publication. I spent two days taking shots and writing notes of the everyday life of the airfield, getting to know the Canadians and picturing them at their work. I remember the lead picture was of a row of Sabre Mark 6 fighters, with pilots in flying gear walking towards the camera, while a Sabre flew low over the top.

After three days, I managed to get back to the office and process the films. Leaving them to dry in the cabinet, I went home after taking

the car back to the garage, tired but thrilled at the results of my first jobs away from the office. Having checked my assignments for the next day or two, I saw the first was not until the afternoon, so I knew I wouldn't have to rush the next morning. The rest of that week all my jobs were in and around London, meaning I would be able to have the next weekend at home.

Fred had told me about Moggie Morris, an ex-Fleet Street photographer who was running his own wedding business just down the road from the office, and was always on the lookout for photographers for Saturday work. The following week, I went down with Fred and Norman to be welcomed with open arms by Moggie, who had so much work he couldn't cover all the weddings he had booked. He supplied the slides and paid £2 for every wedding covered, with him doing the processing and printing. He also had girls who would take the wet prints back to the reception to get the orders.

So I started in the wedding business every Saturday afternoon when I was free, doing three weddings most weeks, rushing back after each one to leave the exposed plates and get fresh slides for the next. This carried on for many years when I was in the country or not away at weekends. I regularly made £6 on a Saturday, getting home about ten in the evening having had plenty to eat and drink at the receptions, and enjoying the extra cash.

I learnt that the name 'Moggie' came from the cockney for a Morris car. They would talk about 'a ten-horsepower Moggie' instead of a Morris, leaving me thinking how attractive cockney was.

I was always busy, either photographing or driving to new assignments. At the start of one week I was sent to High Wycombe, to do a feature on furniture-making at Ercol. I was finishing the assignment on the second afternoon, when I was informed that my office wanted to speak to me on the phone. Dick Forsdick was very apologetic but asked if I could do a job at Falmouth, the next morning at 9.30, which meant I would have to drive through the night to get

there in time. There was no one else available and this was a job with the navy, which involved the first underwater television camera shown to the press. The timing was important as I would have to go out on a minesweeper, which would leave on time, so I started off for Falmouth directly I had finished at High Wycombe, around 5.30. Working out a cross-country route I left, hoping I had enough money for petrol and food left from the float to get back. Arriving at Falmouth at about 4.30 in the morning, I made my way to the dock and parked, getting a few hours' sleep in the car. At eight I found a small hotel, where I could get some breakfast and a wash and be ready for the day's work at sea. Taking the pictures of the new camera, and with a sailor looking at the underwater pictures on a monitor, I got on with writing the story while the ship made its way back to harbour. Getting to my car and putting the cameras in the boot, I sat inside falling asleep again for an hour or so. Then realising I had to get some money, I drove to a bank and on producing my personal chequebook was asked if I would wait while they phoned my branch to make sure I was good for £3. Now with money in my pocket, something made me think that I should phone the office to report I had finished the assignment. Getting through to Dick, he asked if I could do another job at Cambourne, as I was down there already. Thinking I would never get home at this rate, I gave in and agreed.

I was to go to Holman Brothers, to do a picture feature on the manufacture of rock drills and their use, which in part would be photographed in their own mine onsite.

Arriving late in the afternoon, I made contact with the firm before finding myself a bed for the night, which I knew I would use very soon, not having had much sleep over the last forty-eight hours.

The next day, refreshed after a good night's sleep, I started on the project in the factory. Needing pictures of the drills in use, I went into the mine, which had been excavated straight into a hill, by countless trials of new drills on test. With their noise ringing in my ears, I

photographed the drills in use and watched as they got ready to blast away more rock, making room for more testing. As I observed the handling of the dynamite, and tamping it in, with the last stick having the detonator inserted, I was given a stick to look at, and told it was quite safe to handle. It would not explode, they told me, until the small copper detonator that was linked to the plunger exploded. I was fascinated with this pink, putty-like substance, which was cylindrical and about four inches in length, wrapped in what looked like greaseproof paper. I took up the camera and shot pictures of men putting in the last stick with the detonator wires attached, who walked back hurridly as they unwound the wire that would be connected to the plunger. I put my hands over my ears as the explosion reverberated round, feeling the blast of air hitting me, which was followed by clouds of choking dust.

Going back to the offices I wrote the story, having talked to the foreman about the history of the firm and its export potential. It was after five when I left and started my journey back, thinking I would drive all the way and not stop over, hopefully arriving just after midnight.

Having got past Exeter, I decided to stop for something to eat at a transport café on the A303 near Honiton. As I got out of the car, I put my hand into my jacket pocket, feeling the stick of dynamite I had handled in the mine. Not knowing what to do with it, as it was too far for me to go back and return it, I thought the best thing was to eat first and worry about it after. So, at the end of the meal, I decided to take it home, and have a think about it in the morning.

So before I drove to the office the following day, I stopped off at my local police station and handed in the stick of dynamite, not knowing what else to do with it. They rang Holmans to verify my story and then took it from me. I drove on to the office, not having said a word about the explosive to my parents, who certainly wouldn't have slept very well had they known there was a stick of dynamite in

my bedroom.

One morning Norman, Fred and I were sitting round the table in the photographers' room discussing the new electronic flash, questioning whether or not it would take the place of the flash bulb. We had been talking for about five minutes when Norman said to Fred, 'Go on, tell John about the time you tried out the new flash at the BIF.' Fred was a bit hesitant, but with Norman egging him on the story came out. They had been sent to photograph the King and Queen at the British Industries Fair in May of 1950. The two had been sent as Fred was going to use the new electronic flash for the first time and Norman was there as back-up. As the royal party came up the stairs, Fred was at the top lining up his shot with Norman behind him. The box attached to the flash was very heavy , so Fred was slightly bent over to the left, trying to correct the weight. As he took the picture on the Speed Graphic, he was outlined in a blue halo, Norman said, taking the full force of 5,000 volts through his body that propelled him past the King and Queen. So as they came up, Fred went down. Norman took his picture as Fred glided past down the stairs, showing the King with a look of horror on his face watching as the photographer hurtled by. Fred was luckily just a little bruised and battered as he came to, lying down in one of the stands. The feeling gradually came back in his arm, though it was a week before he felt his finger again, the one that had pushed the shutter. The King sent a message to say he hoped he was all right and wasn't too hurt. It appeared that the problem with the flash was the cable connecting it to the camera. This could be plugged in two ways, one that gave a six-volt triggering circuit, while the other put the whole voltage through the shutter and camera. Fred had chosen the wrong way, with disastrous results. That first electronic flash was never used anymore as none of the photographers would ever touch it again.

I was using the Rollieflex camera more than the larger format ones, mainly because roll films were quicker to use, having twelve

exposures on each. Richard had a box made that clipped to the base of the camera, giving three flash outlets that could be synchronised and fired through the shutter. This meant that one could light a subject using the three heads of flash that had large bulldog clips, so that they could be attached to anything with their long leads. The exposures took a lot of working out at first, as it depended on the distance from the subject the bulbs were placed, but soon the photographers all became very skilful at it. If it was a press-type shot, it enabled the single flash to be held high giving far better lighting to the subject, nearly always doing away with the large black shadow behind, which a flash gun attached to the camera usually gives.

We five photographers were always kept busy, working on assignments up and down the country, and my next job was at a tank factory in Leeds. As I was driving along, there was a loud clanging from the engine, which made me stop. On opening the bonnet, I saw one of the fan blades had broken off. Luckily I found it lying in the road at the rear not far away. I was only half a mile or so from the factory, so when I arrived I asked if it could be welded on while I got on with the job of photographing tanks. The car was ready for me when I had finished my work, so I thanked them and drove off. Unfortunately, the car started to boil when I had gone only a short distance, so opening the bonnet again I saw that the fan had been put back the wrong way round. Instead of sucking the cold air in, it was trying to push it out, making the water boil. I phoned the factory and they came out and towed me back in, reversed the fan and apologised for the trouble it had caused.

We photographers had a lot of problems with our official cars, as they were old and built before the war. There were always things like holes in the exhaust pipes, which we had to mend with 'bandages', and every time there was a downpour, because it was a side-valve engine the plug wells filled with water and the engine cut out as the electrics shorted. The only way I found to get water out of the wells

was to use blotting paper, so I always carried a large roll on the backseat. The main problem was that I had to wait until the rain stopped before I could soak up the water, otherwise as fast as it came out, so it went in again.

One morning my door took it upon itself to leave the car. I was driving at about sixty-five miles per hour when it just flew off, landing at the side of the road. Fortunately nothing was coming in either direction, so stopping quickly and ran back and picked it up, and tried to refit it. Eventually, with the aid of some rope I found in the boot, I got myself tied in, the binding attached to the passenger door trapping me into the driver's seat. At the next garage I came to, they welded the door back on to the broken hinges, while I wondered why they had broken in the first place. When it was examined later it was found that the hinges were rusted so badly it was inevitable that the door had broken off.

The cold weather was the worst time to drive, as there were no heaters in the cars, and having to make hand signals out of the open window let out any warmth I had managed to generate. I always carried a blanket in the cold weather, which I would wrap around myself, together with a hot-water bottle, if I could find somewhere to get it filled. I also carried two hessian sacks and a shovel in the boot in case of snow, which completed my winter kit. While my vehicle did the job, I tried not to drive too much at night as the headlight reflectors were gold in colour instead of silver, giving me about as much light as a couple of candles. My last job with the office car was in Manchester at the police training school. I was staying in a pub outside the town and had been drinking with the course instructors until quite late. Driving along a country lane I spotted a car in a lay-by, and immediately noticed it was one of ours by its number. Not knowing that any of my small group were in the vicinity, I nearly stopped, but saw that one of my friends was facing backwards out of the sunshine roof. So not stopping, I puzzled as to what on earth was

going on, but didn't wish to interfere as he was smiling and certainly not in trouble. On asking him about it when I returned, I was pleased not to have stopped, as he told me privately that he'd had a girl on the front seat, and he was out of the sunshine roof because there was very little room!

After six months of trouble from that car, especially when one of the rear wheels had come off and passed me as I was going along the A303, I was at last paid mileage for using my own, which had a heater, saving me the blanket and hot-water bottle. There was always an argument on mileage between towns as the AA and RAC books didn't coincide. I got used to working out my mileages, and soon found a way to get the right money by saying such and such a town and district. When I drove to a town, I had to find where the job was, and not having road maps it would sometimes take me miles to find the place, so I just worked on the milometer.

Having completed an assignment at the Hippodrome, Golders Green, and before getting my car out of their car park, I decided to walk to the shops for cigarettes. When I'd bought them, I was stopped by the sound of car horns from the large crossroads at the centre. Round the corner I spotted a learner at the traffic lights attempting to pull away when the signal was green. On the three successive occasions when it was possible to go, she stalled. It was no wonder the other cars were kicking up. Behind her was a police car, a large Wolseley with a loudspeaker, which suddenly came to life: 'Please be quiet, give the learner a chance.' The noise diminished and as the lights turned to green I could hear her engine rev as she prepared to move forward. However, instead she went backwards, at a rate of knots, straight into the police car. Once again the speaker came to life, only this time in not such a conciliatory tone: 'Now look what the silly bitch has done, ruined our bloody car!' Steam was issuing from their radiator, and with hoots and laughter all around I made my way back to my car, crying with laughter.

My next job, along with many others, was the Festival of Britain. This took place in May 1951, the main part being the transformation of the South Bank of the Thames near Waterloo. The new Festival Hall was built together with a modern sculpture called the *Skylon*. At about this time, colour transparency film was introduced by Kodak. It was supplied only in five-by-four sheet and then only balanced to artificial light. It was a very slow film, being 25 ASA, and if used in daylight had to be filtered through an 85 Wratten filter, which then decreased the speed to 16 ASA. One of my first jobs at the festival involved aerial colour pictures of Battersea Park, which had been turned into the Festival Gardens. Flying in a light, fixed-wing aircraft, I could only take pictures at a fiftieth of a second with the lens wide open at 3.5, though it was a very sunny day. I used the Speed Graphic with a normal lens, telling the pilot he had to go as slow as possible and as low as restrictions would allow. However, I managed somehow as the aircraft was at least stable, but I had the feeling afterwards that the aircraft had been a lot lower over the Thames and London than any aircraft should have been.

The week after this, I was thrilled to be told that I was being sent to East Africa and the Sudan for the Colonial and Foreign Offices, together with one of the writers, Alistair Matheson. This meant that for the following weeks I would be organising the cameras and stock, my own clothes and having medicals with injections for six or seven nasty diseases I might catch.

One of my last jobs before the overseas assignment was to go down to the Bath and Wessex Orthopaedic Hospital, to photograph one of the first new hip operations in the country. Why Bath? I had no idea, knowing only that it was for the Ministry of Health. I started to worry about it on the drive down. Would I be all right photographing a whole operation or would I pass out? I had no idea as I had never had to do this before.

Dressed in a gown, facemask and hat to keep my hair in, I was

shown into the theatre and introduced to the surgeon. The operation started and after the initial cut with the scalpel, which made me feel a little queasy, I was taking pictures whenever the surgeon stood back and signalled to me. The camera made me feel entirely remote from anything going on around me. I just concentrated on getting each picture at every stage of the procedure. The operation seemed to take hours and I was pleased when it was all over, and when the last stitches were sewn. Having a cup of tea after, I silently congratulated myself for not passing out, but I still couldn't understand why I had come all this way to photograph what seemed to me to be a perfectly normal medical procedure. I felt I should ask when I returned to the office, but with all the problems of getting ready for my first overseas assignment, I forgot all about it.

In the office the next day, I learnt from Norman that Andy had got hold of a Leica camera and was going to try photographing in an underground train with available light. 35mm black and white film was very slow in those days and working hand held in a moving tube train was thought to be almost impossible. Anyhow Andy went ahead taking pictures at a 30^{th} of a second with the lens wide open.

Back the office Andy put the film into the developer and went home, leaving it to cook for the night as he said. The next morning, after he had cleared the chemical fog with Farmers, there were the images of the interior of a London tube train.

As far as I know this was the first time anyone had taken that kind of picture with the slow speed of the film we had in the 50's but I could be wrong, although it was a way of doing something that people said was not possible.

Chapter 7

For the next weeks I was getting things organised for my extended trip to Africa, having never been out of Europe before. Firstly, what clothes I should take, besides tropical kit, but never a pith helmet. There was the financial documentation to take care of, the medical from the Treasury doctor, and all the inoculations that were required at the BOAC terminal in Victoria.

The cameras, together with film stock and flash bulbs, were being organised by Mr Kearne, so all I had to do was check them over before they were sealed for customs. With that off my list, I decided that clothes were the next most important consideration, so, taking myself off to a tropical outfitters, I hoped to get all I was going to require off the shelf. Having managed that in a morning, in the afternoon I went back to the office to check on the cameras, and the stock and money we were taking. I also inquired about the dates for the injections and the doctor's appointment, while most importantly I filled in my expenses form for the money I had spent on the clothes and other bits and pieces.

I found out that my injections were to start the following day, beginning with another smallpox vaccination, though I had had one as a child. This was to be followed on successive days by yellow fever, TAB, cholera, typhoid, and typhus. I had also to start taking Paludrine as a preventative for malaria two weeks before departure, and that was getting very close.

I went for my medical while also going for daily injections at BOAC. The doctor was very thorough, and when he had finished said to me, 'Do you ever get problems with your appendix?'

I was a little taken aback by this but said, 'No, nothing at all, why?'

'I was just thinking,' he said, 'that it might be an idea to take it out, in case it blows up when you're in Africa.'

I was definitely not having this and said in no uncertain terms that

I had had it for nearly twenty-two years and I wasn't going to lose it now. With the consultation over, I walked out knowing that medically I was very fit and had still managed to retain my appendix, which I still have after sixty years.

One of the first five DH 106 Comet airliners, G-ALYU
seen here at Entebbe Airport in 1952. The Comet was
the very first jet commercial airliner to go into service
anywhere in the world

A week later, I had dealt with everything and was ready for the trip, going through my cameras with Mr Kearne for the last time. I would have to purchase more film and flash bulbs locally where I could, but overall I was satisfied. Both my arms were still aching from the inoculations, but otherwise I was ready to go and get started, as I

hadn't taken any pictures for nearly three weeks. I knew it wasn't good to leave it much longer as photographers understand that long inactivity between pictures is bad, because it's easy to lose one's skills and make mistakes. This is due to excess worry setting in, when thinking too much about the picture one is taking.

Alistair, for some unknown reason, had decided not to tell his wife of the forthcoming trip. Asking her to meet him in London, he got me to drive to his house and pick up his two cases, which he had got ready without her knowing. He was spending two nights in a hotel near Heathrow, meeting me on the evening of check-in for the flight. It was later during the assignment that I was to learn the cause of this unexpected change in Alistair's behaviour, which made no sense to me at the time.

My father drove me to the airport on the evening of departure, helping me with all my equipment and personal luggage. I met Alistair as arranged and said goodbye to my father. We checked in our luggage and waited in one of the wooden huts for our flight to be called. In 1952 Heathrow consisted of huts plus a few hangars for servicing, while the aircraft were parked alongside the fence, facing the A4. When we were called, we walked to the aircraft, wondering what lay ahead of us in Africa during our months away.

We were flying in a BOAC Argonaut and our first refuelling stop was Frankfurt, followed by Bahrain in the middle of the night. As we disembarked for the fuel to be taken onboard, the heat hit us both, making us feel we had walked into an oven. Not being able to see anything of the surrounding country, we were ushered into a large wooden hut with chairs and tables and a bar at one end.

It was crowded with Europeans working out there, all getting the beer down as fast as they could drink it. Because Bahrain was a 'dry' country, the only place that sold alcohol was here at the airport, and then only when an aircraft had landed. So here were all the locals in the middle of the night, drinking as much as they could before the

aircraft left.

The next stop was Khartoum, and then on to Entebbe in Uganda, where our long flight was to finish. We landed at the new airport that Princess Elizabeth was going to open officially in a few weeks time. It had mainly been an uneventful flight, except for the pregnant lady who had started labour when the aircraft dropped 600 feet in an air pocket, crossing the Tropic of Cancer. Laying her out in the aisle, the stewardesses hoped we would arrive at Khartoum before she gave birth: it was touch-and-go, but she made it to the ambulance before having a baby boy.

Leaving the airport, tired out and longing for a shower, we found a car and driver waiting, and were driven to government offices in Kampala to have a short meeting about our assignments, after which we had the rest of the day to ourselves. Both of us were feeling the heat and humidity quite badly already, having left the UK in winter and arriving in Africa just after the rainy season.

Embarking on our itinerary the following morning, we were picked up by car and taken to the first assignment, which was to be a series on prisons. While Alistair did the writing, I went around taking pictures that demonstrated how good the new prisons were, and tried to get enough to make a feature story. Not being a very good pictorial subject to start with, I was not happy with that first assignment. However, I soon got into the swing of things as more jobs opened up, such as the Owen Falls hydroelectric scheme, and several large mining projects. These, coupled with coffee plantations on the slopes of Mount Elgon, gave me the type of pictures needed for magazines such as *Picture Post*, *Illustrated* and *Paris Match*. The next was a story on the tsetse fly, very good if one is just writing about it, but not so good in pictures. After I had photographed flies in the laboratory, and finding there were twenty-three species that carried the disease causing human 'sleeping sickness', I still had no idea how I was going to make a picture feature from something so small. Then, quite by

chance, someone mentioned that white hunters were shooting buffalo to keep two herds apart, as one of the herds was infected with trypanosomes from the fly. We joined up with the hunters to photograph them shooting.

John Jochimsen with the buffalo he had just shot

Having taken a series of pictures, I was asked if I would like to have a shot at a buffalo, as they were still trying to separate the two herds. Taking a Lee Enfield rifle, I found it different from the one I had shot with in the RAF, due to the wood having been taken off under the barrel, making the gun more balanced. As I walked through the long grass, hearing but not seeing snakes as they moved away from me, I got caught up in a thorn bush while the herd charged away. As I took aim and fired, one animal dropped like a brick. The hunter, John Milford, looked at me in utter amazement, saying, 'That shot

was well over 400 yards and you downed it with one round!'
Actually, I was as surprised as Milford. It had been a fluke, but in no
way was I going to let on. So, to prove it to everyone back home, I
had my picture taken with the dead animal!

Ugandan Railway survey team on way to Congo border

I was upcountry for the next job on my own, as Alistair had got a
leg infection and was not at all well. There was surveying for a new
railway line to the Mountains of the Moon, on the Congo border. The
party were all under canvas alongside a small river, and the first
morning I was woken by an African servant bringing me a cup of tea
and two Rich Tea biscuits. Placing them on a small table alongside the
bed, I sat up and ate one while sipping my tea. Lying back, I dozed for
a short period, noticing when I opened my eyes that the other biscuit
was moving across the table, seemingly on its own. Gently lifting it
up, I saw four ants underneath, so putting it back I watched as they
took it to the edge and dropped it over, following it down the table
leg. Getting underneath the biscuit again on the ground, off it went,

with me marvelling at the intelligence of the ants in the way they had captured my biscuit! That same morning when I had dressed, I took myself off for a toilet break. Finding a quiet place away from the camp I squatted down, unfortunately not noticing I had bared my backside to a colony of red ants. They all bit together making me rise rather quickly and throw myself into the river, which I discovered later, after pulling myself out, was full of hippos having their early-morning wash. Between trying to kill the ants and getting out of the water as fast as I could, I left my shorts behind, ending up at the camp with my shirttail covering my finer parts.

Hippos in Lake George, Western Uganda

One of the last jobs we did in Uganda was the opening of Entebbe Airport by Princess Elizabeth, a normal press-type job for me. She

was stopping off in Uganda for the opening and then flying on to Kenya, before going later by boat to Australia with her husband, the Duke of Edinburgh. Alistair and I would catch up with the royal party in Nairobi, cover the royal visit and then carry on with our further coverage of Kenya.

Finishing in Uganda after shooting a lengthy programme on the veterinary side of farming, I had met an old school pal quite by chance, working in a laboratory on a mosquito epidemic. Both Alistair and I were invited by Geoff Thompson to a dinner party to be held in a large house on the shores of Lake Victoria the following evening, the house and land being owned by a well-to-do farmer for whom Thompson worked, overseeing the health of his stock.

The evening went well with about fourteen guests present, and after the port, with the ladies having retired, our host suggested that the men went out into the garden 'to look at Africa'. Wondering why I had to go outside, I followed the rest and quickly found the reason. Everyone was peeing on the grass, so I joined in, and never again wondered what 'looking at Africa' was.

A sergeant in the East African Rifles

The next day we both flew to Nairobi, landing in the evening and staying at the Stanley Hotel, ready for all the meetings that would be held the following day regarding our itinerary for Kenya.

The first assignment was at Government House to cover a garden party for the Princess Elizabeth and the Duke of Edinburgh, being part of the royal visit to Kenya.

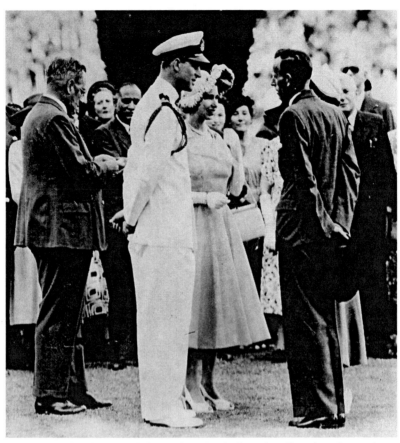

Princess Elizabeth and the Duke of Edinburgh talk to local people at the Garden Party held at Government House , Nairobi in 1952

Princess Elizabeth and the Duke of Edinburgh
talk to local people at the Garden Party
held at Government House , Nairobi in 1952

I had brought a lightweight suit with me but had to buy a trilby hat for the occasion. This is where my training in Fleet Street came into its own, working my way in between the local photographers to get the shots I required. It was then that I realised that two of my friends from Fleet Street were also there, Stanley Devon from *The Sunday Times* and Chris Ware of Keystone Press. Like all good pressmen, after we had got the shots we wanted the three of us sat down to tea and cakes, having worked out that we were going to be together during the rest of the royal tour in Kenya.

Princess Elizabeth in the garden at Santana Lodge

Next day we were all there again for the royal inspection of the King's African Rifles by the Princess. As she walked the length of the front rank of soldiers, all of us press were at the end of the line, waiting for our pictures of her talking to a man nearer us. I was ready with the Speed Graphic with a blue flash bulb in the gun for a colour shot. I was using flash as the sun was directly overhead at that time of year. It would light up her face under the hat she was wearing. Unfortunately, the bulb I picked had a fault and when I took the picture it exploded with a loud bang. The Princess looked up, thinking it was a shot, while all the others got the picture. I felt really bad for

having been the cause of confusion; however, I managed other pictures, as she had to walk up and down three long ranks of soldiers.

A policeman stands guard at Sangana Lodge,
Princess Elizabeth's wedding gift from the Colony of Kenya.
(note his boots on the path ahead of him)

Next day both royals were looking at racehorses, while the number of photographers had been increased with all the local men. It was a real scrum, something that we London men had never witnessed before. We had always been used to working out the pictures with one another, but this was different, so much so that the Duke looked straight at me saying, 'I will be taking my own bloody picture next!'

All I could say in reply was that the locals were out of control and that it was nothing at all to do with the London photographers.

After another day of pictures, with much the same problems, the accredited photographers and journalists moved up to the Outspan Hotel at Nyeri, leaving behind all the local men. The Princess and her husband had been given Sagana Lodge on the slopes of Mount Kenya as one of their wedding presents from the Colony of Kenya. This was very near Treetops Hotel, where the two were staying for a few nights, watching the animals drinking from the lake.

The next day there was a press call for pictures of the happy couple watching the wild animals. These pictures were shot in the morning, leaving the royal party the rest of the day to themselves. Those working for newspapers or agencies quickly wired their pictures back, while the journalists did the same with their stories. I didn't worry about wiring, because my pictures would be used at a later date. I would send my undeveloped films on a plane back to London directly I returned to Nairobi.

While at the lodge the Royal couple cross the primitive bridge that spans the Sagana river. At Treetops, where they stayed for two nights, they watched all the wild animals drinking.

That afternoon, Chris Ware asked me if I would like to come with him to a place where some white rhinos had been caught, as he thought his agency would be interested in the pictures. Hiring a taxi, we went to where 'Bring them back alive, Buck' had these animals corralled. When we arrived the rhinos were in a large open pit six feet or so deep, where they couldn't escape. The land they were in was full of termite mounds at least four or five feet high. Chris went and talked to Buck, an American who made a living out of catching wild animals for zoos. He told Chris that they were only young and that he could go down to take pictures of them. I, feeling a lot safer just watching from above, had a feeling they were not that gentle and could be rather nasty. Rhinos have very weak eyes but a great sense of smell, so directly Chris was down among them, they knew. Then followed a dance between the termite hills and rhinos, with Chris playing hide-and-seek behind the mounds to get away from them as they charged. I started to laugh and it seemed the more I laughed the more Chris ran to get out of their way, as they tried to rush him with their heads down. Eventually I was crying with laughter while Chris had to be rescued from the animals he had been told wouldn't hurt him.

When my friend came up, worn out from rushing around in the heat, he said to me, 'You must have known something I didn't.'

I replied as I wiped my eyes, 'I just thought it looked too dangerous,' and left it at that.

The next day was free so most of us press took the time to get some extra sleep, as it had been a very late session in the bar the night before.

At five minutes past two that afternoon, Granville Roberts of the *East African Standard* took a phone call from his paper in Nairobi to say the King had died. I happened to be walking out of the restaurant at the time and picked up the news with all the shouting. A photographer from a South African paper, Stan Devon and I hired a taxi to take us to Sangana Lodge, hopefully to photograph Princess Elizabeth, now

105

Queen Elizabeth, leaving for London. Having got ourselves outside the lodge we were determined to wait until the cars drove out to get our shots, but before this could happen an official came out to tell us that Her Majesty requested no pictures to be taken. We three photographers stood silently outside the lodge as the cars drove away in a cloud of dust, not one of us taking a shot at that historic moment. Here, seeing the young girl as Queen of Great Britain as she drove away, I felt her sadness, as she just raised her hand to the three of us as we stood there silent, our cameras on the ground beside us. I still feel to this day that I was one of the first to see the Princess as Queen, and the sight of those cars with Her Majesty waving at us so sadly was a moment I will never forget.

The rest is history. The Queen drove to the nearest airfield at Nanuyki and boarded a Dakota aircraft that flew the party to Entebbe. This was because the runway was not long enough to take a larger aircraft, like the Argonaut, which was coming in from Mombassa. There was a rumour around at the time that the crew that had brought the Princess over had been in Mombassa, and had to be searched for as they were not expecting to fly for two days. When they were eventually located, it was said that coffee had to be poured into them, as they had enjoyed quite a night the evening before. Perhaps this is why the Queen had a two-hour wait at Entebbe, who knows?

There were other rumours, one being that the Governor was on his way to Mombassa by train to see the couple off to Australia, and had his codebook with him. When the news came through to Government House of the death of the King, it could only be confirmed that the message had arrived but not decoded. When confirmation came from Kenya the news was released worldwide, on the assumption that the Princess knew of her father's death, which at that time she didn't.

Alistair and I went back to Nairobi the following day to pick up on the rest of the assignments in our itinerary. All the other photographers and journalists who had expected to go to Australia had no money to

get home or stay in Kenya, because they had spent it all expecting to pick up more on the ship. Alistair and I, being the only two with rooms in the Stanley Hotel, had four of them sleeping on the floor in each room overnight until they got their money telegraphed the following day.

Our itinerary took Alistair and me to Mombassa. Having been given a Studebaker for the duration of our stay, an open-backed truck with a lockable cage at the back, and an OHMS number plate, I drove through the game reserve with him navigating.

The roads were of red muram, with large corrugations due to the amount of traffic using them. I soon discovered that if I didn't want to be badly shaken, a constant speed of something approaching forty miles an hour was the only way, as then I was driving on the peaks formed by the corrugations. We passed a sign saying 'Elephants have the right of way', which both of us thought was too obvious for words. However, soon after going round a sharp bend, we came across parts of a car littered all over the road with the engine block the only recognisable bit. Slowing right down as we picked our way between the debris, a man suddenly seemed to jump out of the ground and waved us down. He had been hiding in a ditch because he had come round the corner fast and hit a young elephant. Luckily he had the sense to get out and hide while the mother made short work of his vehicle. We gave him a lift to the next village, with the man thanking us, saying he was only too pleased to be alive. After that both Alistair and I thought perhaps that sign wasn't so silly after all.

I had been advised to carry a rifle while going through the game reserves, so I had bought one before leaving town, thankful we had something to keep the animals away. Stopping halfway through our journey overnight at a small hotel, we carried on the next day, arriving at about three in the afternoon at Mombassa, ready for work the following day.

John Jochimsen in Nairobi for the
East African Standard 1952

The assignment was the Muslim Technical Institute, and a show of all the dhows that were in the harbour that had come down from the north to trade. It would take two days to complete, so I decided to go swimming at the club early the first morning, to get some exercise, having driven all the way from Nairobi. Changing into shorts, I swam from the swimming club out to a moored raft about 300 yards from shore. Lazing on my back, letting the morning sun dry me, I heard someone shouting. Sitting up, I saw a man on the shore waving his arms, shouting at me to come back. So I swam back, thinking how lovely it had been, sunning myself on the raft.

As I walked up the beach the man said, 'Thank goodness you're

back safe, we haven't put the shark nets out yet.'

The feeling of bonhomie left me at that point and I never swam in the sea again while in Africa.

From Mombassa, the next job was at the base of Kilimanjaro, a mountain of just under 20,000 feet with twin peaks that were covered in snow all year round. Here we were to climb part the way up with a group of schoolchildren of different races, showing and proving that all races could work together, especially when young. As we drove that day through the reserve, we saw lions and gazelles together with elephants and giraffes. We stopped occasionally and got out to take pictures of the animals, as they were so close to the road. As we got back in the truck, two leopards came out of the long grass, one jumping on the bonnet while the other rubbed itself against the bumper. Because of the heat, Alistair had opened the windscreen to let the air in, leaving a five-inch gap that the leopard took as a way to get at us inside the cab. It put its paw in as far as it would go, to try and hit either of us, as we both went as far back in our seats as we could. Snarling and getting more frustrated at not reaching us, it jumped off. Not waiting to see where it had gone, I drove off with all speed, winding the windshield shut and thanking my lucky stars it hadn't been open further.

Arriving and leaving the truck at the Lion Hotel, Liatokitok, we met up with the group and started the climb, first passing through jungle before getting higher up the mountain. As we were walking through the trees, our guides told us to be silent, as they had heard elephants not far away. Everybody crept forward as silently as possible, so as not to let the animals hear us. Once out in the scrub, it was possible to see any other dangers, as we were now higher up the foothills where wild animals were fewer. Up and up we walked, the mountain just a gentle slope most of the way up. But as we got higher, the air became more rarefied. I had taken some great pictures while in front of the group, but even I was feeling the lack of oxygen. We

109

stopped for the night in a cave, got a fire going and cooked food for all the young children as well as for the guides and ourselves. We slept very well that night, and in the morning after breakfast we continued the climb until halfway up to the saddle between the twin peaks, where we stopped. It was far enough, the air was now too rare for comfort and it was cold. It was time to descend, especially as the lack of oxygen was affecting some children quite badly.

When we all got back to the vehicle, I discovered that the herd of elephants we had heard on the way up was no more than another group on their way down. Both groups had been told not to make a noise, so they had crept through the jungle past each other.

Before driving off, I thought it a good idea to reload the film in the slides. I went over to a nearby tree to sit in the shade and started working in my black changing bag, taking the exposed film out of the slides and putting them in a box. Unzipping the bag, I took out the empty slides and the box with the exposed film, checked the film holders and put them back together with a new box of film, to reload. As I put my arms back in the bag, I looked up and saw I had an audience of small African kids. I then realised what they must be thinking, as it must have seemed like magic to them with my arms in a black bag, fiddling about, mostly with my eyes shut. I could see their look of anticipation, as if I was going to pull something out, like a rabbit. When I had finished I opened the changing bag, showing them it was now empty, then got up and walked back to the truck. I could never forget that group of small children, something so normal to me must have seemed like magic to them. I often wondered what they told their parents about the mad Englishman who sat under a tree with his arms in a black bag and his eyes shut.

Navigating the 'closed' road from Kilimanjaro

We had to get permission to take the road to Himo in Uganda because it had been closed during the rainy season, which was now over. Alistair went to see the District Commissioner and got it agreed, while I repacked the truck with my precious exposed film. Also in the back was a piece of equipment called a Tanganyika jack: this consisted of about three feet of wood with a large screw going through, a handle at the top and a small platform that moved up and down when the handle was wound. This would be used for lifting the truck higher than any normal jack would. I had never had to use it yet but it was going to be the only piece of equipment we would be needing on that drive.

Starting down the road, it soon became understandable why the road had been closed. Lorries had made two large trenches in it, which were wider apart than our truck's wheels, so with the wet, slippery muddy surface we kept sliding into them. Sometimes we could manage to drive out but mostly we had to use the jack to lift the back of the truck up. Then with a big push it would, hopefully, land away from the trenches, while the front of the vehicle was treated in the same way. This went on for miles, as the road was empty and closed, until on one occasion some natives appeared from nowhere and pushed us out. Alistair gave them money, but as they couldn't write a receipt, and as this happened many more times that day, I had to take a picture to prove the expenditure every time. Getting stuck went on all day, with the jack sometimes used and at other times the locals pushing us out. Once, we passed a bus on its side with all its passengers outside sitting on it, waiting for the next one to come along, but I never knew if another did ever pick them up.

When it started to get dark and we had got stuck again more times than I could count, both of us had had enough. Alistair said he would go back to the last village we had passed and get help, but that might not be possible before morning. I was left stranded in the middle of the road for the night, hoping that no other vehicle would come from either direction, as I did not want to leave the protection of the cab. After an hour, I knew I was there for the night in the middle of nowhere, entirely alone. Winding both windows shut to keep the insects out, I went to sleep nursing my rifle, hoping that nothing would happen during the night.

I woke in the morning with the truck rocking in all directions, not able to see out as the windows had steamed up as I slept. I wound the window down and couldn't believe my eyes. There was I, covered from head to foot in dried mud, while standing before me in the middle of nowhere was an African, dressed in trilby hat, white shirt, Oxford tie, grey flannel trousers, highly polished brown leather shoes

and an Oxford blazer. Raising his hat and speaking in the most cultured English, he said, 'I have just brought some of my men along to help you, as I was told of your predicament. I am the chief of the local tribe and we will get you out.' Stuttering my 'thank you', I was still not sure whether I was dreaming or asleep. Very quickly I knew it was real, as, releasing the handbrake, I was pushed to the top of the hill we had been trying to negotiate when we had last got stuck. The chief then said that Alistair would be along in a minute or two, when he had finished his breakfast. I was miffed about that as I had had nothing to eat, but was surprised when my partner turned up with some over-cooked sausages. These I ate while talking to the chief, who told me of a convent two miles up the road, where we might have a bath and change of clothes. Saying our goodbyes to our rescuers, we drove the further two miles without any more trouble, ending at the convent's front door looking like a pair of wandering nomads. Not only did we get a bath but our clothes were taken from us, and returned washed and ironed. We were both very tired, so, after being asked if we would care to stay the night, we agreed. Leaving the next morning, we thanked the nuns for their very kind hospitality and the food, which the Reverend Mother would not let us pay for. So we left some money in my room, to be found after we had departed.

Driving on, seemingly out of trouble now, it still took us time to get over the help and friendliness that everyone had shown towards us, as two lost travellers. As we continued on our journey we drove over quite a few large pythons that were sunning themselves across the road. These snakes could be anything up to thirty feet long, and going over them was like going up a curb, as they were up to eight inches thick in the middle. We were told later the only way to kill them was to skid over them. However, neither of us felt like doing that as these creatures were just resting and sunning themselves, doing no harm. Often a black or green mamba would chase us in a serpent-like fashion alongside the truck, reaching up to thirty miles an hour,

keeping abreast of us. These snakes were very dangerous – one bite and you were dead – so I soon learnt that if you drove over one, you wound the windows up immediately, as they had a habit of curling round the axle as you went over them and coming up into the cab to attack you. Before getting out of the truck, I would always ask someone to look under the vehicle in case one was still there, waiting to bite me as I stepped down.

The last assignment in Kenya was at the White Fathers' Monastery on the Athi River. The truck by this time had a coil that, unless you wrapped it round with a wet cloth, had only two speeds – stop or go. That was fine but in the heat the cloth kept drying out, so it was a stop every two or three miles to soak it again. Also the chassis was cracked in a couple of places, due to the beating it had had, which sometimes made us think we were going crabwise. Other than that it still went, but for how much longer was anyone's guess!

We had nearly arrived at our destination when a bullet went through the top of our windscreen. I wasn't driving and my first thought was 'some silly bugger can't shoot straight'. Just then another shot ricocheted off the roof of the cab, making us both realise we were the intended target. Alistair either put his foot down or the coil had lost its wet cloth, because we started to motor like never before. I wound my window down and having spotted where the firing was coming from by the smoke from the gun, I started firing back. Nothing else hit us and I was sure I hadn't hit anyone either, as the truck had been bouncing around so much that all I could think was that it was like a Western, with me as the guard, shooting from the stagecoach. Half an hour later we arrived, very flustered. The engine just died as Alistair lifted his foot off the accelerator, knowing it wouldn't start again until the coil had cooled down.

The White Fathers were a great group of people, and so pleased to see the two of us. That evening they laid on a good meal, all sitting round a long table and everyone talking at once. They wanted to know

where else Alistair and I had been and the kind of stories we had covered. The conversation got round to the shots that had been fired at us, and they all agreed it must be the Mau Mau. Neither of us had ever heard about this but it appeared that the Kikuyu tribe was to blame. The fathers hadn't realised it had got that bad so soon, and the feeling among them all was one of extreme worry. For three days we stayed at the monastery, listening to the fathers' reasons for being so cut off from everything, while my pictures depicted them working among the natives and helping the families that were reliant on them for a living. It wasn't until the second day that I found out why the monks were trying to keep us there. It was because when they had visitors they were allowed to drink – hence they were very happy to have us.

We had to leave on the third day to keep to our itinerary and get back to Nairobi, as we were due to fly to the Sudan within the next two days. Luckily the journey back was more restful, with no one shooting at us again, though our truck was starting to fall apart – understandably, considering what it had gone through. We came into Nairobi in the rush hour, having to go at full speed to avoid stopping, and perhaps never starting again. That evening we had arranged to have dinner with the owner of *The Citizen*, Bobby Nahdo, whose newspaper was published once a week. We had met him on the royal visit and had tried to arrange the dinner before. However, it was a great meal and over it we told him of the shooting and the Mau Mau. When the story was published at the weekend, it was picked up by most of the papers, both there and abroad, a story that Alistair and I had initiated as two visitors who had been shot at.

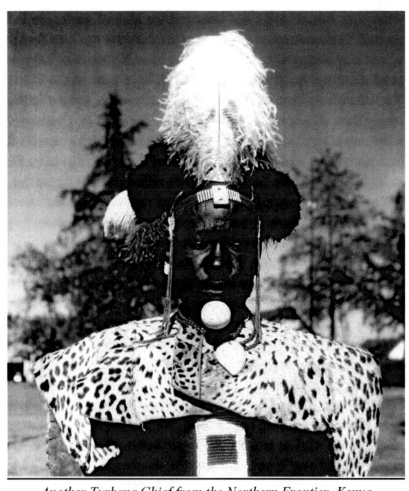

Another Turkana Chief from the Northern Frontier, Kenya

Chapter 8

We arrived in Khartoum in the middle of the afternoon, both noticing the distinct change from the lush trees and pasture of east Africa. Flying in to land, the desert sands took over from the green vegetation we had left behind, with sand blowing around as the aircraft came to rest. As we made our way to the arrivals building we looked around, but could see only desert in every direction, making the landscape flat and very uninteresting.

Having gone through customs with all the camera equipment, Alistair and I were met by an official from the Foreign Office in the Sudan. He had a car waiting and as soon as the cameras and luggage were aboard, we were taken to the government offices in the town centre. Although this was the Anglo-Egyptian Sudan, all personnel seemed to speak English and we never saw anyone from Egypt during our whole time in the country.

As in the other countries, we had a meeting about our stay and the work we had to cover. Finishing at about seven o'clock that evening, we were taken to our hotel, the Grand, overlooking the Nile. Here we were able to have a shower and bath, change our clothes and be ready for a meal with the two people overseeing our itinerary, which started the following morning. Going to my room after our guests had left, I went through the cameras again just for a final check, realising that the sand was going to play havoc with the Rollieflexes because of their winding mechanism. These two cameras would have to be kept covered and used only when the wind was not blowing the sand around.

Our first assignment the following morning was further down the Nile, in an area called the Gezira, where cotton was grown thanks to the nearness of water from the river's irrigation. Driving down, we were to meet with a farmer who spoke English, who would explain the intricacies of his crop. We passed caravans of groaning, overloaded camels kicking up the dust from the desert as they plodded

117

along, all strung together. Further on we came upon a small group of people with telescopes, some as long as ten to twelve feet. Stopping and talking to them, we realised that this day, 25th February 1952, was the day of the full eclipse of the sun, and that we were there at the right time, where it was all happening. Neither of us had been told of this or that most of the world's top astronomers were there to witness it. Here was a great story neither of us had expected, so while I took the pictures Alistair interviewed some of the scientists.

As the light started to fade with the moon covering the sun, the dim light that was left began to turn dark green, with the birds stopping singing as they went to sleep. The Arabs dropped to their knees praying to Allah, making the only sound, while everywhere else was silent. The full eclipse lasted for three minutes before the light started to change back to its normal colour and the birds awoke and started to sing again. As the locals got up off their knees, excited voices were heard all around from the experts, who were ecstatic at the outcome, saying that it was one of the finest eclipses they had ever seen. I had taken some colour transparencies during the eclipse, showing the peculiar colour of the light, with the scientists glued to their telescopes and the locals all on their knees praying.

After that excitement, the rest of the day was taken up with the story on cotton, so having finished late, when we returned to the hotel, I decided to go to bed early again, feeling very tired. Closing the door of my room I spotted something on my bed, looking like a ball of white fluff. It was a small white kitten that was sound asleep, and where it had come from I couldn't think. Leaving it to sleep, I got washed, undressed and into bed. Being so tired I was immediately asleep, but woke some time in the night with something moving around on the bed. Opening my eyes, I could see in the moonlight it was the kitten, hopping around a large scorpion that was advancing towards my face. Falling out of the bed and grabbing the kitten I opened my door yelling for someone to get rid of the intruder. A

servant came almost immediately, and when I showed him the scorpion got hold of it by the tail and took it away together with the cat. I had a quick look round the room and under the bed to make sure there were no more uninvited guests before examining the bedclothes and getting myself settled down again. I remember thinking to myself so much for an early night, as I fell asleep the second time, knowing if it hadn't been for the kitten I might have had a very nasty bite. From that day to this I often wonder where that little kitten had come from or why it was on my bed, and would probably never know the answer.

A few days later, having done a couple more assignments in Khartoum, Alistair and I were walking along the Nile with a man called Terence from the office. It was a sandy foreshore, about six feet wide, ending in a bank, eight to ten feet high. We had all just finished lunch at the hotel and were walking along stretching our legs, talking about the next job, when suddenly, without any warning, a crocodile launched itself off the bank, straight over the top of us, and landed with a great splash in the river. It must have been over six feet long and could have landed on top of us, but luckily it missed with its great leap from the bank. The reason, we were told afterwards, was that we had been between it and its home, the river.

Our next assignment was miles away, so we were flown in a De Havilland Dove to the borders of western Sudan and French Equatorial Africa, to witness the yearly homage paid to the British King by the nomad tribes. This was to be the last gathering ever of its type and the natives hadn't realised that it was now the British Queen, the King having died earlier, which nobody had told them about. This was due to the difficulty of finding them, as they were always on the move. For two days we were shown horse- and camel-racing, with women dressed in beautiful coloured silks riding and sometimes even racing some of the camels. We both said afterwards that it had been something that very few white people had ever seen, or would ever see again. I got some really great colour shots, together with several

119

black and white as well.

We were supposed to pick up a truck to continue our assignments on our way back towards Khartoum, as the aircraft had left. However, I had not been too well for a few days and after managing to complete the assignment I saw the local doctor, who put me into hospital with a bad attack of sinusitis, together with a high temperature, needing daily injections of penicillin. I was put in a ward that was supervised by a male nurse, who was to inject me with the antibiotics twice daily. As I had experienced this trouble many times before I knew about the injections into the backside, but the nurse could not speak a word of English. He would always come with a long blunt needle, until with an aching backside I induced him to get a new smaller one, my bottom feeling full of holes from its predecessor. Any ordinary person would have realised after the first unhappy exploit that a new needle was required for each injection. But not this one! He tried every time first with the long blunt one, before using a new shorter one. After three days my backside looked and felt like a well-used dartboard, but I had to put up with it till the treatment was completed. For the last two days I gave up trying to tell the nurse and gave in gracefully.

Not only did I have to contend with this, but Alistair came in to the hospital one evening to tell me he was going home to his wife, as he missed her so much and couldn't bear to be away from her any longer. Saying he had managed to get a lift back to Khartoum, he brought in all the relevant paperwork for me to continue the trip with the cameras, while collecting the exposed film to take back with him to London. So there I was, in hospital, my partner going home, knowing I had to finish the rest of the work, including the writing, on my own.

I got out of hospital two days after Alistair left. Taking the truck, which had been left for me, I asked the way to my first assignment at El Fasher. I was told that the only way to get there was to follow the countless empty beer bottles thrown down by camel riders, as there were no signposts in the desert. Starting off alone with a brand new

vehicle that had sand channels provided and a motorised air pump for blowing up the tyres, I set off towards where I hoped El Fasher was, following the beer bottles, but relying on my compass as well!

Arriving at the District Commissioner's house on the outskirts of the township, covered in the sweat that was seeping through my khaki clothes, and blessing the Arab who had told me to hang my water container on the truck's radiator to keep it cool, I entered, and got the container refilled. The bag was made from animal stomach, which allowed the water to permeate through the skin and be cooled by evaporation during the forward motion of the vehicle.

Meeting the Commissioner, I was told I had to dress for dinner, even with just the two of us out in the middle of nowhere. Searching through my clothes, I found my dinner suit at the bottom of the case in a very sorry state, but luckily the Arab servant managed to make it look a bit presentable. After I had a bath and as I got dressed, I started to understand why the dinner suit was so important. I felt it was because the man wanted to keep up a civilised way of living and not go native during his time in this out-of-the-way place, having very few visitors to keep him sane over his two-year engagement.

We sat, one either end of the table in the candlelight. Just as the main course was placed before us, a great rushing and moaning sound started, the precursor of a sandstorm. As the room filled with fine dust, which developed quickly into a fog, the commissioner opened a drawer in front of him, put his meal in it and shut it, then took the coaster from under his glass and placed it on the top of his drink. I did the same, as if the most natural thing in the world, then began to wonder how I was going to eat my meal. I saw my host quickly open the drawer, take a forkful, pop it in his mouth, and immediately close the drawer again, all without a word. I said nothing, but wondered if my thoughts had been correct regarding the wearing of the dinner suit, or was it just for the British Raj?

The next day it was back to prisons again. A new one had been

121

built in El Fasher with British money, this being one subject that I had to photograph and write about. The desert sky seemed always blue, with not a sign of a cloud in sight – in fact it always appeared like that until I was introduced to the local rainmaker. I was told that the man could create a downpour to help people irrigate their crops, but I was not ready to believe this without proof, being very sceptical about the whole thing. There was a pile of rocks that stood about fifteen feet high nearby, which was called a jebel, but nobody could tell me how or why it was there, only that it had been there for many years. The old man seemed to need to climb to the top to make it rain.

Struggling to the top, he opened his arms to the sky and started chanting in a kind of singsong voice, while I took a couple of shots, waiting for the rain to appear. I had looked all around the sky before the old man had started, noting that there wasn't a cloud in sight, but as he threw his arms up for the last time a black cloud appeared as if from nowhere, and it started raining. I was completely flabbergasted. Where had the cloud come from, and the rain that lasted for no more than a couple of minutes? As the latter disappeared, and the old man climbed down, he smiled at me, and walking away almost seemed to say 'I told you so.' I had seen the rain and photographed it, but I still couldn't believe what I had seen, as the sky was now as blue as it had been before, with not a cloud anywhere in sight.

The following morning I left, driving towards El Obeid, still wondering what I had or hadn't seen happen the previous day.

Arriving for a stay with another Commissioner, and thinking I would be using the dinner suit again, I had hung it in the truck so as not to get it creased. However, there was no need for the care I had taken as nothing was said about dressing. In fact this Commissioner seemed to me to be an altogether different type to the last one, a man who I thought could cope with anything. After evening drinks outside as the sun set, he was perfectly normal until the crickets started their clicking. Now he got up and started yelling at them, grabbing a

bullwhip and cracking it until they stopped. Then he sat down and carried on with our conversation. The insects' silence lasted only a matter of seconds before it started again, and with that he went through the same performance, stopping only when the servant came out to tell us dinner was served – otherwise I felt this whole mad episode would have carried on much longer. We ate a really good dinner with the two of us talking about the next day's assignments in a perfectly rational manner. Then, while finishing coffee, I saw a very large toad flop in through the open door, and as I watched it started eating all the flying insects it could reach with its long sticky tongue. Nothing was said, and when it had eaten its fill it went out. Before I could say anything another came in and did exactly the same thing. As that one disappeared, I couldn't hold my tongue any longer and asked my host about this peculiar occurrence.

Dipping sheep in the river Sudd to cool them down in Juba

'They are my friends,' the man said, 'the first was Auntie and the second Fred, they come in every night and keep me company.' After that I thought he was not so different from the other Commissioner at El Fasher, and I said no more about the toads, let alone the crickets!

I slept that night on the flat roof of the house in a kind of cage that kept insects or burglars out. It had an outside staircase to it and I was told to leave my clothes and cases in the house and go up naked after my bath. This I did and was soon asleep, waking in the morning to the noise of hundreds of camels and the yelling of their masters. Propping myself up, I saw I was in the middle of a camel sale all around the house. Naked, and with nothing to cover myself, and having to negotiate the stairs down in the open, I snatched the bed sheet off and wrapped it round myself like a Roman toga and walked down, looking neither left nor right until I got into the house.

My job that day was a new hospital that had only just been fitted out, and was controlled by a British doctor with local nurses. It was really modern, the finest I had seen on the trip so far. Photographing and asking questions as I went round with the doctor, we came across a small side ward with four healthy-looking southern Sudanese Dinkas, their skin a lot blacker than that of the Arabs I had seen since arriving in the country. I asked what was wrong with them. The doctor replied, 'Nothing.' I was told that the juju man had put a curse on them and the doctor said they would all die tomorrow. I was mystified when told the four perfectly normal and healthy men would die, as I still couldn't get my head around the African dependence on witchdoctors. I couldn't get them out of my mind. Why did they believe what they had been told, or was it just a type of hypnosis?

The following morning, when I had finished all my work at El Obeid, and was about to drive back to Khartoum, I asked my host about the four men in hospital.

'They all died this morning,' the Commissioner said. 'I had a word with the doctor about something else and he told me you'd be

interested to know.'

I was beginning to think that these assignments had some very funny twists and turns, as I drove off once more across the desert, following the empty beer bottles.

Back at the hotel in Khartoum, I emptied the truck and got the cameras and suitcase taken to my room. I had a couple of days off, which I felt I had earned, so I started by having a good meal and an early night, hopeful of not having any more problems while asleep.

Two days later I was ready for another lengthy trip, a drive to Port Sudan. I started off early in the morning when it was cool, knowing I had to arrive at Ed Damer by nightfall, where I would stop in what was a basic government rest house that night, and be away early, driving to Sinkat for my next assignment. Driving around the bends in the foothills of the Red Sea hills, I was amazed to see a small detachment of British Army troops under canvas. But that wasn't all. As I stopped I was even more surprised when I saw an officer whom I had known slightly, coming towards me. He had been at RAF Nuneham Park in tri-service photo intelligence. Although the major didn't recognise me at first, as I had been only a corporal in those days, he soon realised, when we both started talking about aerial pictures, that we had been together back in 1949.

'This merits a drink,' said the officer and led me into his tent. Out came the whisky, and soon the conversation flowed as the drink disappeared. I'd had nothing to eat since breakfast, and the whisky had quite a soporific effect on me, so when I was asked if I had ever ridden a camel and would I like to, without thinking I said yes. From somewhere a camel was produced, and I, more than a little worse for wear, mounted. Getting on while the animal was lying down, it half-rose on its front legs, while I leant forward thinking this camel riding was easy. Unfortunately, I didn't realise it would now fully rise on its hind legs, catapulting me over its head, and landing me facedown in the sand. As I turned over, the camel brought its head down to see

what had fallen off its back, giving me a great belch in my face to show its displeasure, while soldiers who had now appeared from nowhere all cheered. Needless to say, I slept that night under canvas, thankful that I didn't have to drive again that evening.

In Sinkat the following morning I was met by another District Commissioner, telling me the programme had changed and that now I was to cover the funeral of a very important religious woman, who had just died. Thinking that this wasn't going to be a load of fun, and wouldn't make good pictures, we two drove a few miles to the village of Erkowit, high up in the Red Sea Hills. Here I was introduced to the head mullah, who gave permission for the ceremony to be photographed, though a lot of the Arab tribesmen had objected. I had never seen anything like it before. There were at least a hundred women dressed in silks of every imaginable colour, who followed the body, also wrapped in coloured silks. The women who followed were throwing themselves in the sand, then getting up and throwing the sand all over their heads, and at the same time singing, yelling and screaming as the whole procession moved forward. I was using the two Rollieflexes, and shot most of it in colour with only a few shots in black and white. When it was over I was exhausted, having chased around as the whole procession had moved forward about a mile, ending when the body was laid to rest. That they were some of the best colour shots I had taken on the whole trip was borne out later when three pages of them were published in full colour in the weekly magazine *Illustrated* back home.

I drove to Port Sudan to do a series of pictures about the port, showing merchant ships loading and unloading, and collecting facts about the trading as I went. The ships were all moored along one quay, about fifteen in all, hard at work with the native workers in only loincloths, due to the excessive heat. As I photographed I had to dodge the cranes lowering sacks of goods, looking up constantly to make sure I was safe. Making my way along the line of ships, and

finding different subjects to shoot, such as vehicles being swung aboard, I saw that all the men where covered in sweat due to the high temperature under which they were working. When a full net of bags of cement hit the ground with most bursting, the powder turned the Arabs into white men as it stuck to their sweaty bodies.

Nearing the end of the line of ships, I heard someone call to me, 'Hi, you, with the camera, want a beer?' Looking up I saw an officer on the bridge of one of the ships waving to me to come up. Not averse to a beer in that heat, I went up into a large air-conditioned cabin with ice-cold Beck's. Having finished with the cameras, I settled down for an hour or two, in great conversation with the British crew, and quite a few bottles of cold Beck's, a real treat in the Sudan. I was asked if I would like to stay the night, and without having to think I agreed and thanked them, and carried on drinking.

Wishing them goodbye, and thanking the officers in the early morning, I put my camera case in the truck and drove to Suakin, my last assignment in the eastern part of the Sudan. The town, I had been told, was deserted, as over the years the Red Sea had receded and was now a distance away, leaving the place empty, looking as if the people had only just left.

Leaving my truck outside, I walked through the archway into the silent and deserted town where the sand had taken over, drifting up against buildings with the hot wind. As the place was deserted, except for wild dogs and snakes, I had been told to carry my rifle, which I had slung on my shoulder. It was eerie with only the sound of old creaking window shutters that half hung off the buildings in the breeze, interspersed with screams of wild dogs. There was no movement and not a person in sight, though all the houses and shops were still standing, and remained as their occupiers had left them all those years ago, due to the very dry and high temperature and no rain. One expected someone to appear and open the shutters, but not a soul existed in the place.

After an hour, I knew I had shot enough pictures, never daring to enter any of the buildings because of the snakes. I found my way back to the truck. As I had walked I had been conscious of looking over my shoulder all the time, making sure nothing was following me, and I was very relieved to get out of the place. Although it was the middle of the day, I knew I could never be there at night, as I had felt evil all around me, as if I was being surveyed.

Driving back to Khartoum, after spending another night at Ed Damer, I was passing through the village of Shendi when I stopped to watch something unusual happening. There were two rows of about ten local men of the Hadendoa tribe facing each other, and in the front of both lines sat another two, one each side, obviously the captain of each team. Beside each man was a pile of small twigs plus a wooden club. The two captains started by throwing twigs and insults at each other, while the two teams also exchanged insults, with everybody throwing twigs at the other side. When the twigs were exhausted and all the players were yelling with anger, the main part of the game began, with all grabbing their clubs and rushing at each other, hitting anyone on the opposing team. It was a bloodbath, and the battle went on until there was only one man standing. I was told afterwards by a local who could speak a little English that the side with the last man conscious had won, leaving all the rest in need of medical attention.

The next morning in Khartoum I was driven to the airport again where a small plane, another De Havilland Dove, would take me to a section of the Sudan Defence Force, way out in the desert. They spotted the landing strip by the smoke from a fire that had been lit to show the wind direction, having to do a low pass over it to get the sheep off the runway. The two pilots and I were picked up by an army lorry and taken to a small fort in the middle of nowhere, looking like something out of *Beau Geste*. Here we were met by the English bimbashi, who was Commander of this section of the Camel Corps. He, Clive Meadows, had been a captain in the Coldstream Guards

when his regiment gave up horses for tracked vehicles, so he transferred to the Sudan Defence Force, which still had horses.

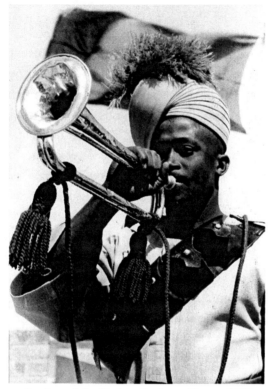

Bugler of the Sudan Defence Force 1952

We were taken to his house, which stood alongside the fort, surrounded with its own wall about five feet high. The crew of the plane were staying until I had finished the assignment, as they were then taking me on to Juba in the south.

That afternoon, I concentrated on pictures in and around the fort, ending with a charge on horseback by the whole troop coming towards me, with the fort in the background, while I was standing on the back of the lorry to get some height. I asked Clive later when this

formation was last used. He replied, 'Never, but it's a lot of fun.' Seeing forty or so horses and riders coming towards one with guns and swords waving, I didn't think was a lot of fun, but I had to admit it did make a good picture.

That evening the four of us drank quite a few bottles of beer after dinner, and I was the first needing a pee. I asked where the toilet was, and Clive informed me, in his inebriated voice, that it was out in the wall that was around the house and pointed me in the right direction. I started walking across the sand towards the wall, shining the torch down so as not to trip over anything. The next moment, I was flat on my back with some unknown animal standing over me, loudly purring like a cat, which it obviously wasn't. Thoughts were flashing through my mind of getting my throat torn out by this wild animal when it got off me, and started rubbing itself on my body. Not having to worry anymore about where the toilet was, I managed to get hold of the torch, which was still shining, to see what the hell had attacked me, while sobering up very fast. It was a full-grown cheetah, insisting on rubbing himself on me. Tentatively I stroked its head, wondering how I was going to get up and away from it, though it seemed pleased to be with someone. As I made my way back to the house I saw that the cheetah was on a running lead from a cable stretched between two poles, and as I walked back the animal walked beside me until curtailed by the length of its lead. Telling my host about my meeting, he informed me I was lucky I hadn't gone the other way, as there were three large lion cubs on leads, which were not at all friendly. As the cheetah had so taken to me, and having by this time got over my fright, it was arranged that it would sleep under my bed for the next two nights I was there. I had two very peaceful nights with the cheetah in my room, making a lot of fuss of it before going to sleep, and in the morning taking it out on a lead for a walk. I had quickly learned to keep away from its claws, as cheetahs cannot retract them and could cause a very nasty injury with them unintentionally. After

the walk that first morning, I was looking around the house at all the other animals in the enclosure when I suddenly knew I had to find that elusive toilet, and so went into the little hut in the wall, raising the seat and banging it down, making sure there were no scorpions underneath. I sat down. Having been there for only a few seconds, there was a draft up my backside and the bucket disappeared. I yelled and it came back, allowing me to resume my contemplations in peace.

Clive had a zoo in his garden consisting of lions, ostriches, servo cats and deer, but he never said where they had all come from, except for the cheetah, which he said had been an orphan cub he had brought up over the years. When we left for the aircraft, which had been guarded for the two days by a detachment of soldiers, I thought how fascinating that part of the trip had been, especially handling the cheetah. I never dreamed I would meet Clive Meadows again, on the other side of the world, two years later.

It was early morning when we took off for Juba in the south of the country, where I was going to see the African part of the Sudan, totally different from the north.

I had time to think about my cameras during the flight, not being able to use either of the two Rollieflexes. They had both suffered from the sand as I had expected they would, each exposure being wound on by the handle, which at the same time cocked the shutter. Both cameras were full of fine sand and ground as the grit had got into the small cogs. They both needed to be cleaned by a camera mechanic back in London, as neither would work in that condition.

This meant that I had only the five-by-four Speed Graphic left. I was now short of both colour and black-and-white film for it, which would mean only one exposure per shot, as it had been in the days of Fleet Street. Hoping that on this last assignment there weren't going to be very many different stories, I settled down to enjoy the rest of the flight, knowing that if the film ran out there was no way I could get more where I was going.

I was to stay with the Governor, so on arrival I dug out my dinner suit yet again from the bottom of the case, in the hope of getting it pressed before I had to wear it that evening. I was told the first job was to picture the Dinkas fishing in the river. It was a sight that happened yearly as they barricaded the river a mile apart and worked towards the centre, netting hundreds of fish that lasted them for a whole year.

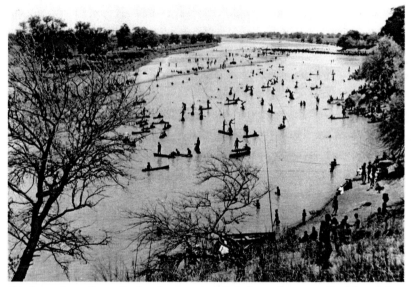

Dinkas of southern Sudan harvesting fish from the river Sudd at Juba

Every year they had the Catholic priest to bless the river, but this year they thought if they had their juju man as well the catch might be bigger. I covered this from above as the river went in a horseshoe round the Governor's house, going down only when the fish were nearly all caught, as they jumped among the natives who were catching and killing them. This made great pictures as that part of the river was in complete turmoil.

That evening, dressed in my tuxedo, I sat down with a party of

people including the Governor's wife, the doctor and the vet, to one of the best meals I had had since leaving home. The whole evening seemed to centre on me, as everyone wanted to hear about the things I had been photographing, especially about the Queen at Treetops. When I got to bed that night, it seemed funny for me not to have the cheetah as company.

In the morning there was a great celebration by the Dinkas for all the fish that had been caught the previous day. This meant that the Governor and I were the honoured guests, with a cow brought in to the circle and slaughtered in front of us as thanks to the gods. Killed by one blow of a spear to its head, it was cut up and taken away for cooking. It was at this point that the Governor whispered to me that whatever I did I must finish the whole piece I was given, otherwise they would take it as an affront to the tribe. After some dancing by the women, two men came into the circle holding pieces of meat, each the size of the Sunday joint, and only half-cooked and warm, which they presented, one piece to each of us.

I knew I had to eat it all but wondered if I would ever eat meat again as I took hold of the joint, which was very, very rare. Somehow, but I don't know how, I got through it, covered in blood and feeling quite sick. Needless to say, I ate nothing more that day and drank only a bottle of cold beer given to me by the chief, from a fridge that ran on paraffin and normally held veterinary medicines.

That afternoon I wandered around taking pictures of native life such as I had never seen before. There were some men with trilby hats on and nothing else, unmarried women with only a leather skirt on, while the married ones wore nothing at all. One man had over his shoulder a deckchair with no canvas, and an alligator following him, and as I looked around he wasn't the only one. If the men stopped to talk, the animals would settle down and take no notice of others who might walk by. Asking the vet about this, I was told that the men thought the alligators were the spirits of their dead fathers, but how or

why the animals behaved like this he couldn't say. I had a feeling that some kind of hypnosis was the cause, because earlier in my life I had seen the same thing done to alligators at a circus. Then, there were five in the ring, and the man controlling them would stop them going into the audience by looking at them and pointing. They would freeze and not move until he said something more to them, proving that in some way he had hypnotised them. But then these animals seemed different because the Dinkas never said a word or made any arm movements towards the creatures that followed them.

The following day I finished the last of my jobs in Juba and flew back to Khartoum, from where I would fly home that evening after months of constant travel and work. Back at the Grand Hotel for the last time, I collected all my camera gear together, and with my clothes and presents I had bought over the months away, I was taken to the airport to await my plane home. I had finished the trip with six sheets of five-by-four film left unexposed, very little, and a little too close for comfort.

Chapter 9

The flight to London was uneventful, except for a stopover at Frankfurt to change planes, resulting in a two-hour delay to London. Landing about ten in the morning at Heathrow, and with all the passengers disembarked, everyone waited to clear customs as soon as the luggage was available. I knew I would be in for a bad time due to the customs officers wanting to check the numbers on the cameras and marry them up with the official lists they carried, together with the rifle for which I had no police permit. It took nearly half an hour before I was free, having to leave the rifle with customs until a gun licence was issued. I found a porter to push the luggage through the two wooden huts to the one marked 'Arrivals', where a group was waiting to greet me.

It was a great homecoming, with my parents, my boss Bob Howarth, Norman Smith and my two best friends, Geoff Bonell and Peter Verall, all there. Norman took a picture of the group with my mother, showing off her new bag, made from the skin of a gazelle I had shot in Kenya.

All the camera gear and the last undeveloped film was put in Bob Howarth's car, while my friends, my parents and I drove back to Raynes Park for me to have a week off before returning to work in London.

I was cold, colder than I had been for a long time, after spending all those months in a hot climate. It was November in England and the sudden change in temperature between the Sudan and London meant that I felt I would never feel warm. For the first two days at home, I rarely left the fire in the lounge, my body temperature gradually acclimatising to London in winter.

My parents wanted to know all about the trip, as did my friends, so most of the week was taken up talking about the past few months. In fact I didn't do very much at all during my time off, simply adjusting and getting used to good food again.

Before I knew it I was on the train again back to London, back to work and checking all the shots I had taken, now they had been processed and printed. I was congratulated by everyone at the office, with my bosses very pleased with the outcome of the whole trip. Now came the hard task. All the expenditure for the whole trip had to be written onto accounting paper, showing the amounts spent daily. Charges such as hotels, meals, laundry, flash bulbs and film, when they had been possible to purchase. Carriage and hospitality and many other sundry amounts, had all to be accounted for. A figure of £1 3s per person per day was allowed for subsistence in Uganda and Kenya, while in the Sudan I was allowed only 5s a day, with the Foreign Office paying for all travel and accommodation. Out of those 5s I had to pay for my cigarettes, any drinks or food other than in hotels. It was impossible for me to offer to pay for a drink as no more money was allowed for me in the Sudan, being a hard currency area at that time.

It took me nearly two weeks to complete the accounts, with Alistair helping. We had to show receipts for everything we had bought, but when the truck had got stuck in Kenya I had taken pictures in lieu of proof. Eventually it was finished and it went to the finance division for checking, coming back with cryptic comments such as 'that is not allowed' and 'why was this spent?' What had been left of the money had already been handed over, but there was now a difference, as they wouldn't allow certain things. For another week it went backwards and forwards, until everyone was satisfied, and both Alistair and I were still just in pocket. There were points made by the people in finance, such as 'if you had been in the UK, you would have paid for your own lunch', so for a time this caused complete stalemate, with me saying, 'But we were not at the office, mostly we were in the middle of nowhere.' Eventually it all got finished and I had learnt a lot for any future assignments abroad, knowing now what would be required. Upping everything by ten per cent was about right

136

for what the finance department would try to knock off!

During all this time I had not touched a camera, but I had met a girl from the finance department called Sheila, whom I had taken out a couple of times. She lived in north London, so, after a meal or the cinema, I would drive her home to her parents. The Christmas break came very soon after and I didn't see her for a week or two until I was back at work, having taken a few more days' leave, which I was due. On my return after the new year I had first to check my cameras again, running a film through each to be sure of the repairs and satisfying myself they were all still on top line before drawing more film from the stores, together with a thirty-five millimetre Leica, to try out while on further assignments.

My first assignment after the new year was to follow a small number of journalists from Hungary around Wales, ending up at RAF Finningley, where they were having a flight in the first UK jet fighter, the Meteor T7 twin-seat trainer, while I in another took pictures of their aircraft in formation.

My aircraft took off last, as we had to wait while the others formed up. Unfortunately my pilot thought it a good idea to throw the aircraft around a little, to prove how responsive it was to aerobatics. I didn't mind being turned over and flying upside down, or going straight up, stalling and coming back down again, or just pulling out before burying us in the ground. What I was less enamoured of was at one moment trying to drag the cameras down, the next pulling as hard as I could against the G-force to get them up off the floor. Finally I got fed up and managed to say to the pilot that unless he stopped messing about, I couldn't take any pictures! At last, alongside the others, I was trying to guide the pilot over the intercom to get far enough away so that I could get the whole formation in one shot. I was using the two cameras for colour and black and white while fighting against the harness that was stopping me from twisting round far enough to take any pictures.

After a while, and taking other shots of the aircraft, the first Meteor went in to land, but my pilot continued to throw his aircraft all over the sky, saying he very rarely had a chance to show off like this, as they were a training squadron. At this point I got really pissed off with being thrown around and hanging onto the cameras for dear life, knowing that if they hit anything hard they would have to go back to the camera repairer again. It was also getting very hot in the aircraft, when at last the pilot flew straight and level alongside the runway, ending up past it. With a hard turn to starboard he did a 360-degree turn back on himself before touching down.

'What the hell did you do that for?' I said, as I had almost blacked out with the G-force.

'I had to do that to take off speed in order to land,' the pilot retorted as he opened the hood, the fresh air bringing me back to reality again.

As my feet were shown the footholds by one of the ground staff, the pilot apologised to me for putting me through all those manoeuvres, saying again that it was a chance in a thousand to be able to do some aerobatics, as they were training pilots every day. I said no more, being only too glad to be back on the ground again with my feet on terra firma.

That was the final part of that assignment, and I drove back to the office, arriving at about 7.30 in the evening. Dropping off the cameras and going across to a small restaurant in Baker Street, I had a meal before going home, having missed my lunch in the mess.

After a few more small press jobs, my next assignment was in Wales, with a man called Tydwal Davies, who was resident in Cardiff, working for the COI in the Welsh Office. As it was to be an early start in Cardiff on the Monday, I left home on Sunday morning and arrived about lunchtime. Unfortunately, having booked into a temperance hotel. Longing for a pint, I went out to find a pub, not realising that there was no drinking in Wales on a Sunday. Not to be

put off I decided to ask a policeman where a traveller might get a drink. Approaching one on point duty, directing the traffic in the middle of Cardiff, I asked the question, wondering what kind of reply I might get.

To my surprise the constable said, after glancing left and right, 'See that pub across the road, go round the back through the car park and knock on the back door. Say Brian Evans sent you, but don't go in for a quarter of an hour as my inspector is in there and will want to finish his two pints before leaving.'

With that, I walked across the road, and waited for the inspector to come out before being ushered in by the landlord, who, after checking by sign language with the constable that I was all right, ushered me in. The pub was full of customers, and I was sure that none was a traveller but all were locals.

The next day I picked up Tyd at the office and we drove towards Snowdonia, where a hotel had been booked quite near the mountain. Going up Snowdon the next day by train, we arrived at the top, where I was so taken with the view that I did a few shots before going to the Llechwedd Slate Caverns, the main part of the story. We had come here to do a feature on slate mining and cutting, as the feeling in the trade was that it was starting to die due to the more economic manufacture of clay roof tiles.

I did shots of the slate being mined, brought out and cut into roofing material, which was done by hand. I was fascinated by the way they split the slate. There were no measurements taken, but the thickness of every cut was exactly the same. It was so interesting to watch these men splitting and forming the roofing tiles without a measure in sight, and it made a wonderful set of pictures with the actual mining shots.

Finishing in the early part of the afternoon, Tyd suggested that we call in on his mother, who lived only a few miles away at Betws-y-coed. As we entered the small bungalow, I felt it was as if I had gone

back in time, with the chiming clock and the porcelain figures on the mantelpiece, and the old lady seated with a shawl round her shoulders. We had been expected, as the cups and saucers were all laid out, with homemade cakes and the copper kettle starting to sing on the fire. Tyd made the tea and the three of us sat, making polite conversation, mother and son breaking into Welsh on occasions.

'Would you like to hear Mother play the harp?' Tyd asked as he pulled off the cover revealing the most wonderful gold Welsh harp I had ever seen. I admitted I didn't know anything about it but I was completely taken with the instrument, especially when the old lady started playing. I said afterwards to Tyd, after the mastery of her fingers, it was music the like of which I couldn't explain, and had left me wanting more. After an hour we left having taken pictures of mother and son together, and she playing that old Welsh harp.

Driving back to the hotel we were both silent. I was not able to get the music out of my mind, or the feeling of peace and tranquillity there had been in that little cottage, and especially Tyd's mother who had been so kind. The next day we did shots of Caernarfon Castle and the town, then went back to Cardiff and dropping Tyd off, drove back home getting in quite late that night.

The Coronation was getting near and this was going to be a big operation for all the photographers at the COI. It was the first one that was going to be shot in colour, so there were countless meetings at the office with others in Fleet Street, and with the film companies, designed to sort out positions and lighting in Westminster Abbey. With colour now shot by nearly every photographer, the lighting in the abbey was of great significance, especially in matching to the colour temperature of the film in use. Firstly it had to be decided if they would light for daylight, because of the amount that would come through the windows. This meant putting an 85 Wratten filter on the cameras, as the colour film in those days was still only balanced to artificial light. This would cause another problem, as putting on the

filter cut down the speed of the film by just over a stop, reducing it from 25 ASA to something like 16 ASA. This would then mean far more intensity of artificial light, as each lamp would require blue filters to bring the colour temperature to that of daylight. Here was a problem soluble only by trials. To have only artificial light, hoping that daylight wouldn't be strong enough in the abbey, or to change the colour balance and put in twice as much lighting, balanced to daylight, and a much slower film due to the 85 filter. Tests were carried out, and luckily they were okay with the artificial light, giving complete colour balance without having to worry about daylight.

Next, it was who was going to be where on the route, and inside the abbey. Mr Kearne and Peter Streatfield were inside, as both had done the tests, while Fred Carrol was on the 'Wedding Cake', the Victorian statue outside the palace gates. Greg was to be up on the top of the palace, while I was in Trafalgar Square. Richard and Norman had different positions in Parliament Square, with Andy just inside the door of the abbey to get the shots of the Queen arriving and departing.

The photographers had one big problem: very few had long focal-length lenses. Mostly we had normal or wide angle ones, which were acceptable in most cases, but not for Fred on the statue, who had to get the shots when all the royals came out onto the balcony.

So he had a 'made-up camera', consisting of a thirty-six-inch lens from an air camera, mounted on the front of a board measuring about six inches wide by three and a half feet long. At the other end, exactly 36inches from the rear of the lens was the back part of a Speed Graphic, with its focal plane shutter. Between the two were three sets of bellows sequentially supported and fixed to the board, with one end attached to the lens, the other to the half camera. So here was a camera, with a thirty-six-inch lens, mounted on a board requiring two tripods to hold it steady. Strangely it worked, a real 'Fred Carno' job, but it took time to set up, so on the day I would help Fred before going to my position in Trafalgar Square. Fred, from his vantage point

outside the palace, would also take pictures of the royal coach leaving for the abbey, together with shots down The Mall as it came back up after the ceremony. Having plenty of time between the arrival back at the palace and shots on the balcony.

All was fixed for the great day, 2nd June 1953, when everyone slept at the office overnight on camp beds, to be roused at 4.30 a.m. Then after a quick breakfast at the small café round the corner, and with everyone given sandwiches to take in their camera cases, we were off. Fred and I were driven to outside the palace and got the fantastic camera rigged and in the right position, much to the amusement of other photographers from Fleet Street. I left Fred and was driven down The Mall to Trafalgar Square, where I took my position, alongside many others, on the stand. By this time it was about eight in the morning, and the number of people was growing by the minute. No wonder we had to get up so early, I thought, as I wouldn't have got to my position had it been left any later. With those thoughts in mind, I sat down and was soon asleep for a couple of hours, as were many of the other photographers who had the same idea.

The day went off well except that it poured with rain most of the time, and fortunately for me, when it was all over, all the crowds made their way to the palace. This made it quite easy for me to walk back towards the office in Baker Street, until I managed to get a taxi. I handed in all the exposed film. I drank three cups of tea while someone reminded me Fred was still on the 'Wedding Cake'. How were we going to get him off with all that heavy equipment and the crowds? Not only that, if we couldn't, then he would have to be given something to eat and drink, as by this time he must be dry and starving. Even if someone could get to him, crowds must be surrounding him, and they were likely to stay all night. Taking flasks of tea and sandwiches, Norman and I set out to see if we could rescue him, as he must have thought by this time that nobody cared! At

worst, we thought, Fred would have to stay there all night, simply because his gear could not be moved successfully through those big crowds.

When we got to the statue, having forced our way through, it was possible only to shout up at Fred and throw up sandwiches, which we hoped would keep him going till morning. Somehow, we also managed to get two Thermos flasks to him, with the help of other press photographers in the same predicament. We then fought our way back, taking at least half an hour to get through the crowds. However, with the help of the police the next morning, Fred was rescued together with his home made camera, which did the job extremely well.

The next big assignment was with Norman at RAF Odiham, the Coronation review on 15th July 1953. The Queen was going to inspect all the different types of aircraft being flown by the RAF at the time. Norman was to do the arrival and close-ups of the royal family while I was to concentrate on the lines of aircraft to be inspected by the Queen in an open-topped Land Rover. There had been a spare press ticket so I had taken Sheila with me so that she might have a good view of the ceremony. I had hung a camera round her neck and, as most of the other photographers were friends of mine, nothing was said. It was a lovely day and I didn't have to work too hard as I was doing general views, while at the same time providing an opportunity for Sheila to see the Queen.

I hadn't done much studio photography but an opportunity arose for publication division that gave me more stress than usual. They wanted, for the back page of a publication called *Today*, a shot of a number of servicemen and women in different uniforms, lying in a circle each with their heads to the centre of the shot, which was to be taken from directly above to advertise the army.

The first thing I had to do was build a gantry, almost touching the roof of the studio to give me enough height, consisting of two large

trestles with two very thick long planks of wood between them. The height was to be two feet below the ceiling, so giving me enough room to crawl to the centre of the planks, which would be apart, with the camera mounted looking down between them. Then on the floor was to be grey background paper, with a penny at the centre, placed in the middle of the cross on the ground glass screen of the Speed Graphic. The lighting consisted of four studio lights with umbrellas, placed in a north, south, east, west pattern. This all had to be built a few days before the shot was to be taken in colour, and all worked out regarding the lighting and exposure before the troops with their different uniforms arrived. I did a couple of trial exposures with some of the staff to get it right, so that on the day I would be ready for the actual take.

The morning arrived and I was in the studio bright and early to make sure everything was on top line for the arrival of the twelve troops. When I had done the tests, the lights had been on for only short periods, but even then, being so close to the ceiling, the heat was only just bearable. What was the heat going to be like when the actual shot was taken, or even when I was altering the positions of the troops from above? I didn't know, and hoped that I wouldn't have the lights on for longer than was necessary.

Everyone arrived at once for the rehearsal, as they all had to know their positions in the circle, making sure the heads were all touching in the middle of the shot. Before they changed into uniform they were laid down on the background and shifted around to get the formation right. Then, after coffee, they all got changed and then the problems really started. The first to be positioned was the soldier from the Blues and Royals: because of the weight of his breastplates and helmet, it took three people to lower him down, as he couldn't move when he was on his back with all that weight on! It took a good ten minutes to get him in position and make sure his uniform was correct. Next was the guard with the busby, for he too had to be lowered into the south

position, while the horse guard was at north. Then the rest settled into their places, able to move around to a certain extent while an officer checked their positioning and uniform. I, by this time, was aloft, as I also had to check the positioning in the ground glass screen of the camera. This had all taken nearly half an hour before a shot had been taken, so now the lights were turned on, I checked on the screen again to make sure nothing was out of place.

Picture of soldiers for 'Today' magazine

Knowing the exposure from the tests I had done, and because the position of the camera was fixed between the two planks, I was using the focal plane shutter. Being very careful not to drop a slide on the figures below, I put the first one in the camera and gave a second's

exposure. By this time I was sweating in the heat and couldn't get to my handkerchief to wipe my face. The sweat was now dripping off my nose in a stream, mostly landing on the plank, but some must have been dropping on the troops below. So, after four more exposures, I called it a day and struggled down from where I had been for the best part of an hour. Giving the exposed slides to Peter Streatfield to get processed, I sat down with a cup of tea and took things easy for a bit. The picture proved to be a great success and looked good as a full page on the back cover of *Today*.

I always said that some jobs and assignments seemed invariably to come together. Like press jobs or visits, portraits and studio shots, or overseas assignments. This happened again with my next one, another studio shoot that wasn't at all simple. It was to be of a model aircraft, a Swordfish over the sea in a slight fog. A large print of the sea was produced as a background, fifty-four inches wide and six feet long. This was secured in a semi-upright format that when flattened to the floor looked like an L, but with a gentle curve instead of the ninety-degree angle. The model was then suspended above at an angle as if flying, with a disc of Perspex instead of a propeller, painted like a spinning blade. This was easy so far, but then came the fog. This had to be thick enough to look like wispy low cloud, but the sea must show through together with the aircraft as the 'dominant' part of the picture. Then came the problem of how to manufacture the mist. Lots of ideas were tried before someone thought of an answer: an electric hot plate with a slow fan behind it on which someone dropped small amounts of liquid paraffin that turned into a smoky mist – just what was needed!

The shot took only ten minutes to complete, and it was great. But not the feeling that made everyone in the studio rush to the toilets. The sea mist had managed to get into the printing rooms as well as most of the rest of the ground floor of the building. In other words, the mist had turned into a laxative with everyone hammering on toilet

doors all over that part of COI. After all had simmered down, and everyone had managed to find a seat in time, things quickly returned to normal.

Andy was leaving and going to America, to join a picture agency. A party was organised in the studio, with everyone contributing to a good send-off for him. I, like the rest, was sorry to see him go, as the six of us had been very close during the time we had all worked together.

Things hadn't been going too well between Sheila and myself, partly because of the distance we lived apart, but mainly because I was never sure where I would be at any one time. We decided to call it a day, which, in a way, was a great relief for me as I really had no time for anything else outside of work, especially as I was away for days at a time.

But then perhaps it might have been because I had met someone else, at the barbers in Marylebone Road, where I went to have my hair cut. It was a ladies' and gents' emporium, and I had to pass through the ladies' section every time I went in. Greta and I would exchange a word or two as I passed, until the day I asked her out, taking her for dinner that same night. Although we liked each other a lot, we never got further than being good friends and remained so for many years. While going out occasionally, Greta would talk a lot about her father, whom she had never known, nor would her mother ever reveal his identity. She lived with her mother in Camden, who I had got to know very well, yet I still couldn't ever get the father's name out of her.

Greta eventually met an American serviceman from Bushey Park, and they married and were posted abroad, after which I lost contact with them for years. However, later in life we all joined up again and remained good friends for many years.

Work carried on in the same way, while in November 1953 I was asked to go to the Dorchester to photograph Miss Egypt, who had won the title of Miss World. These pictures were very much of a

change for me, as I hadn't done anything like this since leaving the *News of the World*. After two hours in her company, taking more than enough pictures for a double-page spread in the *Today* magazine, I arrived back at the office at about 4.30 to be told I had to be in Colchester early next morning for pictures of a military band. This meant leaving that evening and finding a hotel for the night as near as I could to the camp for an early morning start the next day.

Arriving in the town, my first stop was the Red Lion, a seventeenth-century coaching inn, which was full for the night. Getting a couple of likely alternatives from the receptionist, I started trying other hotels until it was almost 7.30, and I knew if I couldn't find a bed soon I'd be sleeping in the car. So back I went to where I had started, the Red Lion, and asked for the manager this time, pleading for a room. After going through the book he discovered there was one room on the third floor, as someone hadn't turned up, or so he said. Grateful for anything, I carried my cameras and overnight bag up three flights, noticing how much older that part of the building was from the downstairs.

Opening the door with a Yale key, I saw that the floor seemed to fall away to the left as I walked in. Not bothered about the low height of the ceiling or the tilting floor, I realised this must be the oldest and less modernised part of the old building. Knowing they would stop serving dinner soon, I had a wash, grabbed my book, and made sure the door was locked before going down to eat. I ate a good meal while I read my book, something I had got used to doing in a hotel where I didn't know anyone. Relaxing after the coffee, and thinking how much better this was than sleeping in the car, I went into the bar to have a pint before going to bed. As it was late and I was the only customer, I decided one was enough and putting the empty glass on the bar, mounted the stairs to my room and bed.

The door was wide open. As I entered I saw the bed had been turned down by the chambermaid, thinking she must have left the

door open by mistake. Shutting it and at the same time checking the cameras were still there, I had a wash and got into bed, turning out the main light to read with the bedside lamp. I always found that a short read in bed helped me to sleep better, so when I had finished and put the book down I saw that the door was wide open again. Now I knew I had shut it when I came in, as I'd made sure the lock was on, something I always did when in a hotel to protect my gear. Shutting the door and pushing the bolt across, this time making sure it was home, thinking to myself that the reason the door kept opening must be that nothing in the room was straight, I got back into bed, turned over and went to sleep. It must have been a few hours later when I woke, wondering why I had woken as I never usually did, especially in the middle of the night. Opening my eyes I couldn't believe what I saw by the light from the corridor. The door was open again and the bolt still out, but not in its housing. By this time I was really fed up, knowing how carefully I had shut it earlier. This time I closed it as before but added a chair wedged under the lock for good measure, saying to myself, 'Now see if you can bloody well stay closed.'

Getting out of bed in the morning, I looked up to see the door wide open again, and the chair having been pushed into the room behind it. Standing there for fully thirty seconds I thought to myself, 'How the bloody hell did it manage that?' Quickly getting dressed, I picked up my camera case and overnight bag and went downstairs, happy to get away from the room. After breakfast, while paying my bill, I asked the manager about the room. It was haunted, he said supposedly by the ghost of a man who'd hanged himself back in the seventeenth century. The manager had let me have it only because I was so desperate for a night's lodging, and would charge me only half rate for the night. I didn't argue, I hadn't really had a bad night, and now I had made on my subsistence, so I was happy. But would I have slept in that room had I known it was haunted? No, I didn't think so.

Two days later, following the night in Colchester, I was driving

over the Pennines towards Kendal and the Lake District. It was a funny sort of afternoon, heavily overcast with low cloud and mist that clung to the car. Not enough for the wipers to clear the windscreen, as I had already had to stop twice to wipe the glass. I was beginning to wonder if it would have been better to use the main roads instead of the almost deserted one I was on. I'd had my full beams on for the last two miles and hadn't seen another vehicle, until, all of a sudden, ahead of me, out of the mist, I saw a horse and cart going the same way. As I had kept my speed down given the driving conditions, I had no problem slowing and passing what I saw was an old-fashioned coal cart.

Noticing as I passed that the sides of the cart sloped outwards with chains hanging from the back, while on the driver's head was an old-style leather coalman's helmet, with a large flap hanging down to protect his neck. The horse was walking slowly, so I was soon past and looking in my rear-view mirror. I saw the whole horse and cart disappearing into the mist.

It was then that I felt something wasn't quite right, what was a Victorian coal cart doing on the road with no lights in this weather? Not having gone far, I stopped and turning off the engine, lowered the window, and heard nothing. 'Had I seen it or hadn't I?' I thought as I walked back, checking that there was nowhere it could have turned off. I could see where my car had pulled out to pass, as my wheel tracks showed in the mist-covered road, altering from straight to a pull to the right and back again. Completely mystified as to where it had gone, I walked back to the car and drove off, still turning the whole episode over in my mind. About a mile further on I stopped at a transport café for a cup of tea. I was the only one there and while waiting for my brew, I asked the woman behind the bar about the strange horse and cart I thought I had passed.

'So you've seen it,' she said. 'You're the third one in the last two days who's reported it.' She told me that nobody seemed to know

why this apparition appeared, because that's what it was she said, as it was only seen on that road in this type of misty dank weather. As I sat down with my tea, I thought to myself, 'Why is it only me that gets involved in these things, that's two in so many days, give me a break!' Then I thought about something Norman had told me some time ago, regarding the funeral of King George V in February 1936. He was photographing it for Fox Photos, and when one of his plates of the funeral was processed, in the leaden grey sky above the gun carriage was an image of the King's head, beard and all. That picture made history as something very much out of the ordinary, with everyone asking why the King's head was on the picture, and how did it get there? It hadn't been retouched or messed about with and Norman had sworn to me that when he took the picture, there was nothing out of the ordinary to be seen.

'Just another of those funny things that happens when one least expects it,' I thought as I finished my tea. Saying goodbye to the woman, I looked around the café which was now empty wondering if that was real or had I visualised that as well?

Sometimes things would go wrong, like helping other photographers. One such occasion happened on a day when there had been a press call about a small ship on the Thames and I was sent along, finding other photographers from the papers already there. Looking to take a different shot from the others, I climbed a high ladder to get a picture of the ship with two cranes framing it. Phil, a friend of mine from Central Press, shouted up to me asking if I would take a shot for him, as there was no room for two where I was perched. So climbing down a short way, I grabbed his slide and took one for him after I had taken my own pictures.

On getting down to the ground, a dock policeman said that no one else could go up where I had been as it was too dangerous. So the others had to take their pictures from the shore without elevation.

Returning to the office I processed my negatives and put them in

the drying cabinet, ready to contact print when I returned from lunch. On contacting my two negatives, I made the prints rather light. But I didn't worry as the contacts would only used to crop the picture before printing.

As I gave them to the editor Dick Forsdyke, a boy brought in the days pictures from Central Press. One was a ten by eight print of the shot I had taken that morning for Phil. Dick turned to me and said 'Why can't you take pictures like this, instead of bringing me small contact prints that look nothing like this picture? I couldn't tell him that it was me that had taken the shot, all I could think of saying was that when my picture was enlarged it would look like the one from the agency. This was done later and Dick apologised, never realising it was me who had taken both pictures.

Chapter 10

The year 1954 started much the same as others, with jobs that were now only too commonplace. Driving up and down the country for work seemed to me to be my only way of living. I hardly ever saw my friends socially – it was as if work had taken me over completely.

Then things suddenly changed at COI. Barbara Fell left under a cloud and Eric Underwood was promoted to head of photographs division. He was a much different boss, more friendly and approachable. I got on well with him and one afternoon I was called into his office to be told I was going to the Far East some time in March. It was then the middle of February, and not knowing the exact date of my departure I had to start getting everything ready for the forthcoming overseas trip. Still working, but on local assignments nearer to London, I had more time to get my equipment and myself prepared, and living more at home allowed me more time with my friends. I saw my father quite often for lunch in the press restaurant of the House of Commons, which we arranged every two weeks, providing it fitted in with both our schedules.

Before I knew it, the date for departure was upon me. This time my father took me to the BOAC terminal at Victoria where I took the coach to Heathrow, arriving in the late afternoon. It was the same performance again with the cameras and equipment having to be checked by customs against the lists I carried. They kept a copy so that on my return they could be sure the same equipment was imported back into the UK. Having done all this, which took a good half-hour, I was ready for the long flight to Singapore.

Once again it was an Argonaut, a comfortable piston-engine aircraft. I got a seat near the back, close to the half-circular sofa-type couch at the rear of the aircraft. I knew from past experience that I would be able to stretch my legs, once airborne. Ten minutes into the flight and I was there, together with three others who had the same idea. We soon introduced ourselves and the beer started to flow

among the four of us. Two were pilots, going to Singapore to join an airline, and the other was a ship's navigator who was getting off in India. We remained until we were about to land in Cyprus, then we returned to our seats.

The aircraft, having refuelled, took off again and the four of us got back together for a nightcap before settling down to sleep. Then the two pilots started. They didn't like the sound of number-four engine. I had to admit it had coughed a bit when it was under power in the climb out of Nicosia, but being no expert I kept quiet. But *they* wouldn't, so soon the pilot of the aircraft had to come back to talk to them. When he was told who they were and what they had seen and heard, the captain started to take notice. He assured them he would check the engine and let them know the outcome. This quietened them, and with the soporific effect of the beer all four of us were soon asleep. We woke with dawn coming up over the desert landscape, and breakfast was served. I looked out of the window and saw that engine four was feathered. It didn't take the other three long to spot that and then there was an argument as to which of the two pilots would go up front to talk to the captain, obviously not wanting to worry the rest of the passengers, most of whom were still asleep. Coming back with the captain, he told our little group there would have to be an engine change at Karachi, being the only place en route where there was a spare. With this we were satisfied that something was being done, so forgetting about the problem we started enjoying the flight, knowing that the aircraft was quite safe flying on three engines, but not knowing how long the replacement would take in Karachi. As India got nearer, the captain came down again to talk to us, asking if we would be able to give the engineer on the ground a hand. Possibly it was the effect of the beer, but all four of us volunteered, so that the aircraft would not be grounded for long. The other alternative would have been a much more protracted delay until another aircraft could be found.

154

As it happened, when the engineer examined the engine he discovered he could repair it, and didn't have to change it, so the four of us and the crew sat in the sun watching him while he worked. Finishing and wiping his oily hands, he ran the engine up for fully five minutes before he pronounced it repaired and signed off, with the captain countersigning.

In the air again and flying down the west coast of India, the stewardess brought down a printed map, showing the aircraft's position pencilled in by the navigator. I passed it to the ship's officer, who immediately looked out of the window, saying, 'This isn't right, we're nowhere near where this says.' This man, I had found out, knew the coast like the back of his hand, as he had sailed up and down the length of India for many years. Calling for the captain again, this time to explain exactly where we were, I asked him if the aircraft would now not night stop in Colombo, due to the hold-up in Karachi. The captain's reply was nothing but succinct: 'If you think I'm going to fly this crate across the Indian Ocean at night, you'd better think again.' That meant all the passengers and crew had a night at the Mount Lavinia Hotel in Colombo.

Arriving in Singapore one day late, I was interviewed and photographed by the *Straits Times* at the airport, before being picked up and taken to the public relations department at Government House. After that initial meeting, I was taken to the Adelphi Hotel for a rest and sleep after my long flight, getting myself ready for a full briefing the following day.

Before going to sleep, I thought about my friend in the publications division who had talked to me regarding his sister. It appeared that she worked as a secretary in Kuala Lumpur, and my friend had given me her phone number in Malaya, while letting his sister know of my arrival – but would she bother to contact me, I thought as I fell asleep? I soon woke up, rushing for the toilet, not knowing whether to sit or stand over it. I had got a really upset

stomach from my dinner, being unused to the bugs in the tropics. I moaned through most of the night with trips backwards and forwards, and there was a knock on my door early in the morning. It was an older man with two glasses in his hands. 'I heard your moaning and guessed the reason – take and drink these two large brandies straight down, one after the other, and go back to bed. When you wake, the problem will have gone.' I had never felt less like downing two large brandies but did as the local said while thanking him and dropping back into bed. When I awoke again about eleven that morning, the dreaded stomach problem had gone, though I felt a little inebriated. I never saw that kind Samaritan again but never forgot that cure, using it often in the future.

Because of my upset stomach, the meeting had been put back to the afternoon. There I met with the people I would be working with during my short stay in Singapore. I was given a new itinerary, which started the day after, and was also told that when I went to Malaya in ten days' time, I would be seconded to General Sir Gerald Templer for as long as he required me. This was something new that had come in from the War Office in London while I had been on my flight to Singapore, so not a lot more was known about the request. Putting it to the back of my mind I got on with the immediate tasks I had been given on the island. Just as I was leaving to go back to the hotel, there was a phone call for me. Trying to think who it could be, I took the call from a Pam Davies, the sister of my friend at COI. She was staying with friends in Singapore, having come down for a few days' holiday from Kuala Lumpur. It was a lovely surprise for me, and we arranged to meet that same evening for a meal and a chat, as I knew no one in this part of the world, or thought I didn't. The evening went well and we arranged to meet again when I got to Malaya, in just over a week.

My first assignment the following day involved aerial shots of the town and specific buildings, such as power stations and hospitals etc.

Taking a taxi to the airport, I went to the flying club, which was going to fly the sortie. The aircraft we were using was an old Auster, a high-winged monoplane of the Second World War, and I immediately asked for the right-hand door to be removed. Strapped in I had worked out that with my foot out on the wing strut I had a full open area for taking pictures. Also, because this type of aircraft had the capability of very slow airspeed before stalling, it was a very stable platform for photography.

Taking off, the pilot climbed to a reasonable height for me to shoot my pictures, with my foot lightly perched on the outside strut. We had almost finished the pictures of the new St James Power Station at the western end of the island, when the fan stopped rotating. With the silence of the stopped engine, all that could be heard was the swearing of the pilot and the wind whistling through the open door.

As he tried both magnetos, with neither wishing to restart the engine, I tentatively asked the pilot, 'What are we going to do now?'

His reply was, 'Well, we bloody well can't stay up here any longer, we'll just have to glide back to the airfield.'

As we both sat in silence, unable to use the radio either, we glided towards the main airport. We approached behind a large transport aircraft, keeping out of its slipstream, while verey lights were shooting up from the control tower.

'That won't do them any good, can't they see I can't stay up here without an engine?' the pilot said as if talking to himself, as he landed on the grass and stopped. Getting out he turned to me and said, 'It won't be long to get this fixed and then we can go up again.'

I had different ideas. 'Don't worry, I've got what I wanted.' I thanked him for the trip, paying him the $30 for the hire and very happy to be back on the ground again.

After that the jobs were much the same as anywhere, silversmiths, docks, agriculture and fishing. I was kept busy every day I was in Singapore, and the evenings I loved. There were so many different

places to eat, especially one seafood restaurant that was built out over the harbour. Here I could relax and enjoy cuisine I had never tasted before. Afterwards, at the cinema, there was a special film most nights after the main programme. The latest films were screened from about 10.30 at the Cathay Pacific building, making a late night of it that rounded off my evenings well.

One night, I was invited to a very special dinner thrown by a famous and well-known Chinese gentleman at the Great World in Singapore. I went with Gerry Fernandez from the PR office, sitting at a long table that must have taken over a hundred people. Every place setting had flowers and a bottle of Johnnie Walker Black Label whisky for each guest. Luckily, I had someone with me who knew there would be at least fifteen different courses to get through over the evening, and who told me to take only a little of every course. This I did, watching in surprise as each emptied whisky bottle was immediately replaced with a new one. It didn't take much imagination to realise that over half the diners were drunk halfway through the meal, with both Gerry and me also partly on the way. I didn't remember much of the evening, or how I got back to my hotel, knowing only that the evening had been something special and unusual, and that I would never take part in one again.

Two days later, whom should I literally bump into but Andy Anderson, not in the USA, where I thought he was, but here in Singapore, working on the *Straits Times*. I had just got out of a taxi outside the Adelphi Hotel when we met. The obvious thing was for the two of us to go in and sit down with a drink, each intrigued as to what the other was doing here. I told Andy of my itinerary and that I would be leaving shortly for Malaya, then I arranged dinner with him for the following evening.

At the office the next day there was a cable from 'Bimbashi' Clive Meadows, the soldier I had met in the Sudan with the cheetah, who had seen a report in the newspaper of my arrival. Would I come and

158

spend the weekend with him? He was now living on top of a small hill or mountain in the nature reserve, and as I was free that coming weekend I hired a car and drove up to see him, a man I had met nearly two years before. Here he now was, living like a hermit in a nature reserve, still with a horse that looked very poorly, and something like a bag of bones. This must have been the only horse in Singapore, other than those that were kept in air-conditioned stables at the racetrack.

He told me that he had left the defence force because it was going to be closed down within the next year or two. He had come to Singapore with his horse as he didn't want to return to the UK. After that weekend, I could only feel sorry for the man, as he was not at all well. Still, as I left I felt I had cheered him up a little, as no one else seemed to visit or take any notice of the shambles in which he lived.

The following day I left for Kuala Lumpur by train, and as it rushed through rubber plantations, forests and wonderful views over the countryside, I thought how different it all was from the desert of the Sudan and grasslands of Kenya, and wondered what this new country would bring forth for me. At the magnificent railway station in Kuala Lumpur, a building from the old British Empire, I managed to get a porter with all my gear and luggage out to the taxi rank, where I was met by Harold Laycock, who insisted on getting it all into his little car, an Austin Ten. Not only did the luggage fill the vehicle, when I got in I had almost to double myself up. At the hotel, after my luggage had been taken up to my room, we settled into the bar to discuss plans for the trip.

Harold had been a journalist in Budapest in the 1930s, working for the Christian Science Monitor, and during the war in the Royal Navy, after which he got married and moved to Malaya, where he became head of public relations for the government. We talked about the first three weeks when both of us would be seconded to Sir Gerald Templer, the British High Commissioner, appointed by Winston

Churchill in 1952 to deal with the Malayan emergency. The reason for the secondment was that Sir Gerald was leaving the country shortly and he and the War Office wanted pictures and stories of his last weeks in charge.

As the drinks flowed, he told me something that had happened to him in Budapest way back before the war. He had just had a row with his girlfriend, and there was very little news that he could send to his office in America. He started to drink, drowning his sorrows while concocting a story, that the president of Hungary was off to Moscow to talk about the border between the two countries. Thinking to himself it was too risky to send, he put the cable in his pocket and went to his local bar, where he carried on drinking the night away, brooding over the lady he had lost. In the morning, when he awoke and got dressed, something made him think of the story he had written the night before, and looking in his shirt pocket couldn't find it. He went round to the bar to see if anyone had picked it up. Talking to the waiter, he asked if he had seen the cable. The reply shook him, as, in his inebriated state, he had asked him to take it to the cable company and send it.

He could do nothing: the cat really was out of the bag. He didn't hear anything more from his office, but other newsmen were getting messages from their papers asking why they hadn't got the story of the president going to Moscow. They all wrote back, 'It is rumoured that the president...' etc. Then Harold's paper wanted a follow-up, so he started writing the same things as the others. Two days later the president left for Russia – was it the power of the press or just luck on Harold's part?

The next day we both met Sir Gerald, who outlined the type of pictures and stories he was after. Shaking hands with us both, he would insist on calling me Little Hiawatha. It appeared he had read a book where Hiawatha was a photographer, and from that day on he never called me anything different, so for me, that was my name.

We photographed British troops on the firing ranges, marching, and on the assault course, while getting pictures of Sir Gerald watching or talking to the National Service soldiers. Next I was sent on a patrol with a party of troops round a village that had been closed off with barbed wire to stop the inmates giving food to the terrorists. I was dressed in a suit of jungle green, given a Sten gun and ammunition, and sent off on a day's patrol. I had told them I had been trained on the weapon in the RAF, so all I had to do was fire it on the range.

I had my camera round my neck and the gun slung over my shoulder, so I could take pictures fast. I had never realised before how dark it was in the rainforest, finding I could take pictures only when going through clearings. Out on a patrol like this, everyone followed the man in front, but in the darker spots I could hardly see him or the one behind. They had put me in the middle of the platoon for safety, but as it happened it was the worst place to be when the shooting started. The day had been going well for me, as I had taken quite a few pictures. I had just reloaded the camera when the bullets started to fly like hornets buzzing. I was in one of the darkest parts, and knowing I couldn't use my gun, as I hadn't a clue who was shooting at whom, I decided to fall flat and hope I wasn't hit. Trying to keep flat, I felt like digging a hole with my nose. Luckily, I had the camera in my hand and managed to stop it being smashed as I fell.

How long I lay there with the bullets whining and whistling above and around me, I don't remember, but it can't have been long. To me at the time it could have been hours, as I was worried at not knowing who was winning or how many of my patrol were still alive. As the firing eased, with just the occasional shot exchanged, whistles were blown and the soldier behind me helped me to my feet, as I, trying to wipe my nose, realised it must be all over, though I had precious little idea what had gone on.

There were two casualties among the soldiers, both not badly

wounded, but as for the terrorists, three had been killed, and I was presented with two bloodstained caps, each with the red star emblazoned on the front. So ended my patrol, my third baptism of fire. I was lucky to be alive and happy to get away from the jungle. I also thought afterwards how peculiar it was that with a camera in my hand I felt it would protect me, and that nothing could hurt me, though given what I had just been through, it was *only* a feeling.

Pam had invited me that evening for a home-cooked meal in her bed-sit, something I missed in my travels round the world. All the single girls who worked for the government in Kuala Lumpur had a fair sized bed-sit to themselves, comprising bed, bathroom, kitchen, and somewhere to entertain and sit. The evening went very well, as Pam had cooked roast beef with all the trimmings, washed down with a bottle of wine that I had brought.

Three days later I was with Sir Gerald in the Chinese market, where he and Lady Templer were talking to the Chinese shopkeepers on a public relations drive to get some of the Chinese out against the terrorists.

I had been taking pictures all morning and Sir Gerald was getting fed up as it was approaching his lunchtime. Asking the last Chinese shopkeeper, through his interpreter, if he sold baked beans, the man had no idea what they were, as the Chinese never ate them. Sir Gerald started to lose his temper, and having had enough said to the interpreter, 'Tell him it's an aphrodisiac.' The man couldn't get the shopkeeper to understand such a word, so he turned to ask Sir Gerald what to say. Having lost it completely at this point, the general burst out, saying, 'Tell him it's good for his Jack,' and walked away, back to Government House for lunch.

One evening, Harold Laycock took me to the Kuala Lumpur press club to hear Han Suyin talk about her book *Love is a Many Splendoured Thing*. My father had told me about this book a year or two before, and that he had known Ian Morrison, who had been a

162

foreign correspondent on *The Times*. After the lecture, I had the chance to talk to the author, telling her of my father's connection with her past lover, which really interested her. As they left the club, Harold said to me, 'You never told me of your old man's job in Paris and Berlin,' so I went through my father's career in the Thirties and during the war, which took up the time for a few more beers.

Two days later Harold and I were flying with Sir Gerald to a jungle fort in a helicopter, a surprise visit to keep the troops on their toes. This fort was situated quite near the Cameron Highlands, right in the middle of another forest. Built of wood, it was designed to accommodate troops on the spot instead of having them transported in or out of the jungle every time they were needed. Villages in and around the jungle had been surrounded by thick barbed concertina wire for two reasons – to stop the Chinese feeding the terrorists, and secondly, to stop them getting to the rest of the villagers, who were mainly Malay. This was working well and the number of terrorists was dropping, especially due to the lack of food and shelter.

Sir Gerald inspected every part of the fort, ending up inspecting some of the men. Stopping at one National Serviceman and staring him straight in the eye, he said, 'Do you know how much it costs to kill a terrorist, sonny?'

The youngster was petrified at having his lord and master standing looking at him. 'No, no...sir,' he managed to stutter.

'Ten thousand f...g dollars, and what are you doing about it, eh!' Turning to Harold while the soldier's face reddened, the general said, 'I hope you're not taking down all my foul f...g language.'

'Sir,' Harold retorted, 'there are some words in shorthand that even I cannot write.'

With that Sir Gerald laughed, saying, 'Eh, yes,' and carried on having a go at another soldier.

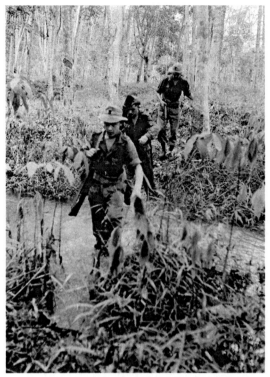

Troops in Malaya searching for terrorists

Early in the afternoon, after the general had finished his inspection, they were to take back two badly wounded soldiers in the helicopter, making it impossible to get me in as well, though Harold had managed somehow to squeeze himself in. It was arranged that the aircraft would come back later to pick up both me and a major, who was going back for a spot of leave. It arrived somewhat later in the afternoon, with the pilot getting jumpy about the weather and the light. However, we took off and as we rose above the trees noticed the Cameron Highlands were covered in low cloud, completely obscuring their peaks. Flying round for a short period, looking for a way over or out, the pilot was not happy, because he hadn't had time to refuel as he should have done before setting out again for the fort. The problem

now was that he couldn't get back to base, nor could he return to the fort due to the lack of fuel. The only answer was to put down for the night in a clearing, hoping that in the morning he could get up in the highlands, knowing there was an army group up there with aviation fuel. At this point in the conversation, the major said that if we were going to put down, it would be in the terrorists' rest area, though the pilot was so worried that all he wanted to do was get on the ground, so saving the last of the fuel in order to get to the army group in the morning, when, it was hoped, the low cloud would have dispersed. On landing, and with the major taking charge, the three of us went into the trees away from the helicopter in case the landing had been seen or heard. The major and I carried Sten guns, and the pilot a revolver, which all of us hoped we wouldn't have to use, though all three of us knew we wouldn't stand a chance if we'd been spotted.

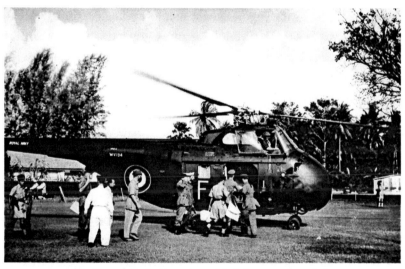

Sir Gerald's helicopter which I spent the night in the jungle looking at

A night in the jungle is not a happy experience, especially if one is lying on the ground, frightened to move in case of being heard. The other problem is leeches, which I found out about very quickly, as they got into my jungle green, sucking my blood, especially as I was lying prone, unable to move in case I made a noise.

Here the three of us stayed all night, and just as the sun was rising the pilot said it was now or never, so we all ran and got back to the chopper. The pilot said softly, as if a lot of people were listening, 'To start one of these we usually have a booster battery, but I don't know about the ones we have on board. I'm worried the noise might bring the terrorists.'

'Sod the terrorists,' said the major. 'We haven't spent the night in the bloody jungle for nothing, try and see if this bloody thing will start.'

With that there was a whine and the rotors started to turn, getting faster and faster as the engine caught first try. When the rotors were at full speed we took off and the three of us grinned at each other, the pilot forgetting all about his start-up procedure, only too pleased to be airborne and out of a very nasty situation.

Making it over the top in a very few minutes, we put down on the eighteenth hole of the local golf course, much to the consternation of the golfers, who were already playing at that time of the morning. The pilot apologised. 'Very sorry, old man, but if I hadn't landed here I would have been spread all over your golf course.'

Asking a passing soldier to get the refuelling party up, it was then that we realised what we looked like, covered in patches of blood due to squashed leeches. We must have seemed like men who had been in a fire-fight as we carried our guns off the aircraft.

The next problem was somewhere to strip off, and light cigarettes to burn off the rest of the leeches, then have a shower, especially as I was the only one with any money. I booked a room for all three to tidy up as best we could, with food and coffee laid on. However,

before we could take advantage of a bit of civilised living, the aircraft had to be refuelled. This was done with the pilot climbing up and sitting on the centre boss of the rotors, while I held a funnel with a shammy leather filter in the fuelling hole, below the pilot but above my head. The fuel had come over in jerry cans, so it was taking all three of us to get it into the aircraft, with the major swinging the full cans up to the pilot. I was the one with the main problem, getting soaked with petrol as it was poured too quickly for the filter to cope, and I really caught it. I was stinging all over as the petrol got into the leech bites, and was soaked in hundred-octane fuel, hoping no one near me was smoking.

Finally we had enough fuel and we could all strip off and have a shower, getting the last of the live leeches off each other with burning cigarettes. Back in the aircraft after eating, I had a funny thought. I now had two bills for hotel rooms on the same day, as my other room was booked for the week in Ipoh. What would the finance department make of that, I thought? I would have to wait and see, but I wouldn't give in without a fight, having risked my life once again.

My last assignment with Sir Gerald Templer was to take his farewell pictures. These were to be at Government House, where Sir Donald MacGillivray was succeeding him as Governor. I was all set when Sir Gerald and Lady Templer came into the room. She was dressed in a white gown with a tiara, while Sir Gerald was in his tight-fitting ceremonial uniform and sword. I first sat Lady Templer in the chair, with her husband standing alongside. After two or three exposures, I suggested the general sat on the arm of the chair.

His reply was couched in his usual language. 'If you think I can f...g sit in these f...g trousers, think again,' he said.

At that point Lady Templer interrupted, saying, 'Surely, dear, you could try, if it would make a good picture.'

With that and a lot of grumbling he did so, and I got the shot and another of him standing without his wife.

Having done everything that was required, I handed the slides to one of the captains, who would get them processed and all the prints made that Sir Gerald would want, before returning the negatives to me, to be sent to London with all the other exposed film.

Sir Gerald Templer with officers
during the Malay terrorist attacks

My work with Sir Gerald was finished, and I knew I wouldn't see him again in Malaya, as he was leaving the day after his farewell broadcast, on 29th May 1954. There was to be one more occasion, however, when Sir Gerald would get me out of a nasty spot of bother.

I was sound asleep in the Chinese hotel I used in Kuala Lumpur the following night, when suddenly the light went on in my room and there were two Malaya policemen, about to go through my cases. Before I could say anything or move they found the two bloodstained

terrorists' hats that the army had given me. I was pulled out of bed and was in the course of being arrested when a British police officer entered the room. I managed to explain the hats, and told the officer to contact Sir Gerald, who would vouch for me. The man went away, coming back about ten minutes later, apologising most profusely and with a very red face. I have always wondered what Sir Gerald said to the police officer that night, especially when he had been woken up. I bet myself I knew all the swearwords Sir Gerald would have used, and thought how near that man would have come to going to jail himself that night.

Sir Gerald Templer left the next day for the UK, saying that the situation had not been stabilised, and declaring in his own inimitable way, 'I'll shoot the bastard who says that this emergency is over.' It was 1960 when the Malayan government eventually declared the emergency finished, being due entirely to Sir Gerald Templer and his shock tactics early in the operation.

Sir Gerald Templer and a Westland Dragonfly helicopter

Chapter 11

Soon after I had finished working with the army, Harold and his wife Elsa threw a party at their home. Pam was invited along with another twenty or so guests and the party was in full swing for two days without a stop. There were people in the pool or just sleeping it off, some ready to start all over again while others danced all night and the rest just ate or slept. When it was over, Pam and I took a taxi back to Kuala Lumpur, both shattered as we retired to our separate beds to sleep off the excesses of both alcohol and food.

The following day I flew to Penang to photograph some of that lovely island. I did two picture features, one on local fishing and the second on the new hospital in Georgetown, which trained most of the nursing staff for work in hospitals all over Malaya.

Me taking a picture of fishermen
on Penang Island, Malaya

The picture I took of the fishermen

While in Penang, I was advised to go to a very special temple, not far from Bukit Bendera. There, I climbed the long flight of stone steps to the door, which was open. Inside it was dark and as I stood trying to get my bearings I could hear a funny hissing noise, as if there was water running somewhere. As my eyes became accustomed to the darkness, I saw where the noise was coming from. Snakes of every size and colour were on long stone tables, coiled round branches of dried wood with burning joss sticks giving off a sweet sickly smell. Standing transfixed and not liking snakes at all, I was quietly joined by a priest, who explained that the aroma formed a kind of hypnosis for the snakes, which rarely came off the tables. To me rarely was not enough and when I was told not to use flash, as it would interrupt their enforced sleep, I quickly explained that I couldn't take pictures in any case, due to the very low light. Making for the door, even before the priest had finished speaking, I breathed a sigh of relief as I hastened outside. I wouldn't have gone near the place had the person who had recommended it told me about its inmates!

Two visitors walking along the beautiful shore of Penang, Malaya

Later that day I took the Penang ferry to the mainland, ending up in Sungei Patani for lunch. This was next to Alor Star, where I did a picture feature on growing rice and fishing in the paddy fields. I stayed overnight at Butterworth before returning to Ipoh, and took some great shots of Chenderoh Lake on the way. The next day I flew from Ipoh to Temerloh, photographing a new road being built, together with shots of the growing and tapping of rubber trees. I stayed overnight in the rest house, and I was at the small airport early the next morning for my return flight to Kuala Lumpur. The airport consisted of a grass strip and a small wooden hut with one man in charge who couldn't speak a word of English. But then on the other hand I couldn't speak any Malay, but we seemed to get on all right with sign language. The aircraft, when it arrived, was a small twin-engine Beechcraft, with an Australian pilot who kept looking at his

watch as we put the luggage onboard. Directly we were airborne and on course, with me in the other front seat, the pilot took out a newspaper and started reading, occasionally looking out of the windscreen to get a fix. As he finished the first page he turned to me, asking if I could fly. When I said no the pilot replied, 'It's dead easy,' and pushed the control column over to me, as it was pivoted at the base. 'Just keep it straight and level, while I finish reading my paper,' he said. So there was I, never having flown an aircraft in my life, totally in charge while the pilot with his headphones over one ear read his newspaper. The man was completely engrossed when he suddenly took the column back from me, saying as he did so, 'Can you see a Dak somewhere near us?' No sooner had I started to look around than a Dakota flew straight over the top of us. It could have missed us by no more than ten feet, leaving the Beechcraft rocking around, getting the whole backwash of the large aircraft as it sped away. 'That's that bugger Angus,' the pilot said, 'he's always doing that to me,' as he turned to the back page of his newspaper. Once again, I was never happier than when I saw the airport coming up. 'Perhaps one day,' I thought, 'I might learn to fly, just in case something like this happens to me again.'

Finishing in Malaya, I spent my last evening in Kuala Lumpur with Pam in her tiny bed-sit eating a great homemade meal of steak and chips. I must say I felt pleased that I was leaving as she was getting too many thoughts about permanence in our relationship, while I had no thoughts of settling down. The following morning, she saw me off at the railway station as I caught the train to Singapore, wanting to know when I would be in touch again. Not telling any lies, I really hadn't a clue as I was off to Sarawak the next day, and had no idea how long I would be away. Telling her that I would be in touch, and waving to her as the train moved out, I thought to myself, 'I'm glad I am going away, that was getting a bit too close for comfort,' as I settled back in my seat wondering what was next in store for me.

After returning to Singapore, the day after next I caught the plane to Kuching. The one day in Singapore had allowed me to send all of the undeveloped film back to London by air, buy more stock and spend what little time there was left cleaning the cameras for the following assignments.

At Kuching, finding I was a couple of days ahead of my itinerary, gave me the chance of a weekend break. The man who had met me from Government House suggested I got hold of a copy of the book *Three Came Home* by Agnes Newton Keith, and take it to the old Japanese prisoner of war camp that still existed just outside the town. This I did, and as I sat in the actual camp the book took me back to those days of cruelty and death and how the three managed to survive and live to tell the story. It was an experience I have never forgotten, a story that came alive as I sat and read it in that terrible place. Years later, I saw the film starring Claudette Colbert and Patrick Knowles, but it never gave me the same feelings that it had while sitting in the actual location, reading about the trials of those women under the Japanese.

Refreshed after my two days off, I was ready for my next assignments upriver with the Dyaks, the head-hunters of Sarawak. I had been given the governor's large launch for ten days, as the Dyaks lived in long houses beside the rivers, there being no roads or other access to them. The crew were Malays, and as they were all Muslims I couldn't have any food onboard that contained pig meat, so my tinned sausages were out. This meant that I had to rely on the crew cooking all my food, which I was informed would consist mainly of rice. It was recommended I take at least three bottles of HP Sauce to ring the changes in my forthcoming diet, together with twenty bottles of Arak for the headmen of the tribes I would be visiting. I was to have an interpreter with me at all times, together with a Chinese photographer who couldn't speak a word of English or Malay, which didn't help me as I couldn't understand him. So it was three men in a boat, plus a

174

crew with very little else to eat except rice.

Our first stop, having sailed from Kuching in the morning up the Santunbong River to the open sea, was at Sebuyau, where there was a rest house for the night. Turning to starboard we passed the Sadong River, and further up the coast sailed into the Big Lupar River, stopping at Sebuyau for the last chance of a proper meal and bed for at least a fortnight.

Going to bed, I found one big problem. Luckily I had left all my luggage and cameras on the boat for the night, as when I opened the door to my room I immediately saw that the floor was covered in bird droppings. Not only that, but above my head the ceiling was covered in swifts' nests. It was easy to see how they got in, as the windows were wide open either side, due to the heat. Not only did I have to be careful where I trod, the bed was in the centre of the room, under a mosquito net draped over, looking as if it might collapse under the weight of the bird shit. Making up my mind and knowing I had to get under the netting as fast as possible, and then undress, I made a dash for it. I was safe from being shat on under the net, but very worried about the way the net sagged under the weight. However, I was so tired I fell asleep knowing I would have to dress in the morning, standing on the bed. I slept quite well but when I awoke I had the problem of the bird shit all over again. Firstly, I had to dress while standing on one leg to get my shorts on. Then finally when I was fully dressed I had to navigate my way to the door over all the slippery 'umbala', hoping against hope I wouldn't slip and land in the stuff. Making it to the door, I wiped my feet on the grass outside before finding my way down to the river and the safety of the launch, away from that terrible room and the rest house.

The morning was peaceful as we motored upriver to the first of the long houses at Simanggang. I sat at the rear of the boat watching the crocodiles and multi-coloured birds as we passed the natives in canoes, fishing. Mooring up at the long house, I had time to look at

the construction of the village, which was housed in one large building made of wood. It must have measured roughly fifty to sixty yards in length with a breadth of something like eighteen to twenty feet. Built on stilts, it stood about ten feet off the ground, with the only way up a tree trunk, with notches cut at intervals. Wondering how I was going to navigate up the entranceway with the cameras, I suddenly found myself in the middle of a dance by the local witchdoctor, who was waving a dead chicken over me, splashing my clothing with its blood. My interpreter told me to stay still until the man had finished his gyrations and tuneless singing, leaving way for me to climb up the tree trunk into the darkness of the house.

Letting my eyes get accustomed to the gloom, I saw, as I looked around, a little man standing beside me with his arm outstretched. This turned out to be the chief of the tribe, and the only way he could be recognised was by the square piece of lino he was standing on.

After the welcoming ceremony consisting of a dead chicken, and having been greeted by the chief of the tribe on the lino, I looked at the whole length of the house, noticing that right down the middle was a wall with open doors, obviously where the rest of the tribe slept in families. At one end there was a large container full of a white liquid, which I was to find out later was their rice wine, a very strong alcoholic drink. But what caught my eye more than the wine was the shrunken heads that were hanging over the top. These were under half the size of a normal head, wizened, and with straw issuing from the mouths. It was then that I realised that the Dyaks were head-hunters, and that these were trophies from one of the last skirmish between villages. Feeling a little worried, I asked my interpreter whether or not it was safe to spend the night in the company of such people. I was assured that I couldn't be in a safer place, as the Dyaks thought the world of the English, and so I forgot my worries. For the rest of that day I took pictures of the work of the village and followed a hunting party into the jungle. They used blowpipes to kill the animals, which

they brought back to feed the whole village in a communal-type kitchen. By this time, my camp bed and clothing had been brought up and placed on the lino, a sign that I was now accepted. I had a lovely meal that evening, though if anyone had asked me what it was I had eaten, I wouldn't have known. When the meal was over and cleared away, all the unmarried maidens of the village lined up, dressed in Dutch silver dollars and not much else. These coins must have dated back a few centuries and could now be worth a small fortune.

Being fed with rice wine in the long house of a Dyak village by two unmarried maidens in Sarawak

There were fifteen young unmarried ladies lined up in front of me that evening, each with a bottle of rice wine and a silver goblet. The evening's entertainment started, with my not having a clue as to what was about to happen. The first maiden poured her wine into the goblet, tasted it to show it wasn't poisoned, filled it to the brim, and putting one hand behind my head poured it down my throat, or most of it, as some went down my shirt. She smiled and the next one went

177

through the same procedure, while I got more and more out of my mind. Halfway through all this my interpreter whispered that if I wanted to, I could take the cup and do the same to her, so in my half-drunken state, with the rest of them this is what I did, knowing that if I hadn't done so there was no way I would have been able to stand up. I don't now remember a lot more about that night, only that I slept very well in my camp bed on that piece of lino. In the morning, when I awoke, everyone else seemed to be about their business, while I, still in my bed, was brought a cup of tea by one of the boat's crew. Although how he had managed it up the tree trunk with a mug of tea, I never found out.

Now I knew the evening's system, I was sure I wouldn't get caught by the maidens again. I knew how to stop them pouring the so-called wine down my throat. I had brought the Arak with me, so that morning I gave the chief three, realising that I couldn't go to bed until he passed out. The first night they had made an exception to that rule, but I was sure I wouldn't get caught again, or thought I wouldn't.

Dyak performing an ancient dance.

178

Working hard for the rest of the day taking pictures, and having meals on the launch, I saw why the house was on stilts, as the river flooded at times. This I could understand, but what happened to the domestic animals that were kept under the house – were they taken to higher ground when the river overflowed? When I asked, I was assured they were.

One thing made me really sit up and that was when I saw one of them pouring water into the wine vessel, straight from the river. I found out that the wine was so alcoholic that it killed any bugs, so they just put water in when it got low, not bothering to brew more. No wonder I was pissed!

That evening, I did a lot of pictures in the long house. Pictures of women and their children, their husbands and their rituals, also the line of maidens as of the previous evening. The same thing happened, but I was now wise as to how to limit my consumption, enabling me to shoot some sixteen-millimetre cine of the evening's entertainment.

The next day we left for Engkilili, near the source of the river. As we got nearer, the width of the river narrowed. I was seeing to my cameras and spent flash bulbs. I had two boxes of one hundred PF60s, and had used one and was packing the used bulbs into the empty cartons, getting them all in except for six, which I threw over the side into the water, knowing that somehow they would break and sink. When I had finished cleaning the cameras, I sat down and just looked at the water before falling asleep, trying to make up for that I had lost in the first long house.

When I awoke, forty-five minutes later, we were just putting into the next village at Engkilili. The same greeting awaited, only this time the witchdoctor had two dead chickens, with which he managed to smother my clothes and me in blood. The rest was the same – the lino, the little man who was the chief, and in the evening the line of unmarried maidens. Thinking to myself I must not drink too much of

179

their wine, I entered into the performance, quite enjoying it.

There were three men who had bells on strips of wood, which they rang in unison, not very tuneful, but just keeping time for others who were dancing. The last girl had sat beside me with her bottle of wine and was plying me with it while I took photos of the dancing. The dancers made a dash for me, pulling me up and putting belts of small bells around my middle. Completely confused at this, I soon realised I was supposed to dance with them, so in my inebriated state I started gyrating in the centre of the floor, not knowing how or what I was doing.

That was the last I remembered of that night, as when I woke in the morning, wondering where the terrible smell was coming from, I suddenly knew it was from me. With my 'dancing' and jumping up and down on the floor, being built for little men it had collapsed, and I had found myself among the pigs below. How I then managed to climb up the tree trunk and get myself into my camp bed I will never know, but the thing I did know was how much I smelt. Still suffering the effects of the rice wine, I managed to get down to the river and throw myself in, clothes and all, not bothering about crocodiles. Coming out, soaking wet and with the smell nearly gone, I vowed never again to dance on the floor of a long house, especially with all the bruises I had sustained passing through it. Later that day, I waved goodbye to the crowd that had come down to see the mad Englishman off, the one who had gone through the floor of their home.

As we sailed back towards the sea, we passed the six spent flash bulbs floating line astern, the ones I had tossed over the side. When I saw them I thought, 'It was a good job I didn't let the whole lot go at the same time,' wondering what the locals would think about those six.

When we reached the sea, we turned into the next river and eventually reached Betong, where I was to stay with the chief vet for the region in the luxury of his family home. Late in the afternoon, we

tied up and were greeted on the riverbank by the whole family, while the rest of the crew, the interpreter and the Chinese photographer stayed aboard.

As we approached the house, I noticed the flagpole but no flag, for on top was a flat piece of wood, the home of their pet gibbon, who came down to greet me. It threw its arms round my neck and its legs as far round my body as they could get. I looked at its big eyes, and felt a creeping warmth down my front, the bloody monkey had peed on me! The family burst into laughter, saying how sorry they were, but the ape always liked to greet newcomers in that way. Anyway, after a good hot bath and a great meal, I was prepared to forgive the animal anything and see the funny side of the whole thing.

For three days I stayed with the family, who were only too pleased to see someone new. We used the boat every day, travelling to different locations and photographing different situations in the veterinary field, while each evening I had a good home-cooked meal and a soft bed. It was the best break I had in Sarawak and I was sorry to leave the family when my time was up. It was back to Sebuyau and on to Kuching, where I took up residence in the rest house for a few nights, away from my waterborne transport.

Two days later I took a flight to Sibu, to photograph and write stories about more village long houses, making sure that the rice wine was kept well out of reach. From here I flew to Labuan for a couple of days in the Shell Oil company aircraft. Things started to get a bit out of hand at this point, for when I was about to board I was told that I could take either my clothes or the cameras, due to the weight. Knowing it was no good flying all that way without my cameras, I reluctantly left my clothes behind and travelled in my khaki drill. At the airport, I was picked up in a big limousine and taken to Government House, Victoria, where I was informed I was staying the night. There were only two small jobs to do on the island, and so at about five o'clock, arriving back at Government House, I was

informed that I had to change as I was the main guest for dinner that evening. Here was I in my shirt and shorts and no dinner suit, as that was back at Sibu, as the main guest at a party for twelve in three hours' time. Telling my host the sad tale of my clothes, all the women rallied round and brought parts of dinner suits together with a shirt and bow. When I eventually got dressed, my borrowed trousers were some three inches too short, as were the sleeves of the jacket, but the shoes were too big, necessitating newspaper to stop them falling off. Looking like a scarecrow just come back from a night out, I joined the party with everyone knowing the reason for my dress, so nobody took any notice and it turned out to be a great night.

After saying my goodbyes the following day, I took the plane back to Miri to carry on with my assignments, having been reunited with my clothes at the airport where I had left them the day before. Having had a good sleep in the hotel that night, I carried on the following day with general shots of life around the town.

I next took a flight to Sandakan, in north Borneo, where the job was at the cutch factory. In the swamps I photographed workers collecting mangrove bark for producing the cutch, and bringing it back for processing. I finished the pictures early in the afternoon, and as I was going to the bird-nest caves at Gomanton early the next morning, at about five, I decided to get an early night.

The next morning I was driven a fair distance out of town to a small canoe and a native who could speak English, and who would paddle me upriver to the caves. I was handed an American automatic rifle in case we encountered animals, and the journey took about two hours. Once there, we pulled the boat up onto a hard shoulder of land, and before venturing into the cave I donned a pair of knee-high rubber boots. These, my guide told me, were because it was so foul underfoot, due to the bird and bat droppings and the cockroaches that lived on them.

The cave was enormous inside, and if one likened it to the dome of

St Paul's it was similar in size and shape, while the smaller dome at the very top was also much the same. The only difference was the large tree trunk that stretched across the smaller of the domes, with ropes attached down to the ground, making them about 200 feet in length. Around the walls were the birds' nests, stuck to the rock and made by swifts with spittle and feathers. Between the nests, bats slept, waiting for the evening before flying out and night hunting. My guide told me that when the nests were collected, men would swarm up the ropes and get them swinging in a circular motion, pulling them off the walls into their baskets as they swung past.

The guide was most insistent that we got out before dark and not stand anywhere near the entrance, as thousands of bats would fly out as the sun set. No sooner had we both got out than, with the sound of millions of wings, the bats came out, making it darker outside, before they flew off for their night's hunting. I managed to get a few shots against the setting sun, and they were gone. Never had I seen a sight like it, literally millions flying out in less than five minutes. There was nothing else that could be done that night so we lit a fire, had something to eat and settled down on the hard rocky ground in our sleeping bags.

At sunrise we were both up and about before the bats returned, ready to catch pictures of them. How the bats got themselves together to fly back in was anyone's guess, but they did just that, millions of them again. After a quick brew of tea, my guide and I went into the cave to try and get more pictures. But due to the physical size of the cave it was impossible to show it, except the part around the entrance. Instead I did shots around the cave with the entrance in the background, trying to light the foreground with a single PF60, to show the birds' nests and a number of bats hanging up asleep after their night's exertion. Any other shots would have needed long exposures on a tripod, and as I didn't have one with me I could do no more. There was one thing I didn't understand – how did they get that

first tree trunk up to that height for the very first time? I could see once one was in place it was possible to raise another with the ropes, but it didn't matter how many people I asked, the answer was always the same – they didn't know!

Leaving before lunch, we paddled back. I thought that having seen the birds' nests, I never wanted to try the soup, and I gently dozed with the sound of the paddle in the water.

Spreading pepper to dry in the sun at the Semegok
Resettlement between Serian and Kuching, Sarawak

Next day I was to catch an old steamer round to Tawau, on the eastern side of north Borneo. The trip was very restful and gave me time to get myself together for some of the last assignments in Borneo. Taking two days, the trip showed me all the lovely small islands that we passed on the way, some forcing the SS *Marudu* to

184

swing constantly to port and starboard as it dodged between and past them, while also missing the cays in its path. I was told that pirates inhabited a lot of the islands and quite a few of the small boats we passed carried the black flag with skull and crossbones. The nearby coastline I was told was deserted, but dangerous with the Suluk pirates using it, as they had done for over a hundred years, along the whole eastern edge of north Borneo. This was the first I had ever heard of pirates and thought it a bit of a joke, likening them to the ones I used to read about in my children's books.

I was staying in the rest house, which was a mile outside the town on the edge of the jungle. It was run by a Chinese couple who could speak no English, though the food and accommodation were excellent, not a bit like the last one I had stayed in. They had shown me where I could have what they called a shower, in a small building at the back of the house. Inside it consisted of an old oil drum cut in half and filled with water, and a shelf to put a lamp and towel on. The floor had been cemented so that the water drained out of a hole about two and a half inches in diameter. 'Great,' I thought as I got hold of the dipper, throwing the water over myself. After a bit I looked down and saw a snake coming in through the drain hole. Not waiting to see what type it was, I threw the dipper and rushed out shouting for the manager and his wife. I tried to explain what had happened, but looking at the confusion on their faces, I suddenly realised that I was standing there, waving my arms around with not a stitch on. However, at last I made them understand, but by the time we got to the shower room and I had grabbed my towel around myself, the snake had disappeared, no doubt because I had hit it hard when I had thrown the dipper at it. It was then that I tried to apologise for my lack of modesty, but their faces still had that blank look as I realised they just didn't understand, I wasn't getting though to them!

That night, in the early hours, I was woken by the couple pulling at me. Wondering what the problem was, they made me understand I

was to follow them. It was then that I heard gunfire and explosions coming from the direction of the town. Thinking it must be the pirates, they pulled me into the jungle where I lay for the rest of the night, listening to the war that was going on below. This was the second time I had had to do this, and as I lay there I wondered what kind of feast the leeches were going to have this time around.

Eventually, going back to bed and getting a couple of hours' sleep, I was so tired I hardly bothered about the leeches, and just lived with those that were left till I woke in the morning. After ridding myself of the last of them, with the help of the Chinese couple – who used lighted joss sticks to make them retract their heads and fall off – I had a good breakfast.

Wondering what had happened in the town overnight, or if my guide would come to take me on my last assignment, I relaxed while waiting for someone to arrive. We were to photograph two waterfalls and some sulphurous hot springs. Luckily there were some locals using the springs, so I was quite happy with the pictures. My guide had brought two clean towels with him so I was able to make up for losing my shower the previous night and get a really hot bath instead. Then it was back to the rest house, to get all my gear and clothes, and back through the town to the airport. It must have been quite a fight that night between the police and the pirates: I could see bodies still lying in the street, covered over, which made me remember the gunfire and explosions I had heard while hiding in the jungle.

Flying back to Sandakan, and then taking a plane to Jesselton, I had a last meeting with the people from the public relations department, going though all I had done in the two countries.

A day later I was on my way, flying back to Singapore, where I would spend a couple of nights at the Adelphi Hotel before getting a plane back to London. There were a couple of messages waiting for me at the hotel, one from Pam and the other from Andy, saying he was laying on a party for me as a farewell. Somehow Pam had got

hold of the date of the party and she was coming down from Kuala Lumpur to see me off as well, something I was not very happy about, thinking I had already said my goodbyes on leaving her at Kuala Lumpur Station.

The night for the farewell party arrived, with about twenty-five people present, held in the house of the *Straits Times'* editor. Andy had organised people from Singapore that I had dealt with over my time in the country. Harold and his wife were there as well as those from the PR department, with some from the newspaper, and of course Pam.

The house was on the shore just outside the town, so a few people were either paddling or just lying on the beach drinking. Andy was looking after me, and I was slowly getting more and more inebriated. I remember walking in the sea, but the rest of the evening was turning out to be a blank. I couldn't think of anything I did except tell Andy to make sure I caught my plane the next day. As for Pam, I recall talking to her, but what I said I just can't remember. I must have fallen asleep after that and the first thing I recollect from the next day is saying my goodbyes at the airport.

Somehow they had got my cameras and clothes on the aircraft, and then poured me onto the plane, where sitting down, I fell asleep again. Waking up halfway to Ceylon, I could barely remember the night before, knowing only what a damn good party it had been, while starting to realise how many strings must have been pulled to get not only me onto the aircraft in such a state, but into a change of clothes as well.

By the time I got to Heathrow, I was fully back to normal and looking forward to a holiday and home life before starting work again. I am sure a lot of people thought going abroad was one long holiday, they should have been with me, they would have found out!

Chapter 12

When I returned to work after a short break, my first job was the dreaded accounts again. Having got used to doing them, and knowing how the finance department thought, I was determined not to lose any more money.

I finished the task in ten days, and not hearing many problems this time, except the two receipts for the same night, I was off to cover the royal visit of Haile Selassie, the Lion of Judah, Emperor of Ethiopia. Being part of the entourage, I took pictures of him as he visited Bath and Oxford, looking at schools and hospitals.

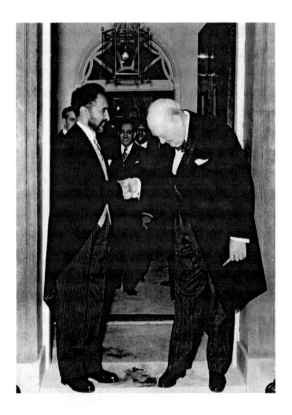

Winston Churchill and Haile Selassie 10 Downing Street

My vehicle was always just in front of the last police car, and every night I stayed at the same hotel as the rest of the party. I got to know the two royalty protection police officers well, as I had a drink with them most evenings. The sergeant, Reg Tyrell, became a good friend of mine, remaining so for many years after that first meeting.

The fifteen days ended at Number 10 with Sir Winston Churchill entertaining Haile Selassie and his son, so creating a fitting picture of the two great men shaking hands on the doorstep.

Towards the end of November 1954, I was off again, this time to Gibraltar, Malta and Cyprus. Flying from the UK in an old RAF Avro York, I landed in Gibraltar, frozen stiff from the draft coming in through the ill-fitting cargo door. There was very little heating in the aircraft, and as the freezing winds came in round the door, it was a wonder I hadn't been fused to the seat. However, as I left the old aircraft, I soon warmed up in the heat of Gibraltar's sunshine, walking to the small arrivals building. My first two weeks were to be on board an aircraft carrier, HMS *Eagle*, which was waiting to sail. It was to take part in NATO exercises in the Mediterranean. I met a lieutenant in the arrivals lounge, and was taken on board and given a cabin all to myself in the stern.

Having had a quick meeting with the captain, who explained to me the part the carrier would play during the exercise, I was told it would finish in two weeks, after which they would put into Valetta Harbour, Malta. On detailing an officer to look after me, the meeting ended, leaving my guide and me to sort out what I would be photographing during my time onboard.

As the ship pulled away from the dock, the two of us got down to working out some kind of schedule. The Lieutenant explained all the workings of the ship and informed me that I had to dress for dinner every evening, as I was now a member of the wardroom. Left to sort myself out, the first thing I did was hang up my dinner suit, after which I decided to walk round the ship and get my bearings, first

making sure I knew the number of my cabin so I wouldn't forget it as I had done before on a carrier.

I soon got into the tradition of the wardroom, picking up my napkin as I went in and finding some officers to talk to as I drank the cheap G and Ts, thinking to myself I could easily become very used to this way of life.

The weather next morning dawned fine so the ship was going to fly aircraft off, while others from shore would later land on. Having been briefed, I decided to spend the day on the flight deck, careful that I didn't get in anyone's way, but taking pictures of the daily routine and the aircraft. Later that day, I was with the batman on the aft quarter of the carrier deck, being given the safety rules. I was shown the net laid beneath us over the sea, which I was told ended in the marines' mess deck, and if I saw the batman jump into it, I was to follow him and not wait.

Three aircraft landed, which I photographed as they took the hook and stopped. The batman told me that the pilots were old hands at it. 'Just wait,' he said, 'until you get some new pilots landing, then you'll see why the net is there.'

I was tired that first evening in the wardroom, and having played cards for an hour or so I decided on an early night, especially as I would be roused at about 6.30 in the morning.

Waking the following morning to a cup of tea, I was surprised to feel the carrier rising and falling very slowly, as if I was in a lift at the stern of the ship. I learnt at breakfast that the weather had changed to a storm-force nine, and due to the size of the ship the aft was going up and down about seventy-five feet. Luckily, I didn't suffer from seasickness, but a lot onboard did, due to the slow motion of the large vessel as it went into the high seas, battling those storm-force winds.

The bad weather lasted for five days, until there was a break. All I could do during that time were pictures of various parts of the interior of the carrier, from the engine room to the messes, hangar spaces and

pilots' briefings.

The weather improved suddenly and flying could commence again, so I took my position with the batman. I got some great pictures of the Fairy Firefly aircraft landing, until there was one that when it caught the hook slewed sideways towards me. Jumping out of instinct, I followed the batman as we both rolled into the marines' mess deck, knowing I would never have jumped had I stopped to think. That aircraft ended up hanging right over where the two of us had been standing, luckily not going straight into the drink, but making me realise the danger of being a batman, let alone a pilot.

Another day and the aircraft were firing rockets at a splash target towed by the carrier. The rockets were inert as they had cement in place of the explosive charge. Once again I was near the batman, but on a perch a little lower down, so that I could see over the deck without having to dive into the net again. One aircraft radioed in with a hooked-up rocket, which he couldn't shake loose, so they cleared the deck and he was told to land. As he caught the hook, the sudden jolt made the rocket fire and it shot the whole length of the carrier deck, disappearing over the bows. Everyone breathed a sigh of relief and thanked their lucky stars it hadn't been armed.

The weather closed in again, and for two days I could do nothing except wander round the ship, photographing places I hadn't covered before. This time the storm lasted only a short time, but still the sea and winds were high, with everything battened down again and the captain not allowing anyone on the flight deck under any circumstances.

When the sea calmed and the sun broke through, normal routine was resumed and flying recommenced. I knew that I had aerial shots of the ship to take, with shots of her squadron passing over, so I attended a couple of briefings where I explained to the pilots how I would like to get the pictures. I would be in the navigator's seat of a Fairy Firefly, facing backwards. Once up and flying I could undo my

191

harness, enabling me more free movement. I would use the Speed Graphic, due to the speed of up to a thousandth of a second with the focal plane shutter, and the larger format.

I strapped myself into the navigator's position, ready for take-off, as the pilot taxied up to the catapult. As it was the first time I had ever been catapulted off a ship, I sat hard back in the seat as instructed, waiting for the off. One moment I was on the carrier, the next over the sea, with the size of the ship diminishing as we climbed to a height to take pictures of the squadron passing over. This was going to be difficult because of the tail in the way, and having to shoot either left or right of it. It meant that my aircraft had to be on another course, higher than the others and cutting across the main squadron's flight path, to get a clear shot. All this had been gone over at the briefings and my pilot got it just right every time.

Luckily for me there was a shelf across my front, so I could put the exposed slides on the right, knowing in the excitement I wouldn't then double expose any.

Making three passes over the ship with the squadron, I felt very satisfied with my work, especially as I knew where the exposed slides were. Looking down at the carrier, it appeared so small, and I felt just a little frightened sitting backwards, as I wouldn't see the aircraft approach the carrier and take the hook. Having strapped myself in hard, I soon knew when the plane had landed, as it stopped dead. At that same moment the slides took off from the shelf, scattering themselves all over the small cabin, something I should have thought about. Now I had no idea which ones were exposed or which weren't, so counting and collecting the slides, I picked them all up, and climbed out of the aircraft. Going directly to the darkroom onboard, I boxed up all the sheets of film, both exposed and unexposed, knowing they would all have to be processed.

Ending my assignment in the Mediterranean on HMS *Eagle*, the following day we steamed into Valetta Harbour. I was to stay on the

ship one night more, so two of the petty officers suggested a run ashore with me. That evening they took me to the Gut in Valetta, a narrow street that dropped down the hill with bars both sides of the road, a well-known haunt for sailors over the centuries. We started drinking at the first bar on the right at the top of the hill and had a drink in every other on that side till we reached the bottom. It was at this point that I must have given up, as I remembered no more till I awoke the next morning in my bunk, the petty officers having carried me back to the ship that night and put me to bed. Saying my goodbyes and thanks the next day to the captain downwards, I went ashore to stay in a hotel overnight, getting the effects of the Gut out of my system.

Admiral Lord Mountbatten was to be rowed out to his ship HMS *Surprise*, as he was leaving Malta, having been in charge of NATO. He was taking another position in the Royal Navy, back in the UK, and was to be rowed out by six admirals. Before His Lordship left Malta, I had to see and thank him as it was he who was personally arranging my trip to Cyprus, as no airlines flew between the two islands at that time.

Early one morning I walked into Naval Headquarters to get my trip to Cyprus sorted. A naval lieutenant took me into see a captain, who was surrounded with paper and on the phone. Motioning me to sit, and putting the phone down, the officer asked, 'And what do you want?'

Taken a little aback, I replied, 'I have to ask His Lordship if he would kindly arrange for me to be taken to Cyprus as the Admiralty in London told me that he would be arranging the trip for me.'

The captain, not being used to civilians coming in and asking for His Lordship to do something, said, 'If you think I am going into His Lordship's office to ask him that, then you're mistaken!'

Fed up at the man's attitude, I replied, tongue in cheek, 'All I know is that His Lordship said he would arrange it, and I feel that it

might be a good idea if you went in and asked him about it.'

The captain, realising now that perhaps this young man might be right, especially when he mentioned the Admiralty, grunted and disappeared into the next office, closing the door behind him. Hearing raised voices, I waited and a minute or two and later he reappeared with a very red face saying, 'His Lordship asked, would you like a destroyer or would an aircraft do?'

I immediately chose the latter, as I had had enough of the sea for a while. I was then told by the captain to appear next evening at RAF Luqa in time for dinner, when a Shackleton would be ready to take me to Cyprus.

The following day, I photographed Lord Mountbatten being rowed out to his ship by six NATO admirals on the day he relinquished his command in Malta.

That evening I took a taxi to RAF Luqa, to be greeted by the group captain in the mess. Shown in, I was immediately introduced to the officers who were flying me that evening. Nobody asked anything about me or about my trip, seeming to shy away from the subject deliberately. After a good dinner the group captain took me with my gear in his car to the squadron office, where I was given a set of flying overalls, with wings and squadron leader's bars. Thinking nothing of it, I shook hands with the CO and boarded the aircraft, with my cameras and case loaded after me. I was asked by the pilot if I would mind taking the forward gun position until we were airborne, and that after I could take the co-pilot's seat. Taking off from my position in the nose of the aircraft, I saw what an attractive night it was, with the full moon reflecting on the sea as we cleared the land, and the cloud shadows scudding across the calm water. Told over the intercom I could now take the seat, I scrambled out backwards, standing up as I came out of the front turret. Taking the seat and thanking the pilot, I felt tired and relaxed while looking at the moonlight on the water, which seemed so mesmeric. After what seemed only a few minutes,

but could have been a lot longer, I pulled myself together, and turning my head to talk to the pilot, suddenly realised he wasn't there. It didn't take long for me to come to the conclusion that I was the only one in charge of the aircraft, but knowing that couldn't be right, as I had never learnt to fly. The control column was moving all on its own, while at the same time I seemed dimly to remember the pilot asking me something earlier, but couldn't think what. Turning round and looking behind me, I pulled a curtain aside, seeing the pilot and two others playing cards. Asking them at that point who they thought was flying the plane, the pilot retorted, 'You are, sir?' in a questioning voice.

I replied, 'No I am not, I can't fly.'

With that the pilot flashed past me into the other seat. It then appeared, when all was calm again, that nobody knew anything about me. It had been assumed that I must be part of MI6 on a secret mission, as I had come directly from His Lordship, and that I must be very important to have had a special flight laid on.

With that, I put them right about myself, and they took me round the aircraft with all its radar and detection gear, until we came to the very rear, which was covered in empty glass bottles of every make and size. There were Winchesters and carboys, pints and smaller, and when I asked the reason the sergeant told me this special flight was a great opportunity to fill up with Cyprus brandy and sell it round the messes in Malta, making a good profit for the crew, just before Christmas.

At Cyprus, I said goodbye to the crew, thanking them for a great trip, and took a taxi to the Acropole Hotel in Nicosia, where I had been booked in for my stay, returning to the UK by trooping flight after Christmas.

It was in a totally different environment that I found myself after my trips to Africa and the Far East. Cyprus was a lovely island in which to work, with its orange and lemon groves, wine and brandy vineyards and beautiful scenery.

A fruit packing station of the Cyprus-Palistine PlantationCompany in Phassouri, Cyprus

There was wonderful swimming and mountains on which to ski in the winter months, together with historic castles that made the whole mix a real joy for me to work in. The hotel in Nicosia was a very peaceful, tranquil establishment, with a young clientele of students and people of my own age, which made this part of the trip more like a holiday than work. All in all I felt I couldn't be in a better place to spend my first Christmas away from home.

I started my assignments with the vineyards and the production of wine and brandy. Some following jobs consisted of traditional Greek

196

dancing outside one of the historic castles at Famagusta, where the ladies appeared in old-fashioned dresses and the men wore white skirts to dance. I remembered seeing Greek army guards dressed much the same in Athens.

Taking a four-day break at Christmas, feeling I deserved it, as I had worked every weekend, I spent it with the friends I had made in the hotel. The owner of the Acropole, Chris Saffroni, was a great host, putting himself out for all his guests. I had long talks with him about the country and the problems of the terrorist group, Eoka. I had had enough of terrorists on my travels and was only too pleased not to have to get myself involved with this lot, or so I thought. Christmas that year was one to remember, and all thoughts of potential difficulties were forgotten as the guests and I celebrated it as only the young could.

The Central Power Station with fuel storage tanks alongside at Dhekelia on the rocky coastline of Cyprus

Looking down on Kyrenia Harbour in Cyprus

*Goats being driven through the yard of a
government stock farm Aphalasa, Cyprus*

*Girls in traitional costume at Bellapais Abbey
at Kyrenia in Cyprus*

The excavated site of a Greek gymnasium at Salamis, Cyprus

Ships at the dockside in Farmagusta, Cyprus

After the festivities, I carried on with my jobs in Limassol, Olympus and the Troodos hills and mountains, thinking again to myself what an idyllic country this was to work in. I had a couple of small assignments with the British Army on the island, one of which was to do with recruitment and transport. That day I was going round the maintenance garages of a large army unit, taking pictures of happy soldiers, when suddenly there was a shout of 'Down!', and like everyone else I fell flat. A bomb had been thrown over the wall and exploded, but luckily the shout had come quickly enough to save any casualties. However, it made me realise that wherever I went in the world, someone seemed to have it in for me!

Finishing my work at the beginning of February 1955, I got myself ready for my flight home on Britannia Airlines, a British Aviation Services carrier that landed at Blackbush in the south of England. I said my goodbyes to the friends I had made at the hotel, and to the owner Chris, who had told me about the restaurant he owned in London. It was called the Boulogne in Gerrard Street, and he said he would be delighted to see me there at any time in the future.

Taking a taxi to the airport, I boarded the four-engine Britannia aircraft together with soldiers and their families going home on leave. I was allocated a front seat with the officers and was soon talking and explaining what I had been doing during my time on the island.

I was slightly amazed when the pilot came into the cabin during the flight, dressed in a beret and roll-neck sweater, which didn't make a good impression on the officers or the men. He had come to tell everyone that the engines had been de-rated in order to take a lower grade of fuel, and that due to this he couldn't get enough height to clear the Alps. So he was going to cross Italy after refuelling at Brindisi, and then on to Nice before flying up the Rhône valley in France. Although no one seemed worried about the change, some, including me, didn't like the sound of things, especially when the pilot whispered to my small group that there was a force-nine storm

201

brewing in France and the UK, with very high winds and blizzard falls of snow.

After refuelling we were soon off again cutting across Italy, direct to the South of France. While most slept and others talked, I began to wonder if this was going to be another one of my peculiar flights.

Later, as we turned up the Rhône valley, we caught the predicted storm head on, fighting against the winds and snow of force nine or ten. Unable to fly above it due to the de-rated engines, we flew at 10,000 feet, making only about sixty miles an hour against the headwinds. Slowly we flew up the valley, and when we were about halfway to Paris we were informed by the crew that Le Bourget would close within the hour, as the snowfall was too great for them to keep the runway clear – but just for us they would stay open. People were being sick, and children were screaming as the aircraft shook and juddered about in the strong winds. But that wasn't the only problem. We were very short of fuel fighting against the high winds at a continual slow speed. The pilot came back to talk to us again, saying that he was not sure whether the fuel would last out long enough to reach Paris. Everyone was now very worried, as he also told us there was not another airport with a long enough runway to take the aircraft before then.

But at last, an hour later, the runway lights of Le Bourget were seen through the driving snow, as the pilot tried to line up on the yellow approach lights. Touching down on the runway, the aircraft slid one way and then the other, till it finally came to rest facing the way it had come, with not enough fuel left for it to taxi to the arrivals building. All the passengers had to leave the aircraft in the howling blizzard, for the walk to the main buildings. Most were dressed for a hot climate and had no winter clothes. I personally was frozen when I got into the building, fretting about what it must be like for the rest of them, especially the children.

There we had to wait for hotel accommodation to be arranged,

together with transport to get us to the centre of Paris. At a hotel somewhere in the centre, and with three officers, I found I was the only one with any money again, so the four of us went to the bar and drank my £2 away before going to bed.

After a short night's sleep, we boarded the aircraft again for the flight to Blackbush the following morning. The snow was still thick as we took off, but the runway had been cleared as the storm had abated during the night. At Blackbush a short while later, the runway was clear, but I could see that it had been as bad here as in Paris, with piles of snow heaped around.

Saying my goodbyes and hiring a car to take me home, I now knew that whenever I took a flight something out of the ordinary would happen. Was I getting paranoid, or if I wasn't, why was it that my flights never seemed normal?

A week later, I was back at work with the dreaded accounts. It didn't take me as long this time, as the trip had been shorter and I had got to know the pitfalls involved very well. The finance department had already received the account for my stay on HMS *Eagle*, so the rest was fairly easy. Within ten days I was ready for work again, the accounts having gone through more easily this time, so once again it was local London assignments for me.

A month and a half later I was sent on another royal visit, this time the Shah of Persia for the Foreign Office. After he had inspected the traditional parade of guards in the Foreign Office courtyard, the entourage were off on a trip round the south of England. Once again I was the second-to-last car, while my friend Reg Tyrell was one of the two protection officers again. It was a fortnight before the Shah's entourage were back in London, for a football match at the Arsenal. A few days later I went to the Savoy Hotel to photograph his reception before he returned home. This event was to thank everyone for the hospitality he'd received, and as usual in these situations I was in a dinner suit, as were the rest of the press and guests. Also as usual,

when I had finished photographing, I took the camera case and put it behind one of the serving tables, and started to eat and have a few drinks, as no one could tell you weren't among the invited guests. I was just sizing up what to eat when I felt an arm round my shoulders, and heard a voice I knew: 'Hiawatha, come and meet Lady T again.' With that Sir Gerald Templer guided me across to a small group who were talking together.

'Look, my dear, who I have found,' said Sir Gerald. Before his wife could reply he turned to me saying, 'How would you like to be out there once more, me boy, just to feel the prickly heat round your belly again.'

I didn't quite know what to say, as the other guests were the Shah of Persia and the old Duke of Norfolk. The Shah was grinning, as he had known me from the trip, but the Duke's face was bright red as Lady Templer stepped in.

'How nice to see you again, John.' She shook my hand, putting everyone at ease before letting me escape back into the crowd after a slap on the back from Sir Gerald.

After that evening, I was back in my normal role, this time for the Home Office covering London's famous prisons.

I started at Wormwood Scrubs, the first prison I had ever been in. All went well to start with, until we went to the tailoring shop. Because no prisoners' faces could be shown, either the prison officer with him, or I, would have to get the inmates' permission to photograph them from the back, or not at all, and this worked well. Everywhere I went, I had to be locked in or let out, so by the time I got to the shop I was used to the security. The warder said he would get the man who was teaching them to get their approval. So while waiting for the men's permission, I looked at the twenty or so inmates, all of whom had large tailoring shears to hand. The officer wasn't getting on too well with trying to talk the men round, and the atmosphere was getting rather nasty, until, for some reason, they all

started laughing. It was then all right for me to do my pictures, which I did as quickly as I could, getting out of the place before anything else was said or happened. Outside, the prison officer said it had been touch-and-go in there, as the majority of prisoners were inside for grievous bodily harm. So, not a nice place for me to be locked in, among those men and their tailoring shears.

The following days it was Pentonville, Brixton and Wandsworth, with the last day Holloway, finishing them all in about ten days. Holloway was a prison for women only, and directly I was inside there were wolf whistles and shouts about how they would like to get hold of me, not saying what they would do if they could. With this racket going on, and especially with some of the remarks, I was finding it difficult to concentrate on taking pictures, but worse was to come. I had been in there all morning, and after lunch with the governor I had only the main block left in which to do general shots. This old building had cells on three storeys, with wire mesh over the open area to stop inmates throwing themselves down. I was looking up at the very moment when, on the second floor, I saw a woman with bright blonde hair being escorted from one cell to another by two warders. The atmosphere in the prison had been jocular up to this point but it changed in a flash with screaming and yelling coming from the inmates. Then from up above, bare bums appeared over the guardrails, and urine started raining down on everyone below. I was being peed on from a great height. Getting out as quickly as I could after collecting my gear together, I was told that the woman I had seen was Ruth Ellis, the last woman in England to be executed, who was being moved closer to the chamber where she would be hanged the following day. This was one more thing I have never forgotten, though I had only glimpsed her by her blonde hair. After that day I was pleased the whole job was over, vowing that I would never do anything wrong that might end me up in one of those prisons.

A couple of weeks later, Eric Underwood asked if I would come to

his office. Worried that I had done something wrong, I shut the door on entering. As I sat down, Underwood explained that he was leaving the COI and taking up the position as head of public relations at the United Kingdom Atomic Energy Authority, and would like to take me with him. It would mean a rise in salary to that of chief photographer for me, and a start in my new employment in just over three months' time or so.

I was very surprised, firstly at Underwood leaving, and secondly that he wanted to take me with him. Saying I would think about it that evening and over the weekend, when I could talk to my parents and pals, I went downstairs to the darkrooms to tell the other photographers. It meant that I would miss working at the COI with all the overseas trips, but I knew I was getting older, and would perhaps be settling down soon, though at that time I had no future plans in that direction. Going home that Thursday evening with my head full of the new job in prospect, I knew in my heart that it was only me that could make the decision, though I needed to talk to my family to get their ideas about it, as well as chatting it over with my pals and getting their thoughts.

At the weekend my friends and I decided to go to a different pub, The Ship at Shepperton. Doug had suggested this as he had heard there was a very good pianist there, one who could play any tune asked for. I phoned Reg at the section house in Tooting nick to see if he was free to join us. Luckily he was and so I arranged a time to pick him up on the Saturday, so that Doug and Geoff could also be collected on our way through.

There was a lot of talk in the car about my new job, though no conclusion was reached as everyone was thinking more about the night out.

The pub was crowded and the pianist as good as Doug had reported. The beer flowed as we sang our hearts out, standing round the piano with the rest of the customers, including two or three

unattached girls, making the pub an even more alluring place. With our plates of sausage and mash, provided in compliance with the licensing laws, we continued drinking and singing until we were thrown out at eleven.

Saying goodnight to Barbara, and thanking her for playing our tunes, I had my eyes on one of the girls as we left. Her name was Chris, and I arranged to meet her the following evening again in the pub. Only Doug and I went down the next evening, as Reg was on duty and Geoff felt he'd had enough beer to last him a week. Meeting Chris again, we sat with a drink and talked for a short while before succumbing to the piano, and getting up and joining in with the singing.

I began to spend most evenings when I was free meeting with Chris in Shepperton, mostly at the pub, being a good place to chat. We both got to know Barbara Andrews, the pianist, very well, and would be asked back to her home on many occasions, when she would carry on playing while we sang our hearts out. Ted, her husband, was there quite often, as was their daughter Julie. It was then that we both realised who the family were – Ted and Barbara Andrews, and Julie Andrews, soon to become a film star in her own right. In fact twice I sang with Julie at her home, once when I had had a little too much to drink, and again when I was completely sober and she and I sang as a duet 'Old man River'. At the time Julie was in *The Boyfriend* in London, and it was on Sundays only when she would be at home.

Chris told me she had been born in Aberaeron in Wales, and that her mother had died from an overdose of gold injections when she, Chris, was only two and a half. Her widowed father had brought her up while putting the electricity into Aberaeron and Borth, with his own generating plant in both towns. During the war he was called up in the RAF, when Chris then had a series of women to look after her while he was away. He had died soon after the war when Chris was

only fourteen, and since then she had been living with her grandmother and aunt in Streatley, and going to school in Reading. She had found a job in London after leaving school, and was now staying with her cousin and family in Shepperton, not far from the pub.

I felt for the first time in my life that this could be the girl I had waited for, but it was early days and so we started just to get to know one another, meeting whenever I could get away from work, but soon taking her home to meet my parents.

After that, it was down to see her grandmother and aunt one weekend, and then quite often thereafter, as she felt this had been her real home for many years. I was taken with them both and they also got to like me more with every visit. It was obvious to both Chris and me that we were in love, and so, asking the grandmother's permission, as their ward was only then nineteen, I proposed and we became engaged.

Chris's family had a history going back to the Spanish Armada, and at some time in the 1700s a Field married into the Cromwell family, and from then on the name changed to Cromwell Field, warts and all!

Chris moved from Shepperton to a bed-sit in Wimbledon, from where we subsequently found a new maisonette in Wallington, still being built, which would be ready in November of 1956. Here we could start our married life. The wedding and reception were arranged to coincide with the completion of the house, with the service to be held at St Mary's Wimbledon Parish Church, on 24th November 1956, making the ceremony under six months away.

I still had to work out whether I would accept the new appointment. Knowing that the money would be more and that there wouldn't be so much travelling and fewer nights away, I decided with Chris to accept the offer.

This meant three months of security-checking, or personal vetting

as it was called, before I could hand in my notice. At the end of that time, I was informed I could take up the new job, and I gave a month's notice at the COI.

So it was then that I joined the Atomic Energy Authority as its chief press photographer, starting in temporary London offices at St Giles Court.

A friend of mine, John Curtis – one of the pals I had met on National Service – had contacted me completely by chance that week. At the time he was employed by Standard Cars in Coventry, and was looking for a better job. I gave his name to Bob Howarth, and Johnny was 'boarded' and got the vacancy I had left behind.

My first job at the UKAEA was with the stand designer for the Queen's opening of the first atomic power station in the world, Calder Hall. This was to take place on 17th October 1956, and I had important decisions to make in the planning, making sure that all the press photographers, scribes and film cameramen had adequate views of the ceremony, and got the pictures they wanted. Calder Hall, and the twelve more to be built before 1965, would give 2,000 megawatts of power to the grid at a much cheaper price than oil.

The Queen opens Calder Hall, the first atomic power station

I was also to take pictures of the Queen being shown round the plant, together with one film cameraman and a still photographer, who would share their pictures with the TV, newsreels, papers and news agencies. I knew the majority of still photographers from Fleet Street, and was congratulated by them, after the ceremony, at how smoothly and well they had been looked after. I was delighted, as I had never done anything like this before.

My next job was at Harwell, for the visit of the Soviet leaders Krushchev and Bulganin, where I was back on the press jobs, photographing them as they were shown round. One shot I took was of the two sitting, dressed in white overalls putting on overshoes. This shot was the one all the magazines used, including a full-page picture in *Paris Match*. That one picture did more for the authority than any other of the visit, and combined with the opening of Calder Hall I felt

I had started well in my new job. It was now time to think more about the wedding and less about the new job, until Chris and I had started upon our married life.

Kruschev and Bulgarin of Russia on their visit to Harwell

"Now at the age of eighty two, I sit in my lounge and look at some of my past photographs on the wall. They are special shots that mean a lot to me and are comfortable to have around"

Soldiers in PNC suits carry a casualty to a
helicopter for evacuation

Red Deer at Warnham, Surrey UK

Jaguar fighter at RAF Bruggen, Germany

Lake Victoria at Kisumu, Kenya

*Four Nandi recruits of the 4th Battalion,
Kings African Rifles*

Erection of the coffer dam Lake Victoria, Uganda

215

The railway station Kuala Lumpur, Malaya

The first G7 Harrier jump jet to be accepted by the RAF

RAF Regiment and 33 Sqdn Pumas on exercise

Chapter 13

It was a dark, foggy day for the wedding, as it was November. Chris had spent the night before at my house, while I had slept at Doug's, my best man just round the corner in Firstway.

As the wedding was timed for midday, the morning for both bride and groom went slowly, both realising how all the worry about it had got to them. Everything had been arranged, but still I had those little niggles in my mind as I got changed into my morning suit. The car picked us up early, driving us to the church in Wimbledon village. It was cold, and late in the morning as we waited outside to greet the guests. I had arranged for two photographers to take the pictures, but four had turned up, all determined not to be outdone by the others. There was Norman Smith, John Curtis, Gerry Hammond and Greg, which made me understand how the brides and grooms I had photographed so many times must have felt.

I retain very few memories of the ceremony, except for the photographers, who had somehow got into the church and seemed to be rushing round the gallery taking pictures. At last it was all over and after the walk down the aisle Chris and I felt more relaxed. Pictures outside the church were taken, and we were on our way to the reception at the Castle Towers Hotel, where we were given a much needed stiff drink before the guests arrived.

It was a large guest list, as there were all the personal friends from both sides, together with relatives and work colleagues. The whole afternoon seemed to be taken up with thanking everyone for presents, shaking hands and kissing. Eventually we could slip upstairs and change to say our goodbyes. We drove into London to see the show *Can Can*, having a great meal afterwards at the Boulogne Restaurant in Gerrard Street. Driving back to Wallington to our own new home, we talked about the day and how it had gone. We had decided not to spend the money we had both saved on a honeymoon, but instead use it on carpets and curtains, making our first home as comfortable as

possible.

The two weeks I had off were spent with trips to the shops buying all the items we needed in the maisonette. At the end of my leave, we were very happy with our first little home.

Chris had given up her job and was now concentrating on her cooking, with me hoping it would get better as the days passed, while I was driving to work most days, and not having to travel away as much as I used to with COI.

If I went to AERE Harwell, I would drop Chris off at Streatley to spend the day with her grandmother and aunt or other relatives, not far away at Cholsey.

I was getting used to the work of the authority and the places I had to photograph, having been shown round by Paul Robeson of the PR department. Harwell was close, but the others were all a lot further away: Calder Hall and Sellafield in the Lake District; Chapel Cross, another atomic power station, at Annan, Dumfries; Springfields near Preston; Capenhurst near Chester; Risely just outside Warrington; and Dounreay in the north of Scotland.

It had been difficult to start with as I had to process film and acquire prints at the COI, although it was great being able to stay in contact with old friends, every time I came back from an assignment, it meant hours in the darkrooms at my old place of work.

It soon became obvious to Underwood that I needed my own darkroom facilities, partly because of time that was lost in processing away from base, but mainly because of security. Every time I took a picture at any of the authority establishments, the prints had to be cleared before they could be used in any periodicals. The basement at Ormond Yard was chosen for the new darkrooms, which were to include a large studio with processing facilities for both colour and black and white. On the colour side, the darkroom was to be one of the first to print and develop colour prints from colour negatives, a great innovation over working from transparencies, as the only colour

prints that could be produced before colour negatives were dye transfer prints, which took time to make and were very costly.

The darkroom got underway and I was given an assistant, a young man named Brian Goodman. He had just finished National Service and this was to be his first job after demob. As the darkroom neared completion, Ray Pearce was recruited on the colour side, and Phil Long from COI was the black-and-white printer.

It was great for me as the chief photographer to have my own darkroom and staff to back me up. The darkroom was only a few hundred yards from the main office in Charles II Street, where the rest of the public relations department was housed.

There was Pam Kirk, who looked after the new photographic library, and Drs Horace Manly and Paul Roberson were there as the technical experts of the department. The rest, on the press side, were Len Cina, Sandy Campbell, Ron Truscott, Cyril Darbey, and Stan White as the chief press officer. The entire PR department was overseen by Eric Underwood, whose second in command was Bill Akroud, who had joined from the Coal Board.

I was in charge of my little empire in the basement of Ormond Yard, far enough away from head office, but no distance if one wanted something like expenses.

At home we were turning the maisonette into a very comfortable home, while I never stopped thinking about where all the money was going. Like all married couples in the late 1950s, we did some silly things, such as buying a St Bernard puppy from Harrods, which we named Hornblower. As he started to grow, he needed large amounts of calcium for his bones, as he started to outweigh the strength in his legs. This necessitated Hornblower being carried up and down a long flight of stairs every time he needed to go to the toilet, until his legs were strong enough for him to navigate the stairs under his own steam. Not only that, but Chris had to negotiate a price at the butcher's for six pounds of meat a day, mainly the butcher's cut-offs,

to feed the dog daily, as he wouldn't eat anything but raw meat. Still, he was a wonderful dog who, literally, became a great friend to everyone around him.

Eleven years after the UKAEA had taken over Harwell from the RAF, the US Air Force used the runway in an emergency for one of its jets. Much of the runway had been built on, and to stop aircraft using it a very large red flashing light had been put roughly where the approach lights used to be, to warn aircraft off.

On the evening of 22nd April 1957, a dual seat T33 jet of the US Air Force was lost, due to instrument failure. It was also running short of fuel, and with the weather closing in it needed an airfield urgently. Spotting the runway and hangars and the large flashing light, the pilot thought it must be RAF Abingdon. He had never heard of AERE Harwell, so after circling twice he flew low over the Ridgeway and lined up on what he thought was a usable runway. As the jet touched down, the pilot slammed on the brakes to prevent it colliding with traffic on the B412. When it came to rest two officers clambered out and were joined by a police sergeant, who later, I was told, said they couldn't leave the aircraft there!

The next day the story hit the newspapers, with the PR department busily trying to sort the whole thing out. Next, the US Air Force wanted to fly the aircraft off again. So, fixing two rocket motors, one on each wing, it was towed back so that it would have the longest part of the runway for lift-off. Another pilot was brought in to fly it out, after new tyres had been fitted and other repairs had been done. The day came when it was to fly out. The pilot applied brakes while he worked the engines up to full power, then released them, and after a quarter of a mile fired the rockets. With the stick hard back, the aircraft went into a steep climb, but at this juncture the port rocket ceased firing, making the aircraft turn sharply to port with the wing touching the ground, while at the same time the pilot made an attempt to raise the undercarriage. In this way, the aircraft became a missile,

and had it not been for the security fence that all but stopped it, it would have ploughed on causing a great deal more damage. The pilot was pulled out and taken away by ambulance within seconds, while the aircraft was deluged in foam due to the fire in the engine.

Later, the aircraft was cut up and taken away in bits, while the security fence was swiftly repaired, and Harwell was back once more to normal. The ultimate flight had taken all of five seconds, as the aircraft had crashed from an altitude of ten feet! Employees and local residents talked about it for many years, and nobody forgot the night the American Air Force came visiting.

Soon the time came for our first child to be born, and I had taken the time off to be with my wife for the birth. I took her into the War Memorial Hospital at Wallington when she went into labour, and stayed for quite a time, but as there was no sign of any arrival I went home to await a call. I had just got there when the phone rang, and thinking the baby must be here I picked up the receiver, only to discover it was the office saying a Swiss journalist had come over to talk to Sir John Cockcroft, and that pictures were wanted of the two of them together. That I was waiting for my first child to be born was no excuse; the caller was most insistent, so I had to go up to London.

After I had taken the shots and left them for processing, I drove to the hospital fast, in the hope of seeing the baby born, but alas it was not to be, for when I got there my wife was sitting up in bed holding our son Paul.

There was a sequel to this story. The next week, when Chris and the baby were home, a large bouquet of flowers with a great box of chocolates were delivered from Madame Jacqueline Juillard, apologising to my wife for taking her husband away at such a time. She replied with a phone call, and so both Jacqueline and André, her husband, became great friends, and for many years our two families visited each other on a regular basis. Jacqueline was not only a journalist but also a chemical engineer, while her husband bought and

sold private aircraft.

André would fly into Gatwick occasionally and stay with us both. One evening, getting a phone call from him at Gatwick, I went to collect him from the private section of the airport, and found he had another person with him.

Normally André would stay the night, so Chris had told me to pop to the fishmonger to get some frozen sausages, as it was the only food shop open late in those days. This I did on the way, as we had had our evening meal earlier.

André told me, while we were driving home, that his companion was an important client and that they'd be staying in a hotel in London, so we were not to bother with any food at home. When we got there, after being introduced to Chris, the stranger went round our kitchen checking everything, especially the wall oven from Canada, which was something very new in the UK.

It turned out that this gentleman was none other than Monsieur Roucout, President of the Société Gastranomique of France, and Chris and I were going to feed him sausages from the freezer! Then came the second surprise, when he asked Chris and me to join André and himself for dinner at Madame Prunier's in St James's Street that evening. Although we had eaten earlier, this was an invitation we just couldn't resist, so asking one of our neighbours to baby-sit we all drove to London.

André whispered to me to let Monsieur Roucout do the ordering, as he was a great friend of Madame Prunier in France and knew what was best on the menu. We started with a lobster each, followed by steak with all the trimmings, making us realise how well the French cooked, yet knowing if anything else was put before us we would have to abstain politely. It was after midnight before Chris and I eventually got into our car and drove home, vowing that whenever André came again there would be no frozen sausages on the menu.

Work reverted to routine with the authority. I travelled to the Lake

District to cover the Sellafield plant, in one of the most beautiful parts of England, with Wast Water and the sea at Seascale close by.

Dounreay in Northern Scotland showing the fast breeder reactor

After my first trip there, I always stayed at the Stanley Arms at Calder Bridge, which was essentially a pub with the River Calder meandering round it. I would take my pint outside in the summer evenings and drink in the garden, watching the salmon swimming in the river. I had met a farmer in the pub, whose farm was a little further up the river, so I would occasionally buy a salmon from him to take home, luxury indeed for my wife, who loved it! Almost next door to the pub were the ruins of a Cistercian monastery, a wonderful place to walk in peace after a day's work at the factory, with only the birds singing and the sound of the river splashing over the stones. To me, these trips to Sellafield were special because of its location – so much more attractive than any of the other establishments I visited.

My first trips to Dounreay were by air, as I could get an internal flight to Edinburgh from Gatwick and change to a local BEA flight in

a Dakota to Wick. What struck me most about that part of the journey was it invariably involved the same pilot, who happened to be the spitting image of James Robertson Justice, and who also acted like him; with some folk even saying they were brothers, beard and all! The first time I took that flight, I was sitting in my seat before take-off at Edinburgh when a man suddenly stood up, saying, 'I don't know where the pilot is. I had better take over and fly this thing.' He walked to the cockpit, started the engines, and we were off, taxiing around for take-off. Somehow I had guessed that this must be the pilot, though a lot of the passengers had no idea what was going on and were a little worried. However, they soon started to laugh about it when, during the flight, he came down with cap in hand, saying he was making a collection for the crew. He was a terrific character, and whenever I took this flight he always did something silly, except for the last time. We were flying along perfectly steadily when he appeared out of the cockpit, asking if anyone would like to have a closer look at the Queen Mother's home, the Castle of May. Two or three said they would, and with that he dived the aircraft and flew low over the castle, giving everyone a great view, but right against all the rules of flying over royal property. That was the last time I saw him – rumour has it he was hauled over the coals, which was a shame as he was really a great character.

Early in October 1957, I was called into Underwood's office with Paul Robeson, neither of us having a clue as to the reason. We were told to shut the door, and Eric told us we had to get the train to Seascale, where a car would be waiting to take us to Windscale. He would tell us no more, except that we were to take overnight gear. I always had my travel case and cameras in the darkrooms, so leaving head office I arranged with Paul to meet back there with a taxi to take us both to the station. We had no clue as to why we were going in such a hurry, or what we would find when we arrived.

On the journey, I got to hear about Paul's past life during the war,

when he was a naval boffin, stationed at the end of Brighton Pier. Scientists there were developing equipment that would help in the forthcoming invasion of northern France. Such things as the panjandrum, cotton-reel-shaped equipment with rockets attached to its periphery, to enable it to go up the beaches, exploding buried mines as it went. Well, that was the idea: in actual fact, it went straight for about ten yards, swung quickly to the right, fell on its side with the rockets breaking loose, while everyone ran for cover – yet another useless invention!

Paul told me of one occasion when he had to phone the dockyard at Portsmouth about some pieces he had ordered and not yet received. He got through without knowing who he was talking to.

When he had finished the man at the other end said, 'Do you know who you're speaking to?'

'No,' said Paul.

'This is Admiral so-and-so.'

'Do you know who *you're* speaking to?' said Paul.

'No,' said the admiral.

'Thank God for that,' replied Paul, and hastily put the phone down.

Neville Shute was one of the other scientists stationed there, and a book was written about them all after the war called *The Secret War*, with both Shute and Robeson having chapters about themselves.

A car picked the two of us up at Seascale Station, and at last we found out why we were there from the driver: the core of number-one pile was on fire and couldn't be put out. The press had started to gather and Paul and I had been sent up to keep them in order, while I was to take pictures for some, as they wouldn't be allowed access. Outside the establishment we were met by an increasing number of photographers and reporters. Paul got them all together, saying that he and I would go in to find out what was happening, and be back to hold an impromptu press briefing when we returned.

There had been two major releases of radiation already, one on the 10th and one the following day. The deputy general manager of the establishment, Tom Tuohy, was in charge and was in the building with the pile on fire. Already, someone had the idea of getting a cover made for the chimney and getting an RAF helicopter to place it over the top. This was in hand but as yet nothing else had been thought of, save the reactor technicians with long metal lengths of gas piping trying to eject the flaming fuel rods to the back of the pile. This had been successful to begin with, but the flaming uranium rods had melted due to the intense heat and were becoming difficult to shift. Tom Tuohy had the idea of drenching the fire with gallons of water from the top, rather than letting it burn itself out. The works' fire brigade was called and managed to drench the fire from on top of the pile, eventually putting it out. Tuohy was the hero of the day as he had spent hours in that terrible atmosphere, managing in the end to bring the fire under control. God knows what radiation everyone had received during the fire and afterwards. Animals in the neighbouring farms had to be put down as the cloud of radiation had gone over the Lake District and further into England. They might have created a health hazard had they been allowed to enter the food chain.

I had managed to get pictures of men in self-air suits going into the reactor for the waiting press, but I had been allowed in for a very short period in an air sui for shots that were not to be published. However, taking as many pictures outside as I could, I distributed the roll films among the press photographers, so at least they had something more to show than just the outside of the building that housed the pile.

Paul and I remained at the plant for a further four days before returning to London. It had been the worst atomic energy accident ever in the UK, but not nearly as serious as Chernobyl in the Ukraine years later. Tom Tuohy died in Australia at the age of ninety, but today there are still parts of Cumbria that are affected by the fallout,

over fifty years after the disaster. It has been said that the fire should never have happened, as the reactors should have been closed down long before 1957, but who really knows if the truth will ever be told?

I soon got back to my normal work, overseeing all the photographic side of the authority's press handouts and brochures while I travelled around the different establishments. I had just won that year's Industrial Picture Award from the Institute of British Photographers. It had been presented by the famous industrial photographer of the time, Walter Nurnberg, who I got to know very well. In fact we became the best of friends in the years that followed.

The pile 'Lido' at Harwell showing the blue Cerenkov radiation

Soon after this another very famous photographer, Karsh of

Ottawa, used my studio in Ormond Yard to take portraits of the four top men at the UKAEA, Edwin Plowden, Sir John Cockcroft, William Penny and Christopher Hinton. Karsh worked with a ten-by-eight camera for his portraits, photographing with very low-key lighting, that showed all the wrinkles and imperfections in men's faces. During the week he was with us I discovered the secret of his portraits, a blue Wratten filter, or filters, as some were stronger than others. Blue being the opposite end of the spectrum to red, it meant that where someone had blood vessels in the face, they would appear black as would wrinkles. As he shot only in black and white, using Ilford HP3 film, this is how he got his results. Also the prints he supplied were always contacts from the large negatives.

The authority was putting on a few exhibitions across Europe, which I attended, photographing the stands and any important visitors. These took place in Amsterdam, Milan, Turin, Brussels, Rome, Hanover and Geneva. The largest was Geneva, which lasted for two weeks, with me having to set up a darkroom there. I took Phil with me to do the processing and printing, and we drove down in my car, taking with us all the photographic equipment, paper and film, while everyone else from the PR department arrived by air. The two weeks passed quickly, and after it was all over we drove back again with all the equipment to London, tired but happy that it had all gone so well.

I had been trying for some time to get permission from Windscale to go up the chimney of number-two pile, and out on to its large filter at the top, the only place I could think of for taking pictures looking down at Calder Hall. Permission had been difficult to get although Number two had been shut down for quite a few months, so there was little danger of radiation. I always had a film badge with me, to detect radiation, and that was changed weekly. I wore it whenever I was in a nuclear facility, with all the readings collated and summarised at the end of each year.

Brian, Sandy and I together with an engineer got into the lift that

229

took us three quarters of the way up the inside of the chimney. It was then a matter of a metal ladder, bolted to the wall, to climb the last bit. The engineer went first and opened the door that let us out onto the filter housing, while we other three completed the climb carrying the photographic gear. The filter housing was about five feet in width with no fence or anything to stop one from falling three hundred feet to the ground. However, that didn't put off Brian or myself, although it was noticeable that Sandy stayed glued to the chimney. Luckily, the weather was perfect, so I managed to shoot two or three shots of Calder Hall in both colour and black and white. These shots, never seen before from that angle, published well, making up for all the climbing and the danger.

Me on the top of one of the chimneys, a Windscale, photographing Calder Hall while standing on the piles filter

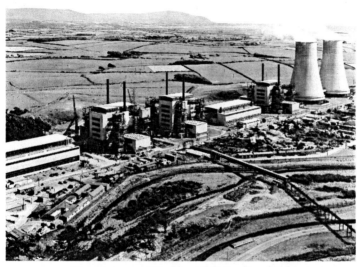

The picture of Calder Hall I was taking

In 1959 Chris was pregnant again, and, on 11th July, Dr Robert Smith delivered Sally at home. I was there for the arrival of my daughter this time, but now there was a problem – the maisonette had only two bedrooms. However, we made do for a bit before having to move to a larger house – not only because of the two children, but also the dog, who now weighed fifteen stone and was taking up half the house himself.

We started looking and found a new three-bedroom house with a large garden at Riverside Close, the other side of Beddington Park, which we moved into a few months later.

In the meantime, I was going not only from factory to factory in the AEA, but also to the new atomic power stations being built – like Dungeness and Sizewell. I drove everywhere now, as well as to Dounreay with Brian, where we always both stayed both stayed in a small guesthouse near the establishment at Fresgoe. A trip up there and back took a week, with three-and-a-half-days' solid work at the

231

establishment. The place was very picturesque, especially with the sea and sands of northern Scotland in conjunction with the large ball of the UK's first fast breeder reactor.

In the new year, Sandy Campbell and I flew over to Geneva again to photograph Cern, a large circular underground doughnut, the world's largest particle accelerator, belonging to the European Organisation for Nuclear Research. That first evening, my friend Jacqueline invited the two of us to join her at her favourite local restaurant. Having had quite a lot to drink talking to Jacqueline, I didn't notice Sandy leave the table. It was only when the manager came over and whispered in my host's ear that I knew something was wrong. It appeared that Sandy, in his drunken state, had started pushing guests' hats down the toilet, and the manager was asking if I could stop him. Going quickly over to the toilets and taking Sandy by the arm, I frogmarched him out of the restaurant, ending what had been till then a lovely evening. I apologised to both Jacqueline and the manager on Sandy's behalf, but never dared to go back to that restaurant ever again.

The next evening we flew back to London, having photographed all day at Cern. The story of Sandy's love of hats was never told to the rest of the department, and early the following year I photographed his wedding in Scotland.

By 1960 I had had enough of photographing atomic energy and was tired of taking pictures of glove boxes, buildings and square piles. I knew I needed a different type of photographic challenge, much like the COI had given me. The work at the AEA had been fine but I knew now it was time to move on, and it all happened at once in a peculiar way. One day Bill Ackroud, called me in about something that was wrong, which I was supposed to have done, but something of which I was totally unaware. Things got very heated as I told Bill I was never aware of the problem, and that he was blaming me for something I knew nothing about.

It ended in a right row with me handing in my resignation. As I had been thinking about leaving for some time, now was the moment, and this was the last straw. Eric apologised and tried to get me to stay, but I was adamant, I'd had enough. Going home that afternoon I told Chris what I had done. She was overjoyed, as she had realised for a long time I was not happy and wanted to go freelance. I had got to know a lot of the public relations people from firms who worked for the authority. Most had told me they would give me work if I went on my own, so I knew that at least I would be starting off with *some* clients. After a few phone calls to different companies, it confirmed my thoughts that I had done the right thing. Now I had to get my new equipment together during the month's notice I had given.

I should like to add something here, something about the man who took over from me, Gerry Hammond. He was driving back from an assignment in the north down the M1, with Brian Goodman alongside him. It was a perfectly ordinary drive home before dark, but a lorry going in the opposite direction shed its spare wheel, which bounced over the barrier hitting Gerry's windscreen, killing him. Brian managed to stop the car and was luckily not hurt. I will always remember Gerry as we had been great friends for a few years, he just didn't deserve to die.

Chapter 14

The first assignment I had as a freelance was for Planet News, a photo agency in Bouverie Street, quite near the *News of the World*. It was of a large party at Sutton Place, Paul Getty's house, just outside Guildford on the A3.

It was to be an all-night affair with everyone in DJs. There was a large press presence, but I was instantly taken with the house. It was a very large Elizabethan mansion with internal and external swimming pools, together with a picture gallery full of old masters, most of which I recognised.

I had been told to do 'arrival' pictures of famous people who had been invited, and to give them to the motorcyclist waiting outside, who would take them to London. Finally, I had been asked to try and get a really good news picture to finish off the assignment. This was difficult because everyone was behaving themselves, until I hit on the idea of someone being thrown into the swimming pool. I knew it would be a waiting game so I just sat outside, close to the pool, hoping! Two o'clock had just struck when things started. I had got my Rollieflex and electronic flash ready on the table in front of me when a small crowd of men seized a girl in evening dress and threw her in: I managed two shots, one of her in the air and the other splashing about as people looked on.

Not waiting any longer, I was off down the A3 to London to get the film to Planet, arriving three quarters of an hour later. Snatching a cup of tea I then drove back to Wallington, arriving at about four in the morning, tired but elated at getting the picture, which appeared in two editions of the *Evening News* the following day.

There followed a few days when nothing happened, and after that it seemed everyone wanted to contact me regarding photographic assignments.

The first was Bill Paterson, who was head of PR for a firm in Stockton-on-Tees, called Head Wrightson. He was located in their

London office, just up from Petty France, and wanted a complete set of shots taken at their works in the north. It was a heavy engineering company, doing work on the new atomic power stations, and a date was fixed for me to go north and start the assignment.

I had bought myself a five-by-four Linhof together with a Bowen's flash outfit, which allowed me to fire up to twelve bulbs at once. I had used one many times before and had developed the skill of lighting with multi-flash. Buying my PF60 Philips' flash bulbs by the hundred, I would use an average of eight on most shots, so a box didn't last long. I had developed this way of working and usually took only one exposure per picture, mainly due to the expenditure in bulbs. I would work out the exposures in my head and the more pictures I took, the more proficient I became, not only at shooting black and white, but colour also. When I had placed my tripods with the flash pans on, I would load the bulbs, ensuring first that all connections to the box attached to the camera tripod were correct. They could then be fired in sync from the shutter with the attached coaxial. If there was a problem, the whole lot might go off as the last bulb was put in, meaning I would have to use my handkerchief to hold that bulb while using only the tips of my fingers to screw it in place. Then if it went off, it didn't burn my fingers.

I had taken on an assistant by this time, to give me help in the factories, wiring up the flashes after I had located them, and also carting all the equipment round. His name was David Leech, a bright sixteen-year-old lad, who not only helped me but was learning as well and would eventually end up as a really good photographer in his own right, a few years later.

Things took off for me and I soon realised I would have to acquire premises in London, so I leased a basement in Hertford Street, Mayfair, and after all the redevelopment work was done I had a studio, darkrooms and office in the heart of the West End. I worried about the cost, but soon saw the extra work the premises brought in,

and felt how worthwhile the whole exercise had been. It was not long before I took on Phil Long to do all my printing, as those were the days when prints were ordered in their hundreds for clients to use with press releases, and this made a significant difference to my monthly totals.

Office building near Earls Court, London

Manufacturing animal feed *Carpet making at Wilton, England*

ICI Billingham factory

Silver smith at work in Sheffield, England

Electron Microscope at TI's laboratory

A large aluminium billet manufactured at
British Aluminium, Falkirk

I was out photographing nearly every day and began to need more backup, either on the job or back in the office. I took on another lad called Eric Clause to do collections and deliveries in a small mini-van, as I no longer had the time to do them myself. The colour work initially was going out to numerous sub-contract labs for processing, until I fixed on one for everything, a place I could trust and liked.

One day, Walter Nurnberg asked to meet me at GEC's factory near Shepherd's Bush. He had been taken on as a consultant to advise on a photographer who could shoot colour. He himself worked only with tungsten lighting so only managed to shoot in black and white. As my ability with colour on industrial pictures was now getting known, it seemed I was expert in that field of industry. Meeting with Walter again and seeing what had to be done, I submitted a price to the PR man, who accepted it on the spot.

Two weeks later, I went back to shoot the pictures required, and although I had David with me, the factory photographer was always

239

there, trying to help. She was obviously very clued up with colour and I was impressed by what she had to say. Taking a chance, I took her on to help with the studio work that I was starting to get from advertising agencies. Her name was Eileen Eaton, and she brought my workforce to four.

When later I was asked if I could make a sixteen-millimetre sales film for a firm called World Wide Helicopters Ltd, I thought back to what I had learnt in the film unit all those years before, and immediately said yes to their PR man, Mike Wilton. In discussing the project, I saw that it wouldn't be straightforward, as I needed to show helicopters in a variety of situations, all doing different jobs. Some sequences in the finished film had already been shot and wouldn't happen again, so these would have to be included. Mike and I slowly conceived the size and complexity of the project, with its different locations, home and abroad.

However, shooting started with a sequence of a bell helicopter, equipped for spraying, working in a potato field. The aircraft flew so low that the skids picked up foliage from the plants, and as it did a tight turn at the end of a run heads from the potato plants were dropped off. Next was a main power line with high towers, where men were changing large glass insulators at the very top. Once again it was a bell helicopter, but this time it had an insulator slung on a cable beneath. As it hovered above the line, men detached the old insulator and replaced it with the new one that had been lifted by the chopper. They did it while the line was live, meaning that the pilot had to keep the aircraft very still until the operation was completed. This operation took about ten minutes, and needed a highly skilled pilot for the job.

The next part was in Scotland, where they were taking salmon fry from breeding tanks and flying them in containers strapped to the skids on the helicopter. Having filmed that part of the operation, I was flown to a small stream, miles from anywhere, to await the helicopter

with the fish onboard. Two men had also been dropped off, so when the chopper arrived they began taking the containers off and gently poured the small fry into the stream. Then I was flown back to my car.

Libya

241

Libya

Now it was time for the main part of the film, a flight to Libya to show the fixed-wing side of World Wide's operations. For this Mike, David, Dennis Bowden and I, together with Bob, an Australian pilot, flew from Gatwick in a small twin-engine aircraft belonging to the company, which was required in north Africa for further work.

The first hop was down to Nice in the South of France, where we stopped for a day while the radio on the plane was fixed. Then it was to Gibraltar and across the Mediterranean to Morocco, where we stayed the night. Lastly, for the next two days, it was along the north African coast eastwards to Libya, finally ending up in Benghazi. It had been a long trip in a small aircraft but enjoyable as we had flown low enough to pick out places of interest on the flight.

After landing at Benghazi's main airport, clearing customs and immigration, and taking off again after all the form-filling, we landed at World Wide's private strip just outside the town. It was getting late

by the time we landed. There were six De Havilland Beavers lined up for the following day's work, to keep the Esso drilling rigs in the desert supplied with food and spare parts. After disembarking, we were tired out, especially Bob, who had flown us all the way from Gatwick. Once into two taxis, we were driven to our hotel, a small local establishment where all the pilots were living.

In the early hours of the following morning, we started work filming the pilots getting their orders for the day and taking off to different drill rigs in the desert, having loaded their aircraft with the day's supplies.

I got into a helicopter that flew me out to sea to an oil rig in the Mediterranean, much the same kind of mission that the fixed-wing aircraft were doing ashore. These operations were filmed most days with David and me going out to the rigs to shoot more material in different areas, with David taking stills while I did the filming. We learnt very quickly about not wandering off the well-trodden paths in the sand, as we were told of the war taking place all round the areas where drilling was underway. We were told that mines didn't deteriorate in the hot dry climate of the desert, and that they would still be very much live, so we were very careful where we put our feet!

Mike and Dennis were getting all the facts so Mike could write the commentary as soon as Dennis had edited the film, after their return to the UK.

The hotel left a lot to be desired, but the evenings were good, as it seemed the whole place had been taken over by the company. There were problems with the showers, but everybody had to get over those. After a day in the desert, two things are uppermost in one's thoughts – a shower followed by something to drink, as the body was longing for fluid of any kind. I would get into the shower, soap myself and then the water would go off. This happened regularly to everyone, but if you were lucky enough it might come back on again. If not, you dried

yourself, soap and all. Lack of fluid was next, so everyone sat round a large table drinking Heineken or whatever the beer was that evening. When one table was full of empty bottles, we would all move to the next, until our bodies told us we had drunk enough. Nobody seemed to get drunk or disorderly, as it seemed to be just a matter of filling one's body with fluid, however much it was, for the next day in the desert.

After a week, filming was finished, and David – who had said before we arrived he had never seen a camel – was fed up at the sight of them. Both of us stayed on for a further few days, doing stills for a Shell calendar, after which we flew back to the UK from Tripoli by civilian carrier.

By this time, Cossor had become one of my clients, as Sandy Rawlinson, who I had first met during National Service, was their graphic designer, and he and I had kept in touch over the years. This job was of a new police radio the company had designed. It was for police motorcyclists, and it had to be shot just after five in the morning in the City of London. Due to the early start, the two of us were to stay the night at my office, have a meal in Shepherd Market, and then get our heads down on the easy chairs. This was to be the last job I would do until after my third child was born, as when this assignment was over I was going home to be with my wife. However, the phone rang at about 1.30 in the morning, with Chris telling me that our next baby was very near arriving. After our first child, Chris had wanted her further births to be at home, so that she could show the new baby to the other children immediately after it was born, or when they awoke the following morning.

I belted down the road to the Hilton Hotel garage, got into my car and raced home to Wallington, telling Sandy before I left that I would be back in time for the job. Arriving home, I was just in time to see the midwife produce our new daughter Jane, and I had time to sit with Chris for about half an hour before returning to the office, picking up

Sandy and the camera, and driving hell for leather to the Tower of London, where we were meeting the police. Having done pictures of a policeman on a motorbike, with Tower Bridge in the background, I drove back to the office in a more sedate manner. It turned out, years later, that the night Sandy and I had spent in the office was the only time I had ever needed to, and it had been the very night my second daughter Jane had been born, 24th August 1961. Was that strange or not?

John Foley, whom I hadn't seen for years, met with me for lunch one day in Shepherd's Market. He was with a large PR company, Campbell Johnson in Bolton Street, very close to where my studio was located, and during lunch he asked me if I would like to spend four weeks in Liberia, starting a public relations photo library for their government. I was very busy at the time but the thought of another overseas trip was too much for me to miss, so it was arranged and I took off a week later for the small west African country. I was met at Monrovia Airport by my 'minder' for the trip, who luckily took over the clearing of customs regarding the cameras. The following days were all taken up with the itinerary that had been planned for me, starting with full coverage of the capital, Monrovia. This took in schools, hospitals, veterinary laboratories, roads – of which there were few outside of the capital – and government buildings. Then there were two bridges in construction upcountry, and pictures of copper mines enormous in size. I also did a lot of photography around the harbour in Monrovia, showing ships flying the Liberian flag. It was one of their biggest earners, as ships that were under their flag of convenience brought in more money than any other country in the world.

Spraying houses in Liberia against malaria

A large copper mine in Liberia

I had a hotel room, luckily on the third floor, as even there hot water came out of the toilet and cold went into the bath. Had it been on the ground floor, I discovered, it could be no water at all or floods in the room. If I took a taxi anywhere, it always had passengers in before I entered, with the driver seeming to do a round trip, dropping people off at various locations. Once it was two women with chickens on their laps I had to contend with, before getting to the restaurant I wanted. This was the best place to eat in town and was called Heinz and Marie, named after its German proprietors. It was said locally that they had got out of Germany after the war, before the Americans caught up with them. Whether true or false, I couldn't say. I also used to frequent a club on the shore that overlooked the sea and sand some evenings, with very little else to do. There were very few decent places to go, and one night while I was sitting drinking my coffee a cockney voice broke into my thoughts. It belonged to a Londoner, who obviously had never been out of England before, landing up in Liberia to repair teleprinters. He was obviously lonely and had had a little too much to drink, when suddenly he screamed that the moon was lying on its back. I had to explain that we were very near the equator, so the moon would appear the wrong way round. After that, every evening the man would look for me, frightened of being alone in a strange country.

Going round the country and finishing in Monrovia, I had met an old acquaintance I had last seen in Nairobi years before. Bobby Nahdo, who at that time had owned *The Citizen* newspaper, but was now the owner of the only advertising agency in Liberia. We talked for an hour or so about the old days, and had dinner together that evening, as I was leaving for the UK the following day.

On the aircraft at the airport, who should sit next to me but the teleprinter engineer, who told me he was getting off in Senegal to carry out more work. I hadn't the heart to tell him that they spoke only French in that country, knowing that his cockney English wouldn't be understood anywhere. Saying goodbye to the intrepid traveller in

Senegal, I took off again for London, looking forward to seeing Chris and the kids again.

A couple of days later, I was commissioned by De Havilland at Hatfield to do the photographs for the sales brochure of the Trident aircraft. It consisted of manufacturing shots, painting and flight-testing, together with two whole days spent with thirty models in the mock-up of the cabin. These were mothers with children, men and women dressed in BEA's flight uniforms etc., while the front cover shot in the studio, showed a gold-plated model of the aircraft.

President Tubman of Liberia came on a royal visit to the UK from 10th–13th July 1962. As I had done all the pictures in their country, I was asked to cover the visit. It was the normal format, starting with the arrival and going through to the royal banquet at Buckingham Palace. I covered it all and met Norman Smith on part of it, with both of us having a good old chat about old times at the COI. After the royal aspect of the visit, President Tubman travelled to Liverpool privately, which I covered as well. One evening I met up with Bob Paynter and Charles Martin again, as Bob was the film cameraman for the Liberian government. Until the end of the Tubman visit in Liverpool, we three old friends worked together – me as the stills man – reminiscing mainly about the good old days at the Colonial Film Unit. Charles opened up one night after a few drinks, telling Bob and I of his wartime experiences with Pathé News. He was the only newsreel cameraman who had been at Dunkirk and all the material that was shot of that operation was his. He had gone over three times to the beaches, shooting material during the height of the evacuation. One of those brave men who risked their lives to shoot the film and stills of WW2 that we still see today.

The years passed quickly, with me working for more well-known names, such as ICI, Tube Investments, the Gas Board, British Aluminium, COI, Ministry of Defence, Philips Electrical, and many small and large advertising agencies.

I made two more films with Mike Wilton, one called *Pioneer Pipeline* for British Aluminium, about a new aluminium pipeline from Lulworth Cove, to take effluent out to sea, and the other *Braking Point*, for Small and Parkes, who manufactured brake linings. I also made a small film of a model dredger in the studio for Bill Paterson of Head Wrightson. With films and still photography, the Hertford Street premises were beginning to become too small, especially as Mike Wilton and a graphic designer called Bill Friend and I had formed a small company called The Hertford Group, which operated out of the basement.

At the beginning of 1964, my fourth and last child Robert was born, on 6th February. This time I was at home and everything was quite normal when, on the evening of the 5th, Chris went into labour. At about midnight the midwife turned up and called the doctor, and they delivered baby Robert. Then they called in the crash team, telling me that the afterbirth wouldn't come away. Everyone ended up in the small bedroom, the midwife and assistant, the doctor, the crash team and me. No one could move so the sister took the baby in the carrycot and put him in the bathroom, while they dealt with the mother. I checked the other three children to make sure they were all asleep, while the medical team decided to take Chris to hospital, having to hold back Hornblower to allow them to bring her down the stairs. Off went the ambulance and I shut the house up for the night, turned the heating off before going to bed.

Early in the morning, having had very little sleep, I went into the bathroom where I saw little Robert in his carrycot, the medical team having left him behind from the night before. What was I to do? I couldn't go to the hospital with the child, as I had to get the other three up, feed them and get two off to school. Should I try and feed the young baby? I really didn't have a clue what would be the right thing, except I knew that somehow I had to get Robert to the hospital. Then the doorbell rang and it was Jan, my accountant's wife, who was a

249

doctor and had never before visited us at home. Telling her of my predicament, I thought she would go through the roof.

'Give me the child,' she said, asking the name of the hospital Chris had been taken to. and she was off without so much as a goodbye.

It transpired later that when Jan arrived with the baby, she had an almighty row with the matron, telling her what she thought about her staff and the hospital. I could only ring up to find how my wife was, as my younger daughter Jane was still pre-school and couldn't be left. Eventually, Chris came home four days later, having had to leave Robert at the hospital for further rhesus tests. That was our last child, two of each was enough for any family! Ten days later and I was back at work, catching up on all the things I should have been doing at the office, but thankful that Chris and I now had a lovely, healthy and beautiful family, including the dog!

The following year, 1965, was very busy with photography and film. Also with Bill Friend concentrating on design work, nobody had enough space, and we all knew we would have to move to larger accommodation. But more was to come as one afternoon I had a phone call from Colin Norton Smith, who just happened to be the PR manager of Cunard, asking if I would be interested in doing all the advertising and PR photography on their new liner, which they had just started building at John Brown's on Clydebank in Scotland.

To be asked by such a prestigious company as Cunard to cover the building and fitting out of such a ship, was beyond my comprehension. I knew now that we were going to have to move quickly, especially as Colin told me they would want literally thousands of prints off the pictures taken by my group. So now it wasn't only moving but also either buying or tying up a photo print trade house for the long runs of black-and-white prints, while the colour work could still be done with the trade house I was using.

After a lot of searching, I settled on Photo Process, who were in Sackville Street at the time, an old established trade house who were

working for the BBC, the Coal Board and RNLI, together with many more smaller companies. I knew Ron Marsden, the manager, as I had used them many times before when the darkroom was overloaded at the UKAEA. So, taking Ron out to lunch, I put a proposition to him regarding buying the company. Ron then had to talk to the owner but knew he would jump at the opportunity, not only that but their premises were very old, and going to a new address would make all the difference to the way they could operate.

I bought Photo Process Ltd for a very good price, found a large basement in Bolsover Street, just behind Great Portland Street, and moved both the Hertford Group and Photo Process in together, once all the reconstruction building work had been done.

Now everything was under my control, and all the work for Cunard could be done in house with the exception of the colour, meaning that all deadlines for runs of prints or photography could always be met. Eileen had decided to leave before the new office was completed, so I took on another assistant, Roger Livesey. I also asked John Curtis to join, as looking ahead I could see that as the ship progressed, more and more pictures would be needed to cope with the Cunard requests. All my other clients had to be looked after as well, so I knew I would be needing this other photographer as backup.

The QE2 on her final trials

Chapter 15

While the change of office in London had been progressing, we had decided to move house again, now our family was complete. We were going to a much larger house in Woodcote Avenue, though we had been very happy at Riverside Close. It was now too small with the four children growing up, and of course the dog.

My daughter Sally and our dog Hornblower

The older children used to ride Hornblower round the garden with Chris and me quite often wondering if he would be any good if ever we were burgled, thinking he'd probably just sleep if anyone tried to get in. But as we thought about that happening, it actually did, two weeks before we were going to move.

I was woken in the middle of the night with a terrible crash and a

great bark from Hornblower. Rushing downstairs, the first thing I saw was the backdoor was missing, seeing it lying out in the back garden, while I was just in time to see Hornblower hit the low part of the fence at high speed. It was obvious that the burglars had tried the back door and all fifteen stone of Hornblower had hit it, throwing it at them. Not able to stop, as he must have been really motoring on hitting the door, he had to go well into the garden to turn round at speed. Then, on coming back, he crashed into the low fence, knowing somehow that this was where the buglers had got over. As I walked through the non-existent door, I knew when I looked at the dog how lucky those burglars had been, for had Hornblower caught them, in the state he was, he'd have killed one of them, and I'd have had a hard time trying to stop him. I immediately contacted the police, who informed me of two burglaries across the road feeling that my house was to have been the third. After that night, there was no more talk of the dog being useless – he had certainly proved himself, though we could never seem to wake him up when asleep, or was that just him, not wanting to be disturbed?

A very quick and interesting assignment arose on the afternoon of 18th July 1966. I was luckily in my office after lunch, when a pal from Fleet Street phoned to ask if I could catch an aeroplane to Rome that evening and fly back with King Hussein of Jordan, taking pictures of him piloting his own aircraft while coming on a royal visit to the UK. I was to pick the ticket up at Heathrow, fly to Rome, wait all night at the airport and come back in the King's aircraft to Gatwick. This I did, and on getting on the royal aircraft in Rome was greeted by the King himself, who knew all about the photography. As it was a three- to four-hour flight back to Gatwick, the King and his wife entertained me, with talk of places they had visited, and asking me where I had been overseas. The King's English was perfect, as of course was his wife's as she was an English girl, the daughter of an army officer, whose maiden name was Toni Gardner. Tea was served

and then as we approached the UK I took the pictures of the King flying with a British fighter alongside, guiding him in. Once landed, there was a ceremonial on the apron, my hosts having said their goodbyes to me before departing. It took over half an hour before I could leave the aircraft, due to the royal visit.

The first thing I did when I was able to walk off the aircraft was to find the waiting dispatch rider and give him the roll of film, after which I got a taxi home, arriving a lot earlier than usual.

The next assignment was to Scotland, this time to the new Forth road bridge, an advertising job showing the stringing of the cables. For this, David and I, together with the creative director from the agency, had to go to the top of the nearest tower by lift, which was somewhere in the region of 400 feet in height. It was only then we discovered, on reaching the platform, that the man from the agency couldn't stand heights. He stood with his back to the top of the tower, not daring to move or look down. Identifying the shots he required, I shinned up to the very top where a large wheel and two men were assisting in running the cable to the next tower. Doing a series of pictures in both colour and black and white, and with David doing other shots from lower down, we finished inside half an hour. But now there was a problem – the lift had gone wrong and couldn't be used. Instead we were told to make our own way down by an unsafe-looking wire mesh walkway, which was attached to some of the already strung cables. Putting our left arms round the small bunch that had been strung, we gingerly walked down from the top of the tower towards land. This so-called footbridge was made of steel mesh, which one could see through to the water below, and was attached only every so often with thinner cables to the bunch already strung. This was fine for us, though we weren't looking forward much to the walk down, especially humping the gear as well. But for the man from the agency, it was a 'no go'. Eventually, it was decided he could go down in the lift once it was repaired, but for us other two it was down

the temporary walkway. We started, slowly at first, but as we got used to it the pace increased slightly until a fair-sized ship passed beneath us emitting a cloud of smoke, which blew around us. Coughing and spluttering we continued down until we reached the ground, at last feeling safe.

On 4th September 1964 the Queen officially opened the bridge, while we in London raised our tea mugs in salute, reflecting again on that walk back over the water.

Ten days after this, the family moved to the house in Woodcote Avenue at the top of the hill in Wallington. Paul, Sally and Jane were now all at school, so Chris had more time to herself, as she had only Robert to look after during the day. Getting stuck into the garden, which was enormous compared with what we'd had in Riverside Close, she made it look great in no time.

The work on the new liner for Cunard was progressing well at John Brown's. Either I would go up every few weeks with David, or I would send the two assistants on their own, if I couldn't make it due to other commitments. This was the start of building but, as it began to look more like a ship, someone had to be up there at least every two weeks. By sending Roger and David, it gave them both the chance to photograph on their own, learning a lot more than they would with me all the time. They used to moan about having to travel all that way in the small mini-van every other week, though they'd take turns at driving. I would examine their shots closely when they returned, telling them to repeat some, if necessary, on the following trip. This way they learnt a lot faster, with both knowing I had my trust in them. Then, when John Curtis joined, he would go up to Glasgow with one of them, so leaving me with an assistant again for other jobs.

As the work on the ship progressed, either one or both of us would be at John Brown's, while other assignments were still being covered in London, such as the son et lumière at the Tower of London, and after at Southwark Cathedral for Philips Electrical. Bill Sykes had left

the COI for the appointment as head of PR at Philips in Southampton Row, and I had been surprised to hear from him, thinking he was still with his old employer.

The Tower of London had to be photographed from the opposite side of the river, from the top of a warehouse in the Pool of London, which was full of ships and cranes unloading. I had been there for a short visit the night before and had deduced it would have to be multiple exposures on one sheet of film, due to parts of the tower lit only at any one time as the story progressed. There were small elements of the programme when most of the tower was lit in different colours, while a lot of it was still bathed in white, but I knew that it was better to shoot it the way I had first thought, giving me control over the amount of exposure for the different colours. Bill's assistant,

Mike Gail, was with us for the evening of the shoot, which proved to have been very successful when processed. I used the same idea when photographing in Southwark Cathedral, with the same very interesting results.

With the family now happily ensconced in Woodcote Avenue, it didn't take me long to meet my neighbours, discovering that the husband on the left owned a colour trade house in Worcester Park, while the one on the right sold property in the Bahamas. Also, across the road, was Peter Earle, one of my old friends from the *News of the World* days.

I started to use the local colour trade house, passing orders to John Taylor next door in the evening and collecting them from him on completion.

It didn't take long before I was on my way to Grand Bahama Island either, as I had talked Jim, the chap next door, into doing a whole series of pictures of the new buildings, golf courses, marinas, malls and restaurants for his publicity. Not only that but I had also talked him into a film to be shot in a few months' time, when more of the development was completed on the island and the weather was right.

Bill Paterson had left Head Wrightson and was now head of PR at Tube Investments, with Sir Edwin Plowden, the new managing director, who had left the UKAEA, to take up his new post. This was all good for me as I now had an 'in' to one of the largest groups of industrial companies in the country. My first assignment for TI was to fly over to Germany in their DH Heron, a small four-engine aircraft, to photograph at a company TI had bought. Taking Roger with me and leaving all the Cunard work in the capable hands of John Curtis, we flew out from Gatwick to Hanover. Completing the assignment in three days, we got back on the TI aircraft at Hanover for the return trip, when it all happened again – we hit a force-nine gale head on. Once again the small aircraft fought against the blizzard, eventually

landing in the UK hours later than expected. I had a peculiar feeling about these things that always seemed to happen to me, wondering if we would make Gatwick or have to land somewhere else.

The COI by this time had started to use me in a freelance capacity again, with an assignment to Rein Metal in Germany for the army, to photograph a new mobile gun that was being proved on their ranges. Alan Gatland was the designer of the brochure, so he and I flew to Hanover, where a car picked us up from the company's hospitality guest house and took us to the ranges. After a good meal that evening, Alan asked about the availability of the gun, only to be told that the engine was out of it and their host didn't know when it would be replaced. So the next morning we talked to the mechanic from Mercedes who was working on the engine. He explained that although he knew of our visit, he couldn't have predicted if or when this new-type engine would fail, which it had done the morning before.. Without it, the mobile gun couldn't be moved, so with a day when nothing could be done, it was suggested that we take a car and driver and go and see Belsen. This we did, and after visiting the very sad museum went into what was left of the camp.

It consisted of a large paved path with on either side, large separate mounds of earth, each showing the number of people buried beneath. Not a sound could be heard as we walked slowly round – no birds were singing, and nothing else moved, except for the few other visitors. Those mounds, the graves of so many thousands of human beings, seemed to stretch into the distance, while both of us felt only great sorrow for those innocent inmates who'd been murdered. The further we walked, the more terrifyingly the actual place haunted us, making it almost impossible to talk. As we came away, time didn't seem of importance any longer, only our abject sorrow, and our failure to understand how one race of human beings could do such terrible things.

It was the following day before we were able to get the pictures of

the gun, but – as both of us have said so many times since – the pictures paled into insignificance in comparison with that visit to that terrible place, Belsen.

I now knew on my return that it was about time I made that extended trip to Glasgow. I hadn't seen the ship lately, only the pictures taken by the others during the last month, so with Roger I set off in my car. The trip went well, especially as Roger appreciated the comfortable seats in the Mercedes against those of the mini-van. Looking to get some different perspective on the ship, we did night shots of the hull as it was being welded, using the same principle as I had done at the son et lumière, multiple exposures on one sheet of film.

Next day, I decided to go up one of the shipyard cranes, forward of the hull, to try and get a shot along the length of the ship, leaving Roger to do other pictures below. Putting the Rollieflex around my neck, with spare film in my pocket, I started the climb to the crane driver's cab. As the man was just finishing his mug of tea, I explained to him who I was and what I wanted to do. It was then that I realised from the position I was in that I couldn't get the shot I had envisaged whilst below. Describing the picture I wanted, which was further out, the driver lowered the jib level, put his hands in his pockets and walked out on a two foot wide steel girder. Telling me to follow him, he walked along the jib, while I watched from the cab. Thinking hard about following him, and knowing that one slip and that would be my lot, I suddenly thought, 'If he can do it, so can I,' and followed him to the end of the jib, not daring to look down. As I neared the end, I thought to myself, 'That's far enough,' and sat down with my legs dangling in about two hundred and fifty feet of space beneath. Looking in the top of the camera and focusing, I took a meter reading and shot a series of exposures, knowing I should have brought the other camera with me, to do it in colour. When I had finished I tried to stand up, and finding I couldn't move now knew my bottle had gone.

With my hands behind me clutching the edge of the girder for dear life, I managed to tell the driver of my predicament. He did no more than stand behind me on the other girder, got hold of me under the armpits, and lifted, bouncing me back towards the cab. There I stayed for the best part of an hour, before I could summon up enough courage even to climb back down again.

However, while I had been chatting to the driver, and thanking the man for getting me back to safety, I had noticed that a lorry was unloading sanitary wear, such as baths and basins, on the port side of the ship. But there was also another lorry on the starboard side near the bows, loading what looked like the same baths and basins as they came out of the ship. I wondered if I should say anything to the crane driver, but decided not to in case what I had seen was not what I thought. Saying goodbye, I slowly climbed down to the ground, vowing I would never go up a shipyard crane again, let alone walk out on the bloody jib!

Back home at the weekend, I started to realise that the weekly trips by Chris and the kids to a riding school were becoming very popular with the five of them. So popular in fact that we had bought a pony for the children, and Chris was thinking of buying a horse for herself! Realising that this was going to cost a lot of money for keeping two horses at livery, I suggested in a roundabout sort of way that it might be cheaper to find a property in the country that had stables and land, never dreaming Chris would pick up on my thoughts. However, this she did, and having lived in the house for only just over a year, she was in favour of finding such a place. The next Saturday, we started to look again at houses and found a place in Newdigate, a seventeenth-century house that had land and stables. It was no good my trying to argue, Chris had made up her mind, that this was the house and we were going to buy it!

The following Monday, we put our house on the market and started planning a new life in the country, with horses, and other

animals that were to follow.

Eventually we moved, horses and all, with me rather frightened of the animals, but thinking to myself that in time I might get to love them. So there we were, in a strange place, not knowing anyone, with more land than was needed for the horses we had, and me telling myself I should have kept my mouth shut.

Two days later, we had almost got the bedrooms furnished, as was the case with most of the rest of the house. That evening, after the children had gone to bed, Chris and I decided to have an early night. About two in the morning, the mother and father of all storms started, with great streaks of lightning and thunderclaps, the like of which we hadn't seen or heard before. As we both lay awake, a big animal came and lay between us, Hornblower! He was petrified, and nothing was going to move him from our bed. So for the rest of the night, the three of us got very little sleep, as every time the lightning flashed the dog howled in a mournful fashion and the bedclothes nearly came off. With all this going on, the children all woke, and as everyone was frightened by the storm it was decided we should all get up and go downstairs for an early breakfast, including the dog, who would not be separated from the family.

On 2nd September 1967, the *QE2* was launched from John Brown's yard on the Clyde. The worry was that it might hit the opposite bank, so great chains were attached to stop it going too far.

The QE2 on her speed trails off the Isle of Arran, Scotland

I had stayed in London, going to Gatwick late in the afternoon to collect all the exposed film of the launch, as Cunard wanted prints overnight. Colin and I picked the pictures to be printed. I had had everyone on the launch, John Taylor, John Curtis, David Leech and Roger Livesey, so that the whole ceremony was captured from as many angles as possible, while the John Brown photographer took it from the air. Back at the office, the printers ran a nightshift and so we managed to get the print runs out that Cunard required early the following morning.

After the launch, the ship was hauled to one side of the builder's yard and work started on the superstructure. The ship quickly took the shape of a liner as the top structures were built on, finishing with the exterior painting of the whole. During all of this, my small band of photographers were taking shots of all the completed sections, which at that point were few, as all the internal cabins and décor had yet to be finished. She was moved to dry dock at Greenock for checking and the final painting of the hull.

The hotel manager, who had a cabin on the ship, woke one morning and put his feet out of bed to find his floor under water. Shouting, 'We're sinking,' he ran out to find the corridor dry. It was then he remembered he was in dry dock, and discovered later that the water had come from a leaking pipe and not the sea!

The *QE2* did her speed trials off the Isle of Arran, with me shooting pictures in both colour and black and white from a helicopter. Working with the five-by-four Linhof and Grafmatic slides, which took six sheets of film each, I had the side door of the aircraft off and was sitting on the floor with a rope round to stop me falling out, my feet resting on the skids beneath. Luckily, it was sunny and the weather remained fine all day. Starting about eleven in the morning, my first shots were of her coming out of the Clyde into the open sea, where she put on speed and started manoeuvring. Fortunately the pilot was good and seemed to know the positions that I required the aircraft in, so saving a lot of time and talk between us. At one point the aircraft was only just above the water when the ship came round in a fast starboard turn towards us. It made a great shot as the pilot brought the helicopter up with the large vessel coming at us at top speed. The captain blew the siren, as he couldn't see the aircraft until it appeared over his bows, going up and missing the superstructure of the ship by a whisker. This was probably the finest shot of the *QE2* going at full speed that anyone could ever have taken.

The pilot landed me on Arran while he went off to Prestwick to refuel. Very thoughtfully, he had put down in a pub garden, giving me the chance of something to eat and drink. I could see the ship all the while from my vantage point and watched her steaming up and down, as I sat there having a meal. It took about half an hour for the chopper to return, having refuelled, and so we took off again to continue the shoot. Luckily, we had just about finished when the pride of the Cunard fleet stopped moving. They were having trouble with the new engines that had been designed and built in Germany. While flying

around, the pilot radioed the ship and asked if it would be carrying on with the trial with 'No' being the immediate answer. So the assignment was finished and the helicopter took me to Glasgow Airport, where I got a plane back to Gatwick and home. I was very pleased with what I had taken and even more so after I had seen the prints.

The following week found David and me on our way to Bilbao in Spain, aboard the ferry from Southampton, with my car. This was to photograph for Loewe, part of TI, another bottling plant and an extrusion machine that made pipes from red-hot steel ingots. The first job was the bottling plant, which was in a brewery again, but this time the bottles were a lot smaller than those at the Newcastle brewery. But it was the same thing: take a full one off one belt, drink the beer and put the empty back on the incoming one. This we did while taking the pictures, saying to ourselves that we were drinking the beer only to keep ourselves fully hydrated in the hot weather of Spain.

The extrusion mill was large and the red-hot ingots were fed into the machine automatically. All went well to start with, as we two moved the flash stands around as we took different shots of the process. Then somehow one red-hot ingot fell off the loader, down the side of the machine, setting the oil alight beneath. Everything stopped, as no one had any idea how to rescue the red hot billet, which had ignited not only the oil but was also burning through all the electrical wirings. Then it was decided to evacuate before anything else went up, so we both got out, leaving the crew who'd erected the machine to stop the fire. It wasn't until the following day that we could get in to complete the assignment, when the Loewe installers had the machine working once again. They had had to work all night on the feed that brought the ingots to the press, partly redesigning it on site.

Catching the ferry home that evening, we were both thankful that the job was over, as at one stage in that building it had been extremely dangerous.

265

Chapter 16

Cunard had decided that to get the *QE2* finished, they would have to send her away from John Brown's on Clydebank and down to Southampton. The reason was that too many of the internal fittings were disappearing before they could be installed. The week after the engines had been repaired, she sailed down south to Southampton, to complete her fitting-out.

This made it a lot easier for me to get to terms with all the pictures needed onboard the ship, for as the different areas were completed, shots in both colour and black and white were required. Also pictures had to be taken on behalf of firms who had supplied equipment, as Cunard would not allow any other photographers on the vessel. The workload mounted as the ship neared completion, still with parts going missing from the ship. For example, two grand pianos went on board then disappeared, with the security staff swearing they had never seen them come off. How anybody could pinch two grand pianos from a ship without anyone seeing them go was beyond me.

Then there was the problem of the roof in the double up-and-down lounge. Every time a lifeboat was lowered, the large false ceiling fell down. Then there was the evening when the last of the carpet in the first-class lounge was laid. I had just discussed with the fitters how I was going to photograph the area the following day, and they had told me they would work through until it was finished. Knowing the lounge would be ready for us to photograph, Roger and I arrived the next morning, and there, from the middle of its expensive carpet, someone had removed a piece the size of a suburban living room, fireplace and all. It was impossible to shoot the pictures as the whole carpet had to come up and a new one put down, all because the piece that had been removed couldn't be matched.

To a lesser or greater degree things were happening all the time in different parts of the ship: once, when I was photographing the captain's cabin on the five-by-four, giving something like a five-

266

second exposure in colour, halfway through the outer wall of the cabin sprung. This effectively created a double exposure to that part of the shot. I took another and this time nothing happened. I feel it should be mentioned at this point that all the fluorescent tubes on the ship had been specially made to give the same colour temperature as daylight.

Christmas 1968 saw her first sea trials, with passengers to the Canaries, but none of my employees wanted to be away for the festive season, so I hired Greg and Peter from the COI to do the job freelance over their holiday, so allowing us all a break from the ship.

Back at work again after Christmas, my first job was a film for British Aluminium in their old factory on the shores of Loch Ness. This was to be shot in black and white as it was to show the factory as the first aluminium smelter in the country, with the hydroelectric generators put in by Lord Kelvin in the 1890s.

I had already flown up before shooting commenced to see what lighting would be required, as everything would have to go by air. I saw that photoflood bulbs were the answer, because there were plenty of light sockets to take them. With a box of large bulbs, the camera and tripod, Roger, Pat Bowman who was the PR manager and I took off to shoot the film, which would constitute an historic record of so early a factory. One evening, Pat told me that his company were trying to sell the site, including 20,000 acres of land and two villages for one pound. I couldn't believe this until I realised the vast amount of money that would have to be invested to make the area viable.

A short time after finishing the film, I was still thinking about the proposition when Pat called me over to his office in St James's Square. There I met a man who had maps of the area for sale, who could tell me everything about the place. It was at this point that I knew there was no way I could ever raise enough money to cope with a project of this scale, and I had to back out. For many years after, in fact still today, I wonder if I could have made a go of it, knowing it

would have changed the lives of the whole family. Could I have pulled it off? I didn't know then, and after all the years that have passed I don't know now!

Later that year, the *QE2* made her maiden voyage to New York, thereafter sailing backwards and forwards across the 'pond' as well as trips all over the world. In fact during her time afloat, she sailed through the Suez Canal over 700 times! Quite a record.

In 1967, I was commissioned by Cunard to take pictures of the Queen Mother saying goodbye to their ship, the *Queen Mary*. It had been sold to America and was to be put on permanent show in Long Beach, California.

I remember the day well, as the Queen Mother was dressed in powder blue with a large matching hat. I had photographed her on many occasions over the years and knew how good she was with photographers, always putting herself in the right position for everyone to get a good shot.

I had done pictures of her on the bridge with the last captain who was to take the liner to the USA, and knew that she would go down to the restaurant deck next. So taking more pictures there, I then somehow got into the nursery with the sister, so I was alone with the nurse when the Queen Mother came in. Having shaken hands with the nurse, the Queen Mother turned to me saying, 'It's Mr Jochimsen, isn't it? Let me see, you have four children, haven't you? How are they?' Hardly able to reply, because I hadn't expected she would talk to me, or even remember me, I managed to stutter something about my offspring and thanked her for asking. Then taking pictures of her talking to the sister, I carried on with my assignment until she left the ship.

How she had remembered my name and my family was typical of that great lady. She had a mind like an encyclopaedia, and yet had no idea I was going to be there. This type of thing happened with her on a few occasions when I was photographing her, because if she didn't

have time to talk, she would always smile.

In 1969 Roger and I went first-class-return to New York, this time to do pictures of happy travellers enjoying their voyage. We had individual cabins and all the luxury that went with them, such as eating in the first-class restaurant. After the first day out, we found that our stomachs wouldn't take all the rich food and we gave up eating at lunchtime, but making up for it in the evenings. Taking pictures day and night, we concentrated more on the entertainment – the theatre and cinema, dancing and bars. It wasn't until a three-day break in New York that we had any time to ourselves.

When in dock, the ship's doctor thought he should learn to pilot the boat put aside for medical emergencies at sea, in case he had to take charge for any reason. This was first in line of the lifeboats, on the starboard side of the ship, and had to be lowered to the water some one hundred feet or so down. It was a new type of boat that was steered and propelled with water jets. When in the water, I sat bent forward to get a camera out of the case just as the hook was released, which swung right over my head. Had it hit me, it would have killed me, as I had my back to it and nobody saw it happening. Roger managed to grab hold of it at the end of its swing before it could do more damage.

The doctor decided he would have a go at steering the boat. It seemed to both of us that he hit most of the wooden piles around the harbour before he got it out into open water, which then gave us some good shots of the ship in harbour. After missing a few other craft, a crewman took over to get us alongside and attached once more to the cable, which hoisted us back up the side again.

Two days later, we were out at sea again on our way home to Southampton, knowing these would be some of the last shots we'd take of that wonderful ship that had been so much a part of our lives for over four years.

Returning home on the Thursday, I was greeted by my wife,

saying she had found a horse for me, which we were going to see the following Saturday, with the intention of buying it. She had found it in the *Horse and Hound*, at a riding school to the north of London. I tried everything I could to get out of buying it, as I was still terrified of horses – but to no avail. Saturday came and there was Drummer, a seventeen-and-a-bit-hand horse, the right size for me so I was told. They managed to get Chris up on him with difficulty, as she was only five feet four. She walked him round the school three times, and getting off awkwardly said we would buy him. So there was I, having bought my own horse, which was going to be delivered to Newdigate the following week.

Drummer arrived and was put in a stable until I got home that night. We had bought all his tack as well, fortunately, as for a horse of his size that would have been very costly. Eventually, I managed to mount and rode him round the field. The following week I took him out onto the road, thinking that this was easy – until he turned round and took me back home, with nothing I could do to stop him! However, my riding progressed (or didn't, if looked at another way). I would tack him up and ride him out till we came to the same place, where, every time, Drummer would reverse and walk back. Chris also tried to get the horse to do what she wanted, but with her size had even less control over him than I had.

The following Saturday, some of Chris's relations came from Reading for lunch, to see the new house and land. The wine flowed, and with a couple of brandies after the meal everyone was in the right mood, especially me, who decided to show them who was the horseman in the family. Going out I tacked up Drummer and taking him out into the field where Chris and the children did their jumps, I trotted him round, then cantered, then took on a couple of three-foot jumps. Forgetting that everyone was watching, I carried on for another half-hour, at the conclusion of which I knew I had conquered my fear of riding. It was but a month later that I went hunting with the

Surrey Union, and never looked back to when Drummer used to control me.

John Taylor and I had formed a film company together, called Taylor-Jochimsen Ltd, and because I was committed to so much stills work at the time, he took over the Bahamas film. Two months later, however, I started filming a production for Crawley Borough Council, called *A Place to Live*, with the help of Charles Martin who worked with me on the production, finding the locations. The film ran for forty-five minutes when finished, the only problem being that the council changed from Labour to Conservative three quarters of the way through shooting. This necessitated more footage and large alterations to the commentary, resulting in the production not being completed until 1969.

A month later and I was on my way to Sri Lanka for Cunard Brocklebank, the commercial shipping side of the large Cunard company, taking pictures for an advertising leaflet to recruit men to their fleet of merchant ships. I flew to Columbo, having had to go via Athens to get there, and was met by car that took me down to the port, where I joined a merchant ship for the duration of my stay. I lived onboard for ten days while it remained in harbour, loading, among other goods, Ceylon tea.

I shot pictures of all the officers on duty, dressed in the blazing heat of the harbour in white shirts, shorts, socks and plimsolls, and of the ship being loaded by crane. I took other pictures of officers sailing, and yet others relaxing in the shore-side cafés. The old Mount Lavinia Hotel was still there, but was now downgraded from its status of years before.

I had a silent chuckle to myself when I was invited to the swimming club, with all its members British and a lot older than I was. They all looked and acted like the last remnants of the old colonial days, especially in the way they shouted at their native servants.

Although I liked Columbo, I was shocked at all the old cars that drove around the city. I discovered that no new vehicles and very few spares had been imported for over ten years, and therefore the cars all looked wrong as they had been repaired according to a mixture of different makes.

Getting home again, I was surprised to see calves running round one of our fields. Chris had realised we wouldn't be using all the land for the horses, so having met with local farmers had leased out part of the land to Peter and Doreen Hall at Green Lane Farm. Now we had chickens and ducks as well as horses and calves, and were well on our way to self-sufficiency. Unfortunately, Hornblower, that wonderful great dog, died of old age in his sleep – luckily while the children were at school. He was very sadly missed but it was decided not to have another dog immediately – we would wait to see how everyone felt later.

I now started working for the armed services more and more, sometimes directly or through COI, due to the personal vetting security rating I had gained while working for the UKAEA. John Evans at Admiralty Arch was my contact at the MOD, who was in charge of the group that made brochures for the research establishments. My first assignment for John was a brochure for the Empire Test Pilots School at Boscombe Down near Amesbury, Wiltshire.

This was a school where many overseas students came, including quite a few from the RAF to learn how to become test pilots. The students were highly trained pilots already, who, during the course, would fly a variety of different aircraft. I worked closely with the editor of the book, as I took pictures of the flying, lectures and social events. As the courses were long, a lot of the overseas students lived with their families in accommodation in or near the establishment. I spent two weeks working on the book, which included quite a few air-to-air shots.

It happened that one day when I was among the approach lights, just having taken a shot of a Tornado taking off that a Concorde came in and did a touch and go. Going round again, by this time a lot of staff had come out to watch, and were lining the runway. By now I was ready for it, and got the shot that was used in other brochures, learning afterwards that it was the last Concorde to be built and was using Boscombe to check its instruments – hence the crowds who knew its arrival.

For a long period I now seemed to work only for the MOD, because of that first brochure. I did books about HMS *Vernon*, *Dryad* and *Dolphin*, the Royal Hospital Haslar, and the Army Air Corps at Middle Wallop. Later I was to do many more, but I had other clients who wanted me, such as International Nickel, who needed a series of pictures on sherry for their magazine in Jerez, Spain.

I flew to Spain and took the train to Jerez, and ended up in a very nice hotel that first evening. As I thought about an evening meal, I had a phone call from the public relations manager who looked after the different sherry companies in the city. He came to the hotel and ate with me, telling me in perfect English of the arrangements and itinerary he had planned for my visit. I learned that there were quite a few bodegas in Jerez, and each one would be visited, otherwise there would be problems with any that we left out.

On the first morning I was picked up by car and taken to the first bodega I'd be photographing. Starting with the vines and harvesting, I took pictures until about eleven, when I was taken and sat down in a place where the different sherries were stored in large barrels. The tasting then started, first from a barrel bearing Napoleon's name. This they told me was now too old to be drunk, but try this one, they encouraged, which was fifty years younger. So the morning progressed, me drinking more sherry than I had ever done before. Next we progressed to the brandy, though I was beginning to wonder when lunch was.

Finishing at about a quarter to three in the afternoon, before any sign of a meal, I realised that if it was going to carry on like this for the rest of the visit, I would have to work twice as hard and fast every morning, if I was to get all the pictures I wanted.

After a large meal came the siesta back at the hotel. I was to be picked up later and taken out for another feast at about 8.45. Managing to get to bed about midnight, I now thought I knew how the Spanish spent their days, and was determined not to drink as much sherry and brandy as I had on that first day.

The next two days were much the same, except that I had managed to cut down my intake of sherry, and had definitely kept off the brandy. I did manage some lovely night shots of the town and the lit bodegas, before meeting the big man, Don Jose Ignacio Domecq Y Gonzales, at his house. Known not only for his sherry but his nose for the best as well, he could differentiate an extraordinary sherry from one that was merely great. He being someone I had been looking forward to meet.

After taking pictures of him and drinking a really remarkable sherry, which even I could distinguish from others, we got talking about horses. He had a string of Andalusians, and he showed me three of them. Schooled to the extremes of the Spanish Riding School, Domecq offered me one to ride.

In a suit and having had a fair amount of sherry, combined with brandy, I accepted and mounted. It was a large yard, and directly I touched the horse's flanks with my heels we were off doing the Spanish trot. I just could not get the right seat to go with the animal, as I had never experienced this trot previously. Disappearing from view round some stables, at last I managed the trot, though it wasn't very good.

Getting back to Don Jose and dismounting, sure I must have looked a little dishevelled, I thanked him and asked did he ever sell his animals? Much to my surprise the answer was yes, with the great

man asking if I was interested in buying one. I did want one of these horses, knowing I could make a lot in stud fees back in England. I asked the price.

'To you,' Domecq said, '£200, and you pay for the transport.' I hadn't expected that, and still a little inebriated I agreed, saying I'd be in touch directly I got home.

The rest of the assignment went well, and in every bodega I was given either bottles of sherry or glasses, plus posters advertising bullfights. Putting this together in a wooden case for shipment home, I was lucky to have an excess baggage ticket. On landing at Gatwick, I had to stop at customs with the cameras and the large packing case.

After dealing with the cameras, the customs official said to me, eyeing the crate, 'What have you got in there?'

'Samples,' I replied. 'I was given all these as I went round doing my job.'

'Samples of what?'

'Sherry, brandy and a few posters.'

The customs officer looked at me saying, 'I'm not going to open that, how about £5 – is that okay?'

'Done,' said I as I passed the note over, going off with a porter wheeling my drink behind me.

I decided to sell Photo Process and the lease of the premises in Bolsover Street, mainly because the Cunard assignment was now over after nearly five years, and Wilson's recession was starting to bite into advertising and photography. I managed to sell the whole lot for Photo Process's overdraft, to a friend of mine, Bill Bamford. Then, unfortunately, I had to make my own staff redundant, as I was now going to work from home. David Leech, Rodger Livesey and John Curtis had to go directly, while Phil Long stayed with the new owner of Photo Process. I took my own darkroom equipment home, allowing me to concentrate exclusively on my own work, without having to worry about paying twenty staff every week.

Chapter 17

It was while I was hunting on Leith Hill with the Surrey Union that I came across Home Farm for sale. It was in the hamlet of Broadmoor, a seventeenth-century farmhouse and stable yard comprising seven stables with about five acres of land to the rear. I was so taken with the tranquillity and quaintness of the place that I couldn't concentrate on hunting for thinking about it.

However, after the hunt, and having ridden back to where I had left my Land Rover and trailer, I let the rear ramp down and opened the front door. Taking the saddle and girth off I led Drummer in, quickly running round the back to raise the ramp up. Drummer was two thirds of the way out backwards by the time I got there, so I tried again. I didn't want to tie Drummer in as he could easily break the bar if he backed out again. So, after six more attempts, I gave up. Drummer had never done this before, and being entirely alone I had no one to help. The horse just stood when he was out of the box, either because it had been a hard day's hunting and he was tired, or he was just trying it on.

A lorry came past and stopping it, I gave the driver money to phone my wife, asking her to come and help me get the horse into the trailer. The man kindly did as he was asked and Chris arrived later, got hold of Drummer's reins, and took the horse into the trailer while I pushed the ramp up.

'Why couldn't you do this?' Chris said.

Drummer whinnied as if to say, 'Don't push me so hard the next time we're out, and I will go in, no problem.'

That afternoon Chris and I went to see the house in Broadmoor. She fell in love with it straightaway. Once again that was it, we were going to buy another property, though we hadn't lived in Newdigate for very long either.

Two months later we had moved in, loving the house and the area that was somehow so different from anywhere we had lived before,

yet only thirty miles from London. I created a darkroom in one of the outbuildings so that I could do all my processing and printing at home, while the horses had large brick-built stables all to themselves. The one problem was there was no mains electricity, only a small generator. Needing more power, we bought a twenty KVA diesel generator, which made all the difference. We already had a 2.5 KVA automatic generator, which was fine during the day, until the new one was needed for the darkroom and other equipment, such as washing machine and immersion heater. Both generators soon came into their own when Edward Heath brought in his 'three-day week' with all its attendant power cuts.

The first photographic job was for ICI, a 'bath for all seasons' for David Whitter. A lorry turned up one day, full of different makes of plastic bath, side panels and taps. Luckily I had room for them in an outhouse. Each bath had to be photographed in different surroundings, denoting one of the four seasons of the year, the only trouble being that the client couldn't wait for a year for me to photograph them.

Starting off on Leith Hill, I found masses of rotting yellow and gold leaves, which would do for a bath in autumn. Getting the children to help, we managed to cart the bath to the spot some 400 yards away. Putting the first one in position, in went the taps, followed by the side panels. They were all to be photographed on five-by-four colour transparencies, with the baths looking authentically as if in use. Unfortunately, as the side panels were made of a different plastic from that of the baths, they photographed in a slightly different colour in daylight, but obviously balanced in artificial light. I discovered this on the first trials, but managed to get over it by slightly adjusting the exposures. However, some baths and panels were made of the same material and therefore caused no problem. I just had to be careful when fitting the panels to read the labels.

I hired a van and driver to take me round the country with the

baths, starting up in Scotland at Aviemore, where the only snow lay at that time of year. This was for the winter scenes. That caused untold hilarity from skiers who, when passing, saw our baths planted in the snow. Then it was down to the Lake District for springtime bubbling streams and lakes, waiting for the sun in all cases, until finally we arrived back home after about ten days away.

ICI were delighted with the shots, but because the brochure had gone well over budget, they cut the baths from every picture, instead of allowing each one a full page as had been envisaged. Now, anyone looking at the brochure would never have known the days and hours that had been spent, trying to make each bath look like a 'bath for all seasons', when now they'd been removed from their background.

As it happened, the next job was also for ICI, but this time it was rat poison that had to be advertised! The assignment was for the advertising department at Thames House, Millbank, and consisted of making a model set and trying to find some rats. Asking the rat catcher at Mole Valley Council, I was put on to a firm in Leatherhead, who bred them for films and advertising. So now I had to make the set. Firstly I bought a wooden-framed window, about two-and-a-half-feet square, and stood it up roughly two feet away from the wall in an outbuilding. Fixing it in position, I wire-meshed the gap between wall and frame, creating a small cage with a window at the front. Next, having sought the advice of the rat people, I blacked out the window and hung a shrouded forty-watt light, so that it shone only into the cage.

Setting up one electronic flash above the cage, so that it covered the whole interior of my small set, I put another to the left and slightly forward. Then with the Mamiya on the tripod and the 180-millimetre lens in place, I was ready and sitting just far enough away so that the rats couldn't see me in the gloom.

The day arrived and the first scene was of a small bag of grain that was spilling out due to a supposed rat bite. The girl who did the rat

278

handling put four of them on our stage, and now we had to wait in the dark for them to start eating the grain. I did about six shots when they were in position, as the flash didn't seem to worry them, being too fast.

Differing shots followed, the next being a bale of binding string that rats love to chew. Every change of scene, the girl would remove the rats until the stage was reset. She also employed the trick of rubbing Vaseline over the animals, making their hair stand up to look as if they had just come out of the sewers.

Finally my shots were almost complete, with just one more main picture to take – of an empty opened can of rat poison with dead rats draped over and around it. I asked the girl if she had any dead rats, and without a word she promptly killed the ones we'd been using and put them in position over the can. 'A very successful shoot,' I thought, but not the type I wanted to repeat too often.

My next assignment was back to Aviemore by train, and this time nothing to do with baths! It was for a feature in the *RAF News* on survival training for air crew.

The first day was taken up with rock-climbing and canoeing in white water. For the canoeing, I was using a zoom lens on a thirty-five-millimetre camera, to get the look of fear from the students as they negotiated the rocks, as well as some general views of the whole group. Next came the rock-climbing, learning how to scale very steep inclines. Luckily I was able to walk up another way to the top, so that I could take shots of my subjects as they tried, some unsuccessfully, to conquer the climb. They were all quite safe as the instructors had them securely roped, but the strength these pilots needed to make the top was just not there in some, flying being considered a rather sedentary job.

The next day was going to be different, as we were to be at altitude in the snow. The art director and I had been rigged out in heavy survival kit, and as everything had to be carried I took only the small

thirty-five-millimetre Olympus outfit with me, not knowing what I was in for. The first part was fine, as we went up in the ski lift as far as it went. Getting out in thick snow with the two instructors, we ventured out slowly, and with every third step or so sank in the snow. Having pulled one leg out and walking on, the other would sink, making our forward movement slow. Gradually, the pace increased, but the wind had now started to blow hard, straight at us, again slowing us down.

John, Deep in snow in the Cairgorms

Eventually, after about an hour and a half, struggling with our heads down against the elements, we came to an ice hole fashioned of hard snow in the side of a small mountain. This was where I started to take pictures, as three aircrew had been in this so-called 'ice house' sheltering from the weather for three days. It was surprisingly warm inside, though anything must be better than the wind and snow

outside. I finished the pictures and sat on a block of ice to eat my lunch, and was surprised to learn it had been cooked by the three pilots!

After that small break, it was off again around the mountain to meet up with some air cadets, who were on a hike. To me, we seemed to have walked for hours, and I had no clue as to where I was or where I was going. Eventually we came across the cadets, but now my problem was the storm having restarted. When I opened my case to get the camera out, the snow started to fill it, though I had my back to the howling wind. Getting the camera out and wiping it dry as best I could, I took some shots of these poor little kids plodding their way over a barren snow-covered landscape, none of them knowing when they would get home. They were quite safe though, having three instructors looking after them.

But I was not at all happy. Here I was in the middle of nowhere, having finished taking pictures and knowing I now had a two-hour walk back to the lift. The blizzard was blowing harder, while one or other of my legs kept disappearing into the snow as I walked, really making me ache.

Eventually we made it to the lift, and I remember thinking to myself never again would I do such a walk. I was shattered, cold and wet, as were the others, and my thoughts of that day stuck in my mind for years. I wouldn't care if I never saw another snowflake again.

Back home, my next assignment was for ICI yet again. This time it was a large book covering all aspects of the company. I had ten shots to do for it, with other photographers doing the rest. The graphic designer was a man called Royston Cooper, a flamboyant gentleman with a mop of black hair and a full black beard. He wore a corduroy jacket with a red spotted handkerchief dangling from the pocket. His corduroy trousers were held up with a tie, and his footwear was mostly sandals, depending on the weather.

We became close friends, after having done a few more jobs

together. Royston was also an artist of some distinction, having painted posters for London Transport.

One morning, I was walking down Curzon Street and was taken by a bright green picture in a gold frame in an art dealer's window. Looking, I immediately saw Royston's signature at the bottom. In the centre was an old London bus ticket, stuck at an angle and bent out from the rest of the picture, which was of green background paper. Longing to know the price, I went in to inquire, and nearly had a heart attack when told it was 700 guineas.

When I got home I phoned Royston, asking him if he thought that a piece of green background paper with an old bus ticket stuck on was worth 700 guineas?

The reply was typical Royston. 'If people are willing to pay good money, who am I not to take it? I have plenty more old tickets and had thought about coming to see you. You've got all the coloured background paper I could ever need to make more.'

I burst out laughing, not only at my friend but at the thought of all those people who invested in modern art.

The children were all in their new schools. Paul was at St John's, Leatherhead, as a boarder; Sally and Jane were at St Teresa's, the convent on the other side of Ranmore; and Rob was at Bury's Court, a boarding school at Leigh. Sally would sometimes ride out with me on Tea Rose, when I went hunting and juniors were allowed. The little pony managed to keep up with Drummer, though I was never far ahead of my daughter, and was certainly not attempting any large jumps with her. Hunting for me was just a matter of a good fast ride over someone else's land, whether or not we ever saw a fox. Later I realised that without hunting to keep foxes on the move, their population would grow and farmers would lose many more lambs and calves.

My next job was to Portland Naval Air Station, and then a helicopter ride out to HMS *Hermes*, to spend two weeks aboard her in

the North Sea. This was for the MOD, pictures that showed daily life onboard a carrier. Setting down on her flight deck, I was met and taken to the captain who, after talking about the assignment, passed me over again to a lieutenant, who would look after me. I was going to do quite a bit of flying, so I was fitted with a survival suit and helmet to use on every flight.

For the first few days the weather was good, which was unusual in the North Sea. On those days I went around shooting pictures of daily life onboard. When it came to the flying sorties, the weather closed in and I would go from my cabin in the rear of the ship to the pilot's briefing room well forward, only to be told that flying was off when I got there. So back again to what I was doing, only to find, when I got there, that flying was all on again. This backward and forward rushing up and down the ship went on for two days of flying, or supposed flying. Sometimes it wasn't only the walk, but on most occasions struggling in and out of my survival suit as well.

Then the weather changed and I managed to get off in a chopper to take pictures of the ship in rough seas. While I was airborne, I had noticed a small fishing boat that seemed to be keeping pace with the carrier, about half a mile astern. Asking the pilot why it was there, he told me it was a Russian spy trawler, trying to record all the radio traffic aboard *Hermes*. I heard later that the captain of the vessel had radioed *Hermes* to tell them he had finished his tour of duty, but another so-called fishing vessel would be taking over. It was said afterwards that the captain swore like mad at the man's cheek when he got the call.

With more flying and pictures taken, the time went quickly, and when we sailed into the Firth of Forth on our way to the Rosyth dockyards, the sun came out. I took my last shots from the air as the carrier passed under the old Forth railway bridge, having enjoyed the two weeks on board, but I wasn't looking forward to the long train journey home.

Having a few days off for a change, I took Drummer out for some good exercise, as he had been stuck in the field behind the house while I'd been away. We rode gently together around Leith Hill, until we reached Coldharbour, where there were racing stables and a sand gallop back towards home. Letting Drummer have his head, we flew through Forestry Commission land and on to the gallops, me hoping no one else out riding was coming in the opposite direction. At the end of the gallops it was down a steep pathway to the hamlet of Broadmoor, and as I rode through the gates of Home Farm I felt fully invigorated by the two-hour ride.

Although not having a lot of land, Chris and I had not only horses but chickens, ducks and geese. Fred was the gander, and I was the only one who could pick him up, put him under my arm, and literally have a conversation with him, though neither understood each other. There was one very randy Aylesbury drake, which would cover any duck or goose in sight. It had come with us from Newdigate, with the rest of the birds. When the fertilised goose eggs hatched, some were ordinary small goslings, but some were the offspring of the drake. These would be large ducklings, much bigger than ordinary ones, but they lived for only three to four days, obviously due to the mix-up of genes.

Due to the recession, work for the future was starting to look a bit thin for me, so, applying to the *Dorking Advertiser* as a freelance, I was taken on for the following weekends. This made up slightly for the lack of employment, and I wasn't worried about working weekends, I just needed the money.

Chris, in the meantime, had started catering, doing cream teas, after finding that Home Farm had planning for use as a bed and breakfast and restaurant, which dated back to the mid-Thirties. The teas really took off, as we became better known through the publicised walking routes round Leith Hill.

In the autumn of 1975 Robert became very ill with an ear

infection. He was taken to hospital in Guildford and operated on immediately, putting worries on his all. Surgery was a success, and we went and saw him in hospital the next day, taking two of the large baby ducklings that had just been born. Although we were not allowed to take them inside, we showed them to him through the window, after our visit to the ward. It was while we were there that we learned he had locked some of the nurses in the sluice. It had happened the day before when three of them went in to have a chat away from the sister. Shutting the door, they had left the key in the lock, and Robert had turned it, keeping them in and causing all kinds of staff problems. Boys will be boys!

That Christmas was the toughest Chris and I had ever had. Money was tight, as it was for many families. But with the help of Green Shield stamps for the children's presents, and me cutting holly from the fields and selling it at Covent Garden, we got through.

A couple of months into the new year and I started picking up rumours from Fleet Street that Harold Wilson was going to retire. There was talk of him and the raincoat manufacturer Sir Joseph Kagan, also about his secretary Marcia Williams, and it was thought that he had the beginnings of mental confusion. But on top of all that was the main rumour that if he didn't retire the army would take over the country in a bloodless coup. These were not the only stories going round Fleet Street about him at the time, for in lots of cases the well known ones had permeated down to the local papers countrywide. On 16th March 1976, Harold Wilson did retire whether or not for any or all of the reasons mooted at the time. I hadn't a clue as James Callaghan took over as Prime Minister.

My next job was with Ted Weston of COI for John Evans. Ted and I travelled by train to Portsmouth to join HMS *Indomitable*, tied up in the dockyard. This aircraft carrier was one of the newest in the fleet and was going out to Cardigan Bay to test-fire three rockets, as the main part of the exercise. Although Ted and I had other pictures to

take, these were going to be part of a new brochure for John Evans, for which I was doing all the photography, with the rest being taken in different establishments.

The rockets that were test fired would go only about half a mile, as it was the firing off the ship that was the main point of the trials. There were other scientific photographers onboard from Fort Halstead, who were photographing with movie cameras, pointing up how the rockets left the launch site. I had only an ordinary Mamiya camera to get my shots, and it was very much up to my reaction every time to capture each missile emerging from the smoke. Ted and I were positioned on the starboard side of the bridge, with a speaker giving the time to launch. It was three launches and three exposures and keep your fingers crossed. I couldn't really tell until the film was processed, but I had a good idea I had got all three as they shot out. We were flown off by helicopter when we finished, landing at RNAS Culdrose, and then driven to the station to catch the train to Plymouth, and then on to London, arriving home very late.

A few months later, Chris got the job as manageress of the old people's day centre in Dorking, as work started to flow again for me.

I was commissioned by COI to cover the G7 meeting that was taking place at 10 Downing Street on 7th–9th May 1977. I was to be inside, taking pictures in colour of the participants for James Callaghan, the Prime Minister, to give each an album when the meetings were over. It was the third of the G7 meetings and the first to take place in the UK.

I was there early the first day, getting to know the names of the people attending. There was President Giscard d'Estaing of France, Chancellor Helmut Schmidt of Germany, Prime Minister Pierre Trudeau of Canada, Prime Minister Giulio Andreotti of Italy, President Jimmy Carter of the USA, Prime Minister Takeo Fukuda of Japan and Roy Jenkins for the European Commission.

I found myself for most of the three days alone with these people,

knowing I was with the most important men in the world, but trying not to let it worry me as I had a job to do. On the first morning, before lunch, everyone was having drinks and I was taking as many pictures as I could get before they went in to eat.

Seeing me without a drink, Pierre Trudeau offered me one, only to be stopped by Callaghan who said, 'He's here to do a job and not to drink.' That started something I would never have dreamed would ever happen to a photographer. Trudeau, Schmidt and Carter each bet £50 among themselves to be the first to get me to have a drink without Callaghan seeing. It took till the third day before Trudeau managed it, collecting his £100 from the other two, with me having to knock back a large gin and tonic quickly while the Prime Minister of Canada took my empty glass before anyone saw it. What shook me most, when I think of it today, was the thought of three of the most important men in the world, having a bet between themselves about me. As everyone left Number 10 on that last afternoon, the three came over to me and shook my hand, saying something like, 'Great pictures, and it was it a pleasure to have met you.'

'That's me they're talking to,' I thought, me, the photographer!
The next assignment was for Peter Baker, the man who for thirty years had run the Bluebell Girls for Madame Bluebell. At the time he had five troupes working worldwide, besides the one I was to photograph at the London Palladium. As I arrived and set up in the front of the gallery one morning, Peter explained that he would set the girls on stage and use the stage lights. This suited me, as I would never have been able to illuminate the stage with my own lights. Taking all morning to get the shots, they turned out to be exactly as Peter had envisaged them.

A full size copy of Sir Francis Drake's ship the Golden Hinde on it way down the Thames, on press day.

Chapter 18

All four of my children had grown up, with two having started work. It seemed only yesterday to me that all had seemed so small. Realising I had missed the best part of their growing up, because of my job, and by not being there when they needed me most. While earning money to keep my family, had made me forget that they hadn't seen as much of me as they should have done. But what does one do as a well-known self-employed man, travelling the world? I vowed to myself I would try and put it right, that I must be at home more before my children left, leading their own lives. Paul had finished school, and achieving two A grades had won a flying scholarship whilst in the Air Cadets, advancing him towards his private pilot's licence, with thirty hours' training at Ipswich, and the final five at Biggin Hill. Passing, he was flying before he had got his car licence and was working at the Ministry of Transport in London. It wasn't long before he got fed up with that, with the daily travelling to London, and so applied to the RAF to be accepted for training as a pilot.

Sally had started work as a trainee veterinary nurse in a local surgery, before leaving there to work at the Department of Transport in Dorking. Jane, still at school at St Teresa's, studied hard for her 'O'-levels, and Robert was at St John's College in Horsham.

Chris had left the old people's day centre in Dorking and gone to take the position of manageress of a day centre for the mentally confused, also in Dorking.

As all this was happening, we moved again, this time to Abinger Hammer, where we had room for both Tuffet and Tea Rose, as Drummer had been retired and put out to grass on a friend's farm. With two German shepherds and an old English sheepdog, life settled down again, with Chris and me starting to think more about farming in the future, while carrying on with our present jobs for the time being.

My next assignment was for the Coral Leisure Group Ltd,

consisting of a large brochure, working with Alan Gatland as designer, on casinos in London. The casinos were Crockfords, Carlton House Terrace, the Curzon House Club, Curzon Street, the International Sporting Club, Berkeley Square and the Palm Beech Casino Club, Berkeley Street.

All the gaming photographs had to be shot with models, as real punters could not be shown. This meant on every photo session different men and women had to be used. The cost of all those personnel was very high, as every shot taken had to show different people at the tables. Sometimes I could get away with some by changing clothes or hairstyle, but generally there was a constant change of people every morning. Also, the shots had to look different in each of the casinos, though the games played were the same. It meant different models combined with different shots to show the clubs off at their best, while by the time I got to the fourth I was hard pushed to think of different angles.

Not only was it the gaming side of the operation, but there were the different dining shots as well. Every club was very proud of its food and the way it was presented. There were different types of dining, club to club. Some had concentrated on Chinese food with more normal fare, while others had gone for Indian, and every club had a spectacular bar that also had to be shown.

The shots had to be taken in the mornings as gambling started after lunch at every casino, and any sign of me or my models had to be away by then. The only shots that could be taken at night were the exteriors, with the doormen in evidence, and these I did one evening after dark, using the same van as I had used for the baths, to give me height. Two or three studio shots were required for the cover, plus a shot of the guards' band outside Buckingham Palace, to show it was London. These pictures took a fair time to take and the brochure was finished in 1978, with Corals, Alan and me extremely pleased with the result.

Paul passed out as a pilot officer in the RAF on 24th April 1980 at RAF Henlow, being the last of the graduation ceremonies to be held there. My wife and I were there as the proud parents, seeing their son pass out. He went on, after his leave, to do his flying training at Church Fenton.

My next assignment caused me a lot of embarrassment, but the nurses thought it very funny! I was to do a series of pictures at St George's Hospital, Tooting, for the COI. When I drove in, the rain was lashing down, so with my equipment and my raincoat on, I made a rush for the entrance. Taking off my raincoat and meeting the matron, I started work in one of the wards. For the very first picture I took I needed to crouch down, putting pressure on the seam of my trousers, which parted with a resounding rip. Not knowing what to do or say, I grabbed my raincoat, saying I felt cold as I put it on. However, it was hot in there, and in no time I was sweating. The matron, realising my predicament, ushered me into an empty side ward, got half a dozen safety pins and left me to repair my trousers, while everyone waited for the session to continue. To say that my face felt red as I came out is an understatement, being half to do with the heat in there, but mostly to do with my ripped trousers! Looking round, I saw that even the patients had grins on their faces, but worst of all the sister looked as if she would burst out laughing any second. It was not at all the way I liked to start an assignment, but I had a good giggle about it later when I got home.

Walter Nurnberg rang one evening to ask if I could find a space to do a series of block courses on lighting at Guildford School of Art. After retiring, Walter had taken the post as head of photography. Over the years, Walter and I had become close friends. I immediately said yes, the courses being of three weeks' duration, which were to start in a month's time, two a year for two years.

I enjoyed teaching as a break but found that none of my first set of students knew how to print. For the first week of the course, I had

them in the darkroom, showing them how to choose the right grades of paper for the negative and then how do 'dodge' parts of the prints with extra exposures, using their hands. Then, I would teach them what a good negative looked like, before getting to the main part of the course, lighting. On each of the four courses I taught, I found no one had taught my students any darkroom or printing skills.

Photography for the Met Office calendar followed the end of the first course. Once again, like the baths, it had to show all seasons, and once again there were going to be difficulties. However, everything fell into place, except in the case of the winter shot. I managed to get that shot with frost instead of snow, and as it was nearing the end of the year I knew the place to do it was once again Leith Hill. This time I had been asked for deer or people to be in the pictures, as many deer and walkers roamed that beauty spot. I had got to know a taxidermist who worked locally, because of some stuffed ducks I had borrowed from him for an advert for ICI. Ringing him up and asking if he had any stuffed deer, I managed to borrow a couple.

Armed with these and getting up early one morning, I drove up the hill, knowing the frost would be greater up there due to the height, just under a thousand feet. Placing the deer in the best spot I could find, and waiting as the sun broke through the trees onto the frost-covered foliage, I took the shot. John Evans said afterwards that the pictures were great, just what was wanted, not realising he was looking at two stuffed deer!

After this, everything seemed to be for the Ministry of Defence. Over a period of years, I shot pictures for three RAF calendars, with my first assignment at 16 MU, Stafford. The shot consisted of a large lorry and trailer, called a 'Queen Mary', with two aircraft wings onboard at night, escorted by two RAF police on motorbikes. As the shot would look a lot better in the wet, the fire brigade at the unit were called to supply the downpour. They had to make sure the 'rain' missed the photographic lights, lest they shorted out. However, all

went well save that everyone got soaked barring me, as I was taking the shot from under an umbrella.

There was a postscript to this picture, for coming into the unit was a railway line with a level crossing that hadn't been used for a couple of years – the line now went nowhere. Nevertheless, the level-crossing keeper had been sitting there for two years, day in, day out, with nothing to do except read a book. It was the day before I arrived that someone suddenly realised they'd been paying him for the two years, just to sit and read every day, with no hope of a train ever being seen again. A great job if you can get it!

The pictures for the calendars were great to do and I was very lucky to get the assignments, as every place visited meant just one months picture for the calendar. It gave me time to put a lot of thought into just that one final shot, without having to worry too much about time or other pictures. I could approach each one as an artist composing a painting, and put everything into just that one image.

Interspersed with shooting these were other photographic jobs, one being of 10 Downing Street for the front of a card for the eightieth birthday of Her Majesty, the Queen Mother. This was to be followed by pictures of Mrs Thatcher and her husband Dennis on the steps of Number 10, for their Christmas card.

At Downing Street, I had managed to park my car in the road. I was getting the Linhof camera set up for the occasion when Mrs Thatcher came over to talk to me about what was required. She basically wanted to show the whole of the front of Number 10 with the flags on top, with the two of them standing on the step. Everyone knows that the houses in Downing Street are high, with very little room to get back far enough, especially to get the flags in shot as well.. Besides that, I had told Mrs Thatcher at the time that she and her husband would look like two small peas outside a large pod. She wouldn't be put off – she wanted the flags as well as Number 10 head on. So, I went back, under the arch to the Foreign Office, to get as far

away from the building as I could. I could get the full height of the house with the arch making a frame for the picture, but still couldn't get the flags; all I could see was halfway up the poles. I was using a sixty millimetre wide angle on a five-by-four camera in the upright position, one of the widest lenses for that format. Also, as this was an architectural shot, I couldn't tilt the camera, because the uprights would start to converge, and I couldn't use the rising front, as it would show only more of the arch at the top. By this time Mrs Thatcher was looking in the ground-glass screen at the back of the camera, aware of my problem but not giving in.

I suggested the flags be lowered to half-mast, for then I could just get them in, but she wouldn't hear of that. By this time I was beginning to wonder who was taking the picture, the Prime Minister or the photographer, as she kept eyeing it through the ground glass. Eventually there had to be a compromise, so I did the shot without the flags but with the two of them looking like very tiny people. Once again I said to them it would be better for me to come in closer and just do a shot of the two standing at the door. But Mrs Thatcher would not have that, the shot had to be bigger, taking in more to left and right of that famous black portal. Eventually, that was the shot she picked, and COI, who had organised the assignment, got a lovely letter from her secretary in which she thanked me for taking the time with the final shots. I have the card as a memento of that day, unfortunately not signed.

Over quite a long period, I had done a lot of work at Number 10, and on one of the last occasions I was sitting in a small room having a cup of coffee, waiting for whomever I was to photograph. When the door flew open and Mrs Thatcher said, 'John, have you seen Dennis?' Before I could say no, I hadn't, she was gone, with me grinning and thinking to myself of all the times I had heard that said on TV.

At this time and over a period of about six months, I did trips to Northern Ireland for the army. I would fly into Aldergrove and be

picked up in an unmarked car by two soldiers in civilian clothes. Getting in the back with my camera case and overnight bag, I always noticed the Sten gun on the floor in front of the passenger seat, and the speed at which we went. They would never ask any questions and I would try and sink further down in the seat, always with a funny sensation in the back of my neck, as if something was about to happen. Arriving at the camp I would be taken to see the commanding officer first, and then an officer from the MOD PR department. Here I would be briefed before being put in uniform, the idea being that I was much safer dressed as a soldier than as a civilian photographer.

Dressed as a soldier in Northern Ireland

Some of my pictures would be shot from the back of armoured vehicles, especially in towns, so that people would not see the camera as I photographed troops walking on patrol. I could never get over the look of those small towns, with supermarkets and shops having the same names as those at home, but with the army in charge, patrolling them. In places out in the country, I was out of the vehicles and with the troops, walking with them and taking pictures. At one village, I

was walking backwards, photographing soldiers walking towards me, when a voice behind me said, 'Don't go any further than the end of this hedge, sir, otherwise they'll be able to see you and take a shot at you from across the fields.' Needless to say, I immediately froze and stopped my backwards walking.

One night, I was to go with the troops to a brewery, where there was thought of a stash of arms and explosives. Arriving and taking the camera and flash out of its case, the PR man and I went round taking pictures of the search, with the dogs helping. Finishing after about an hour, we returned to where the camera case had been left, and picking it up I found it was a lot heavier than when I had left it, especially as I still had the camera and flash in my hand. I opened the case, and found myself looking at bottles of beer that some crafty soldier had put in, hoping I would carry them back to the billets with nothing said. Unfortunately I had to tell an officer, as the PR man had seen them as well. Soldiers were always looking for an excuse for a drink, and I should have known, with all the beer around, something like this was sure to happen.

I always had that funny feeling that something nasty would happen to me, when I was in Northern Ireland during the Troubles, but luckily it didn't. I had been well looked after every time I was there, but comparing it with Malaya, with all the bullets that were flying around then, I was always pleased to be home again, as it could have been just as bad.

My last assignment with the Queen Mother was at Hyde Park barracks, where she was in her element with the horses she so dearly loved. I took pictures of her going round, and the visit was to end with a picture of her with all the NCOs. Before she arrived, I had lit the shot, the army having laid out the chairs, with every soldier knowing where he was to sit. Setting up the Linhof, I took a meter reading, knowing everything was now ready. Having finished my pictures with the Queen Mother entering the mess for a rest, I went round to get

ready for her appearance with the NCOs. They were already in place and putting the slide in the camera – all I had to do was turn on the lights and take the shots. She arrived, and taking her place at the front of the group sat and chatted with a soldier next to her. I turned on the lights. I was just about to take the picture when Her Majesty said, 'Mr Jochimsen, do you know your front tripod leg is sinking?' Pulling it up, and thanking the Queen Mother I took the shot, not knowing that this was to be the last time I would ever see Her Majesty.

Chapter 19

Later the same month, there was a job for ICI in Cardiff. I drove down with David Whitter of their PR department, who explained that his company had invented a foam that when blasted between two layers of bricks not only insulated the building but also stuck the two layers together as it hardened in the cavity. We were going to photograph this foam in use where the building's outer course of bricks were falling away.

Picking a particularly bad example, where from the side I could see how the outer skin of bricks had moved from the upright, I got to work taking shots of the workmen drilling and injecting the foam.

We had done this a couple of times when a lady in one house offered David and me a cup of tea and a chat about the whole scheme. With the kettle on, she called out that she was just going up to get a clean tea towel out of the airing cupboard. A few seconds later there was a scream, and both of us rushed up the stairs, thinking she must have fallen. But that wasn't the problem. When she had managed to open the airing cupboard it was one solid block of foam, encasing her clothes. The workmen had not looked to see if there were any holes through into the cavity – instead they had just taken it for granted there would be none.

I now knew it was time to forgo the tea and get into the car, leaving David to try and placate a woman for the loss of all her smalls!

We spent the night in a hotel, with thoughts of the poor woman trying to extricate her underwear from a solid block of foam, as she didn't want the workmen coming across her smalls. However, I learned later that ICI had recompensed her well, while David had left strict instructions with the workmen that all cupboards attached to outside walls had to be well looked into, in case of any such recurrence.

There were other assignments for the MOD, one being at the naval

298

armament depot at Gosport, which spread over quite a few acres. Working from one building to another, I came across a very large hangar that had its own police post guarding it. Checking my pass, they handed me a small fire extinguisher and then lifted the barrier, not saying another word. In the hangar, I saw it was full of torpedoes, all on racks to a height of over ten feet – hundreds of them, with wires attached. Looking at the very small fire extinguisher in my hand, I thought someone was having a joke. If they thought I would stop to put out a fire among that lot, with that small device, they didn't know me, as I'd be miles away in no time. Being very careful, I took pictures using only natural and in-house lighting, in part because I didn't have enough illumination to cover such a great area. After an hour I had finished, and returning to the barrier handed in the extinguisher.

'How on earth do you think I could put out a fire with this?' I asked.

'I wouldn't know,' retorted the policeman, 'we only do what we're told.'

Driving away, I wondered if I would ever understand government thinking.

Next it was Priddy's Hard in Gosport, an old, unused ammunition factory that had been arming ships since Nelson's time. The wooden pier was still there where over countless centuries explosives of different kinds had been loaded onto ships, the last some time during the twentieth century. I had been commissioned by the MOD to photograph the place, which was to be sold, making way for new housing.

I was taken round by an MOD police constable, with the first part of the establishment being a small working museum, showing the history of the site, with examples of the armaments that had been produced over the years. Doing a few shots of the museum and contents, we started off around the old factory, with the first building

being the old laundry. The building itself looked ordinary – it was what had made it that was far more interesting. All the working clothes for centuries had been washed in it, so much so that gunpowder had been sluiced out into the soil for years, making the area highly dangerous. The policeman said to me that there was enough gunpowder in the soil to cause an almighty explosion, if it was not excavated properly.

We entered a row of huts that had been used to manufacture mortar bombs. Some of the wall covering had been torn off the interior, as some bombs that had not been made properly had been hidden behind the cladding over years during manufacture. This was not only highly dangerous but in some cases, had those bombs got into active service, they could have pre-ignited in the mortar tube. In effect the whole of those huts was like a minefield, though they had all been found and were being blown up under controlled conditions. Walking round, I couldn't help but feel a little uncomfortable.

The last buildings were two that had been built in Napoleonic times, of brick construction with moats around them. The policeman's next story really put the place into perspective. It concerned efforts to clean out the moats with a mechanical digger. This had been tried about a month before my visit, and had ended quickly when the digger fished out two large shells, both very much live. All work had stopped immediately, with experts trying to work out how best to clear the moats safely. It was felt that those had been in the water since the end of World War II, when ships had offloaded wartime munitions. Nobody knew what to do with them, so they had ended up underwater. When I had finished, I must admit that Iwas pleased to get away from the place.

My children had all left school by this time. Paul got his wings at RAF Shawbury, having finished his flying training as a helicopter pilot. He was posted to 33 Squadron, RAF Odiham, flying Pumas. Jane had got a job at the South East Road Construction Unit, with the

Ministry of Transport at Dorking. Sally was still at the Ministry of Transport, while Rob was working on a farm at Leigh, also near Dorking.

I had done a few studio shots in the past for the British American Tobacco Company: now they wanted a series of pictures, taken at night on the apron at Heathrow, of aircraft loading and unloading, for further advertising.

Ringing public relations at Heathrow for permission, I discovered that my old friend Reg Tyrell was now Chief Superintendent of Police at the airport. Ringing Reg direct, he said he would fix it and a date was made for the photography to take place. I arrived at Heathrow at about seven in the evening, with Reg suggesting we had a beer or two before starting work, to catch up on each other's news. Unfortunately, two beers turned into a few more, so that by the time we started taking pictures both were a little under the weather, to put it mildly. Wandering about the apron with the Linhof on a large tripod, I was taking pictures while Reg was telling people what to do for each shot. It was fair to say that although the pictures were good, and what the client wanted, if anyone had asked me to put a caption to any, I couldn't have done. Not that it mattered, as it wasn't a press job, though people were telling Reg afterwards that two rather unsteady gentlemen were seen walking around the apron taking pictures, seemingly completely oblivious to moving aircraft.

That was the last time I saw Reg, though we had talked on the phone quite a few times. Later that year I had tried to trace him again, but was unable to find him. To this day I don't know what happened to my old friend, but I have never given up trying to find him.

My next job was for Philips Electrical, again after all those years, with the start of the round-the-world yacht race from Gosport. I had taken Ken Simons, an old friend of mine, along for the two-day shoot. I was to go up in a helicopter while Ken would go out on the press boat. The race had started before the chopper turned up, but that

didn't matter too much as I was mainly to take pictures of the boat with the name Philips on its spinnaker. This was quite easy to find once we were airborne. We circled the boat from a height, then went down to water level, so that other yachts showed in the background behind ours. Unfortunately, having rushed them to be processed, the pictures showed the wrong sail had been rigged on the boat, so the shots were no good. Ken had managed to get pictures of the boat before she hoisted her spinnaker, so those were the ones they wired back to Holland. This happened sometimes on jobs – things could go wrong that were not the fault of the photographer.

The next job for Philips took nearly seven weeks to complete. It was a large brochure about the company, mainly photographic, designed by Alan Gatland and written by George Sutherland. It was for David Whitter, who was now with Philips in their offices just off the Aldwych. It was a big task and had to be got out in a hurry, as it was wanted urgently. However, the date was met and everyone was congratulated for doing such a good job in the time available.

I had a meeting in Guildford one morning when Paul phoned early from Odiham, to say he would be flying down the A25 at about 10.30, and would buzz the house. He quite often did this as our house was on the A25 and the RAF used the valley when flying south.

I waited in until I realised that if I was to make my appointment, I would have to go. Driving along the A25 towards Guildford, I saw a Puma coming towards me quite low as the road rounded Shere. The headlight on the aircraft flashed as Paul recognised my car, and I flashed back twice before the aircraft passed. Not seeing the car in front had stopped, I had to brake hard, noticing that the driver was already walking back to talk to me.

'What's the matter, mate?' he asked, 'why were you flashing me?'

'I wasn't flashing you,' I said, 'I was just signalling to my son in that aircraft that went over low.'

'I've heard some things,' the man said, 'but that beats them all.'

302

With that he walked back to his car, still mumbling to himself – something about 'bloody drivers and their sons'. Perhaps it was best that I didn't hear the rest of what the man said, as he was certainly not happy!

Out of the blue, I had a letter from Greta, one of my old girlfriends, who I hadn't heard from for years, before I was married and first worked for COI in Baker Street. It was to tell me that her mother had died and that Greta and Rod would like both Chris and me to spend two weeks with them in San Antonio, where they now lived. Soon it was arranged, with Rob going as well.

It was a great two weeks for all three, as neither Chris nor Rob had been to the USA before, and to them it was a different world. One day, when Greta and I were alone, she started to reminisce about her mother and why she had never told her daughter who her father was. She told me that on her deathbed her mother had said that her father was Lord Louis Mountbatten. I could not believe this, though Greta said it must be true, and showed me a signet ring that her mother said he had given her when in Hollywood in the 1920s. The ring was unusual, set with quite a large ruby, something that a moneyed person might give. I remembered back to the days when I also had tried to get the name out of her mother, but she wasn't going to tell anyone at that time.

On our return to the UK, I sent Greta a copy of Lord Louis's biography, a large book of his whole life with many pictures. She concentrated immediately on one picture, taken in Hollywood in the late 1900s, showing His Lordship with his wife and Charlie Chaplin. Also in the picture were a couple, not named in the caption. Greta said she recognised the woman as her mother, for the dates when she was in Hollywood matched up to when Greta had been born. Also, she had a picture of her mother from about that time, and it clearly matched the picture in the book, so Greta said.

A few years after this, Greta died of cancer, but Rod kept in touch

until he too passed away two years later. I cannot say to this day whether this story was true or not. Would Greta's mother have delayed telling her daughter about her father's name until her dying breath, if it wasn't true? Neither I nor anyone else will ever know, only Greta, but now she is dead. Did the truth die with them all, or was it just wishful thinking by her mother?

I got back to work directly I returned from America: John Evans had been waiting for me to do a further series of brochures for the MOD. The first was for the hydrographic department in Taunton, requiring me to spend a week there to photograph everything needed by the designer.

Next SCRDE, the Stores and Clothing Research and Development Establishment. The wrap-around cover was to picture thirty-six service personnel, all in different uniforms, standing on a white continuous background. This had to be done in a very large studio, and I found one in Mitcham that fitted the bill. It was for John Evans to find the service people who most suited the range of uniforms that would appear in the picture. Not only that, but he had to get them all there on the same day, arranging for food to be on hand all the time, and providing changing rooms, there being eight servicewomen among them.

I had the camera on a gantry, looking down on the assembly, having to position all before they changed into uniform, as had been the case many years before with the clock-face scenario in the studio at COI. The white background had paper laid in strips for everyone to stand on, while this first check on positioning was made. Then, with all remembering positions, they broke for coffee before changing.

Back changed, but still on the paper, they took up their positions. Then, because of the conflict between the many different colours and uniforms, they all had to be moved again. It was another hour at least before they were ready to be photographed.

After taking a few colour shots, and noticing that someone had moved slightly, I had to check again in the ground-glass screen, to ensure that nobody was covering anyone else.

Finally it was finished at about four in the afternoon, and everyone breathed a sigh of relief, as it had taken all day while I hoped that nothing would go wrong in the processing.

Next it was ARL, the Admiralty Research Laboratory in Bushy Park and Teddington, followed by DES, the Defence Engineering Service. Then Boscombe Down, Porton Down and the Empire Test Pilots School for the second time.

ARE, the Admiralty Research Establishment, and the Naval Weapons Trial Organisation followed in close sucession. In fact by

this time I had lost count of the number of establishments I had photographed, sometimes working with graphic designers from COI, like Alan Gatland or private design companies.

It was in September 1984 that my daughter Jane married John Terris, in the little church at Wotton, with the reception held at the Wotton Hatch, just across the road. Some time later, when Chris and I were having a quiet evening, the conversation got round to farming again, and on the spot we decided to move once more, but further south this time, to look for a place with more land. It took some time but eventually we found the place we wanted in Slinfold near Horsham – Ranfold Farmhouse, with over eleven acres.

After building two barns we started farming with fifty calves, feeding from an automatic feeder, and a small flock of sheep with which we hoped to learn all about their problems, never having worked with them before. We had raised calves and foaled horses previously, so we weren't starting farming without experience, but like everything else, experience only comes through practice! Two years later the farm next door came up for sale, and being too good an opportunity to miss we bought it, Bramble Hill Farm, one with many more buildings and 110 acres.

Throughout all of this I was still taking pictures and Chris was still working in Dorking. but I was trying hard to get assignments nearer home, so that I would not be away from the farm so much.

Two of the sheep had been late lambing, and while one had no trouble, to be on the safe side the vet had been called out for the other. I was holding the ewe up by its back legs with its head resting on the straw, while the vet had his hand inside the ewe. Rob was standing watching until the vet pulled a lamb out, saying to Rob, 'Swing it round and start it breathing.' The vet meant backwards and forwards, but never having done it before Rob swung it in a circle, with the lamb slipping from his fingers at the height of the spin. Taking off, the animal flew up towards a heap of straw, with the vet watching, not

believing his eyes. Landing in the straw it bleated as the vet said in all seriousness, 'That wasn't very clever, was it?' I could hardly keep a straight face as I looked at him, but worse than that, I nearly dropped the ewe. Rob was trying to keep a straight face too, as he picked up the lamb, which was no worse off for its free flight, and gave it to its mother, who immediately licked and bonded with it. Not the best way to get a lamb to start breathing!

I had also started working for *Farming News*, where I combined photography with learning more about farming. But there was still more and more work from the MOD, mainly photography for new brochures about other establishments, such as Farnborough, with the RAF medical section and the crash investigators.

Whenever a helicopter was needed, the MOD would either get me to go to Odiham or meet the aircraft on site at any of their establishments. Not only that but the boss of 33 Squadron would always put my son Paul to fly me on these sorties, thinking that father and son worked better together. I went on many flights with him, shooting aerial shots for inclusion in brochures, or army camps that were up for sale – in fact most of my jobs for the ministry seemed to need aerial pictures.

I would forget that it was my son flying the aircraft as I would be concentrating on getting the shots, except occasionally when Paul would say over the radio, 'Now where do you want to go, Dad?'

There were a couple of times when Paul banked too steeply with the large side door of the Puma open, forgetting that his father was sitting on his camera case, which was moving towards the opening. Although I had a belt round myself, stopping me from falling out, I didn't want to lose the cameras. On those occasions it was just a few words and Paul would bring the aircraft back to level flight. I never worried about flying with him – he was a professional and a damned good pilot.

In 1986 we moved to Bramble Hill Farm, just outside Horsham. It

was easy to get the animals up the lane and into the new farm, but it took a bit longer to get the family into the new farmhouse. Sally was there for a short time before she moved in with partner Billy at his house near Farnham. Rob lived there, helping us with the farm, and Jane, who was married, lived with her husband, while Paul was at Odiham.

We had realised before we bought the farm that some of the buildings were right for conversion to industrial units. Having got planning permission, this was some of the first work done on the farm, to start bringing in money. What we hadn't realised was that because there wasn't much left on the farm – everything we needed had to be bought either new or second-hand. Then there where the animals to stock the farm, and a tractor and equipment. The sheep were increased over six months to 400, plus 14 rams. The fifty calves we had brought over from Ranfold were sold, which helped with the purchase of the sheep.

There was a small chicken house, which we repaired, and bought twenty birds as a trial. We were soon selling eggs to local people, and thought about enlarging production to sell free range on a much larger scale.

Meanwhile, the first industrial units had been let and others were under construction, so that when finished we had ten in all.

I had let things slip a bit with my photography when one day Dave Scrivenor from COI rang to ask if I would go to north Wales and photograph Caernarvon, Harlech, Beaumaris and Conway castles for a Japanese magazine. He couldn't tell me the name of the periodical as it was all in Japanese, but they needed large transparencies, as the publication was big in size and very upmarket. Leaving the farm in the very capable hands of my wife, I went away for four days to do the assignment. Chris had given up her job at the day centre for the mentally confused, saying that when she'd found herself carrying on a conversation with five people all at once and not understanding a

word they were saying, she knew it was time to give up, especially now that we had a full-sized farm to cope with.

The job in north Wales went extremely well, as I had good weather there. I had found how good it was to be back, taking pictures again, but now I had more things to worry about, livestock and the farm.

A week or so after my return Dave rang again saying that the Japanese were so delighted with the pictures they would like me to do another assignment for another magazine in the same group. This, once again, was an architectural assignment, but this time showing exteriors and interiors of different properties. The first was a thatched country house, then a flat in Canary Wharf that had been converted from an old warehouse, and lastly a modern, up-to-date three-bedroom semi-detached house. I immediately knew of an old thatched house in Newdigate, which I arranged to shoot with the owner's permission. The flat in Canary Wharf and the semi-detached house were organised by the COI, so I started with the one nearer home in Newdigate, taking two days to finish the pictures. Then it was Canary Wharf and lastly the small house in Bromley.

Once again everyone seemed to be delighted with the pictures. I started to give more time to the farm, as it was starting to grow. Over the first year and into the second, the chickens were increased, eventually to 3,000 free-range birds, the eggs being sold to a wholesaler initially, while I'd been going round selling to shops and markets. It became clear that private sales was where the money was, and soon I was delivering as far north as Richmond, and south to the coast. We took three people on for the farm, two in the egg room, with Chris in charge, for the collection, grading and packing, while I was kept on the road most days with the selling.

The third was a man called Tom, an old boy who had been in farming all his life, who looked after the sheep. As long as sheep are closely watched daily for such things as fly strike and foot rot, there is not a lot more to do except at lambing time. There is the bringing in of

outside help, as people have to be with them, twenty-four hours a day. The first lambing of the flock in March brought in three girls from agricultural college who needed the money and the experience.

Chris and I suddenly found that Rob was keen to do the night stint, when one girl in particular was also on. It soon became clear to his parents that there was more to Rob working at night than met the eye. To cut a long story short, it wasn't long before wedding bells were being talked of and Rob and Julie got married, living for a long time in a mobile home on the farm.

Paul landed one day in the Puma just outside the farmhouse, when luckily everyone was around. He had flown in with a squadron leader, who came to inquire whether we would let the RAF use one of the fields every month for navigational exercises, day and night. We readily agreed after it was explained that they would also have a map of the farm and would ring every month to check which field they could use.

So it started, and went on for the rest of the time we were on the farm. Every year the RAF would lay on a lunch in the mess at Odiham and invite all the farmers and their wives, giving them a trip in a helicopter as thanks for letting them use the fields.

Every time Paul landed at the farm, he would bring the crew into the kitchen, and if everyone was busy he would make tea for the three of them and hunt for the biscuits. The RAF used the facility day and night, not only with Pumas but also Chinooks, much to the wonderment of the local population, who couldn't work out what was going on.

A month or so later, Paul was married to a Scottish girl called Margaret, and they went to live in Guildford while he was still stationed at Odiham. But that didn't last long as he was posted to Northern Ireland, and they set up home in RAF accommodation on the airport at Aldergrove.

The years rolled by and Chris and I were busy on the farm every

day, with me still getting assignments for photography. These I managed to fit in by taking days off from my egg deliveries and getting in a part-time driver when necessary.

I had noticed for some time that my wife hadn't been feeling well, but she would carry on with her work on the farm, saying she felt all right and that it would pass. Talking it over with the children, and finding that everyone was worried, it was felt that Chris should see a doctor. Having seen her GP, I took Chris to see a specialist, who hinted to her that it could be cancer, as she had been so sick. This consultation had hit not only Chris very hard but the children and me as well, with all now thinking of that possibility. The children all rallied round and looked after my dear wife until the day came for an exploratory operation, which confirmed it as a cancer that had grown too large to be removed.

For almost two years Chris suffered with chemo and radiation therapy, being very brave all the time. She still took a lot of interest in the farm, and in the early days of her illness she even carried on working with the chickens, helping to get the orders ready for the next day's delivery. The first year passed and Chris got worse. But she still wanted to remain at home as long as possible, and if it hadn't been for my two daughters, Jane and Sally, with help from Rob's wife Julie, the farm would not have been able to carry on. However, with further help from Beverly, Tom and Rob, things went on as normally as they could under the circumstances.

It was then that I got the chance of a large assignment to photograph all the historic houses and places that were held in the care of the Ministry of Defence. This meant that I had to visit locations as far afield as Fort George in Scotland and Fort Brockenhurst in Gosport, together with many sites in between. I discussed this with both Chris and my children, knowing that I wouldn't take the job if it were felt I shouldn't be away at this time. The positive feeling was that everyone could cope, and so I took the

assignment, ringing home at least once every day. It went on for over a month, after which I could then concentrate on looking after my wife again, with the help of everyone around – without whom I could never have managed.

Fort Brockhurst, Gosport, UK

Royal Navy College church, Greenwich, London

On the ceiling of the lower hall at the Royal Naval College is depicted the triumph of peace and liberty over tyranny, as shown in the photograph

Chris had always wanted a farm, somewhere where we could be self-sufficient. Right from the earliest days of our marriage, she had bought books on smallholdings, never dreaming that one day we would eventually own one. But in those last few months of her life, she always wanted to be brought downstairs to be able to look out over the farm, and when I brought home the cash from the sale of eggs she would count it and put the money into bags, always wanting to know how well the chickens were doing. At times when she felt well enough she would walk short distances. She would ring me on the car phone to ask where I was, as she wanted to put the kettle on for a cup of tea when I got home. Mostly I would be outside or only a few minutes away.

However hard everyone had tried over those last few months, Chris was fighting against the inevitable, and she died after a long and painful fight on the evening of 1st February 1996, in Mount Alvernia Hospital in Guildford, a terrible loss to the whole family, but at peace at last. We had been married for nearly forty years, and it was so awful for me and the family, knowing we would never see that lovely, caring mother and wife again.

After the funeral, the family decided that the farm should be sold, and as I was now sixty-seven I should retire from photography as well as farming. With the kids and me, Julie, Beverly and Tom we kept the farm going until it was finally sold on 31st November 1996, the same day that I moved into a small two-bedroom house in Southwater, near Horsham.

My last assignment as a photographer had been the book *Defending our Heritage* for the MOD. It was beautifully presented with a foreword from Lord Cranborne who, at the time, was Parliamentary Under Secretary of State for Defence. It ended with these words:

I am particularly grateful to Anthony Peers for his research and to John Jochimsen for his splendid photographs. I hope their work will be rewarded by stimulating the interest of a wider audience, signed 'Cranborne'.

Perhaps a fitting epitaph for a well-known photographer, who had started his fifty years work with glass plates and ended it when cameras went digital.

A Few Words More

Now at the age of eighty two, I sit in my lounge and look at some of my past photographs on the wall. They are special shots that mean a lot to me and are comfortable to have around. A lot of my pictures, especially those I took for the COI abroad in my younger days, were missing, due to the disbanding of their photo-library some years ago. There were historic pictures of Princess Elizabeth and the Duke of Edinburgh at Treetops, the Queen Mother, Haile Selassie, the Shah of Persia, Winston Churchill and Mrs Thatcher, to name but a few.

Then there were all the overseas territories that I covered for the Colonial and Foreign Offices, historic pictures. I had a few that others took of me, but at last I have found more at the Imperial War Museum, all thanks to Hilary Roberts who is in charge of their photographic archive. But how pictures taken for the Colonial Office finished up at the Imperial War Museum, I will never know. Also I should like to thank Miles Templer for allowing me to publish three pictures of his father, Caroline Dempsey of the National Media Museum in Bradford, Eric Jenkins of the UKAEA Picture Archive at Harwell, Lisa Highway and Paul Stonell of the Royal Collection Enterprise Ltd for all their help in finding some of my old photographs.

I should also like to thank Peter Cowlam for editing the book, and Jon Kirk together with Tom Evans for their help as well. Lastly, Damian Cecil and Art Hutchins who both helped me in finding and working on some of the pictures.

On the day I was born in 1929, there was a tsunami in Hastings resulting from an earthquake near Ipswich. It caused a twenty-foot high wave on the beach, but luckily no one was injured or killed. Then very soon after that, the American and British economies were in recession, as they are today, and in 2004 across the Indian Ocean was one of the largest tsunamis ever recorded, with thousands killed.

That was the year I first thought about writing my memoirs – strange how history sometimes repeats itself!

I should now like to thank all those who helped and gave me work over the years, and became my friends. I thank them all from the bottom of my heart, for without their input my life would never have turned out as it did. This goes for everyone mentioned in the book, but there are a few that became very great friends and to them I owe so much more. They are:

Norman Smith, Charles Rosner, Walter Nurnberg, Dick Forsdyck, Terry Mead, Scot Robertson, Brian Goodman, Paul Roberson, Phil Long, David Leech, Roger Livesey, Alan Gatland, Ken Simons, John Taylor, Ted Weston, John Evans, Johnny Curtis, Billy Williams, Peter Sargant, Pat Bowman, David Whitter, Charles Martin, Sandy Rawlinson, George Sutherland, Don Harrison, Peter Curtis, David Scrivenor, Ted Lowe, Ian Crighton, Reg Tyrell and last but not least the Rev. Doctor David Scott. Some are not with us anymore, but I shall never forget them nor their kindness to me over all the years I knew them.

To my children and my dear departed wife, who I know will think about this book wherever she is. I wrote this for you all to show something of what your father and husband did while he was away, all those days and weeks. There were times when I felt I would never finish it, but the thought of leaving this for you pushed me to the end. So to Paul, Sally, Jane, and Robert, this is for you – read it and pass it on to your children, let them know about their grandfather's life.

Lastly, if anyone who reads this book still remembers me, please send an email and let's talk about the old days – johnjoch@tesco.net

John Jochimsen, 2007

Also from MX Publishing

A stunning memoir of living with the Naga
Headhunting Tribes In India

"Imagine waking up to the rustle of a jungle wind and the howling of monkeys. Imagine a place where morning coffee doesn't come from Starbucks and the nearest doctor is a three-day hike away, longer if it rains. Imagine navigating your way down a trail — where a hungry leopard could be lying in wait — just to use the bathroom. Imagine cobras, man-eating tigers and neighbors who decorate their homes with the human skulls they hollowed out the night before."

Ocala Journal, Florida

www.mxpublishing.com